# HERE I STAND

---

INTERPRETATIONS IN ART
A series of Columbia University Press

*Mannerism and Anti-Mannerism
in Italian Painting*
Walter Friedlaender

*Paul Klee: Legends of the Sign*
Rainer Crone and Joseph Leo Koerner

*Theorizing Modernism: Visual Art
and the Critical Tradition*
Johanna Drucker

# HERE I STAND

## PERSPECTIVE FROM
## ANOTHER POINT OF VIEW

NORRIS KELLY SMITH

Columbia University Press

New York

Publication of this book has been aided by a grant from the Millard Meiss Publication Fund of the College Art Association.

Columbia University Press
New York    Chichester, West Sussex
Copyright © 1994 Columbia University Press

Library of Congress Cataloging-in-Publication Data
Smith, Norris Kelly.
     Here I stand : perspective from another point of view / Norris
Kelly Smith.
        p.   cm. — (Interpretations in art)
     Includes bibliographical references and index.
     ISBN 0–231–08426–9
     1. Perspective.   2. Visual perception.   3. Space (Art)
     4. Painters—Europe—Psychology.   5. Art and society—Europe.
     6. Art, Renaissance.   7. Art, Modern—Europe.   I. Title.
     II. Series.
     ND1475.S65   1994
     750'.1—dc20                                              93–42141
                                                                  CIP

⊗
Casebound editions of Columbia University Press books are
printed on permanent and durable acid-free paper.

Printed in the United States of America

c 10 9 8 7 6 5 4 3 2 1

To Mary and our children

and to Robert Jordan (1926–1993)

# Contents

# Illustrations

COLOR PLATES   (insert after page 70)

# Foreword

*Here I Stand* is an original and important book. It is the kind of book one wants to see in art history: passionately partisan, critically interpretive, focused and precise in its analysis and yet large in scope and in the implications of its thesis. Unlike many other books on perspective, this is a book to read, and to read with pleasure, precisely because it is not a historical survey but rather an interpretive essay: a study of the ways in which pictorial structure in Western painting embodies meaning.

*Here I Stand* is also a very ambitious book. It deals with some of the best known and most written about images in the European tradition—from Brunelleschi and Masaccio in the early Renaissance to Monet at the close of the nineteenth century—and, in particular, with an aspect of picture-making that modern scholars have considered central to the achievement of that tradition: the construction of pictorial space. From the outset Smith declares his position, clearly challenging the standard and venerable literature in the field—above all, the writings of Erwin Panofsky. Whereas scholars from Panofsky to, most recently, Martin Kemp have dealt with Renaissance perspective in terms of applied Euclidean optics or mathematically controlled illusion or as the geometrical construction of space, isolating space as an abstract problem—indeed, *the* abstract problem—Smith insists upon setting the issue into a more social context. On his reading, the new perspective system developed in the early Renaissance offered a way of declaring a point of view in more than just a physical or perceptual sense; for Smith there is an ethical dimension to the artist (and hence the viewer) locating his position, "taking a stand." Smith

explores the complex social dimension of images, the ways in which pictorial point of view speaks to the position of man in society (specifically, Renaissance Florence or Reformation Germany or Protestant Holland or atheist Paris of the nineteenth century).

He builds his argument on the two famous (lost) demonstration panels created by Brunelleschi, one showing the Baptistry of Florence, the other the Palazzo della Signoria. Noting that the two subjects represent in effect church and state, Smith offers a resonant reading of their possible meanings for the artist and his public. The interpretation is compelling precisely because it enlarges and enriches the possibilities of meaning in these images. It makes sense, and we come away with a much more deeply satisfying understanding of the issues—not only of that particular moment in Florentine art and history but of the ways in which images per se can mean. Above all, Smith insists on the ethical dimension of that meaning. His analyses of the spatial structures of those images (insofar as we know them from literary descriptions) and their implications (the dominant and centrally focused Baptistry vs. the Palazzo della Signoria seen on angle and within the public space of the piazza) establishes the basis for his thesis that the space imagined in pictures is a social space and that point of view is ethically loaded.

Smith's own point of view, his approach and his values, are defined by Renaissance ethical values, those of civic humanism as well as, most important for him, those embodied in Luther's declaration, "Here I take my stand." Taking a stand is central to Smith's thesis. By insisting on the ethical dimension of spatial construction he is able to offer new and illuminating readings of individual pictures. The difference between a single-point centralized construction and a two-point asymmetrical one becomes charged in Smith's view, as he articulates the viewer's encounter in terms of potential movement, that is, freedom of movement. Smith's engagement of the heroic protagonist of Uccello's *Deluge,* to take one very satisfying example, gives that figure—always acknowledged as compositionally central but never before taken so seriously—a meaning fully commensurate with his prominence in the picture, a meaning illuminated by, even as it further illuminates, a concept of humanist heroism. His reading of Altdorfer's *Holy Kinship* as a Protestant construction, a moment of methodological as well as thematic arrival in Smith's text, demonstrates beautifully the implications of how figures (we the viewers as well as the painted personae) move in architecture, of how architecture determines our position in a complex of ways.

From the communal bonds of church and state, Smith moves to consider family, already implicit in Altdorfer, by turning to examples of seventeenth-century Dutch painting, exploring with great sensitivity a pair of images by Emanuel De Witte. Finally, Smith's thesis concludes in a surprisingly moving and convincing consideration of Monet's serial confrontation of Rouen Cathe-

dral. Because he has taken the ethical and moral dimensions of artists' experience so seriously, Smith is able to offer a most penetrating reading of these Impressionist images, one that locates them morally as well as historically; issues of atheism and solipsism, of attitudes toward institutions and history emerge to complicate these famous paintings, enhancing the complexity of their meaning and lending them a stature that, despite their centrality to discourse on Impressionism and its crisis, they have never had.

*Here I Stand* climaxes Smith's long career as a teacher of art history—first at Columbia and then at Washington University in St. Louis. All the more moving and persuasive for being a deeply personal meditation on painting, the book is striking for its maturity. The text derives a special force from the very individual voice behind it. It is a rare thing in the field of art history: a book written with powerful conviction, one that brings its own moral and critical sense to its subject. In leading us to new awareness of our dialogic relationship with images, Smith reminds us that the dialogue transcends mere visual perception and aesthetic detachment; by his own example he attests to the ethical charge of painting, its function in defining our own position in the world.

David Rosand

# Acknowledgments

My thanks to the government for a small Fulbright grant that helped make it possible for me to spend ten months in Florence and to the German Institute in that city for permission to make daily use of its library.

I am grateful, too, to Professor David Rosand for assistance with both text and production, and for his generous foreword, and especially to my son, Professor David R. Smith, for invaluable help with preparation of the text and with the mechanics of getting the book into the hands of the Columbia University Press. My thanks, too, to Patricia Cristol, manuscript editor, and to my wife Mary for undertaking the difficult chore of preparing the index.

Norris Kelly Smith

# Introduction: The State of the Question

To begin with, a paradox. It has become a near-ubiquitous cliché among art historians to speak of the vanishing-point perspective that was perfected early in the fifteenth century as "scientific" perspective. But what are we to make of the fact that that method was invented at a time when there was hardly anyone (perhaps no one) alive who could have been called a scientist—no practitioner of the "scientific method," no one concerned with the systematic measurement and testing of observable relationships among natural phenomena; yet on the other hand, by the 1950s, when it was often said that 90 percent of all the scientists who had ever lived were then alive, "scientific perspective" had quite disappeared from the fashionably advanced painting of that decade? Equally puzzling is the designation of Renaissance perspective—the *costruzione legittima*—as "mathematical," even though neither the invention nor the application of the method involved any mathematical calculation whatever, other than the division of a base line into a number of equal segments. But again, why should the designation "mathematical" have become popular among art historians at a time when our mathematical knowledge was expanding with incredible rapidity, yet modern painting had become as wholly nonmathematical as could be? Might it be the case that the modern scholar's desire to characterize the *costruzione* in terms commonly associated with immensely successful intellectual achievements of our own day has been ill conceived, misguided? Such, I believe, is the truth of the matter.

In order to find out where and why we took this wrong turning, we need to consider developments that occurred in the academic study of the arts between the middle and the end of the nineteenth century. When John Ruskin

was appointed Slade Professor of Art at Oxford in the 1860s, it was well known that he was an intensely moralistic critic of art and architecture—that his "seven lamps" of architecture, for instance, were sacrifice, truth, power, beauty, vitality, memory, and obedience, and that the title "professor" carried with it the expectation that the holder of that title would *profess* his earnest convictions, and those of the artists he dealt with, in regard to just such matters as those seven words bring to mind. By the time of Ruskin's death, in 1900, there had arisen, beginning in Germany, a new and altogether different conception of scholarship to which the notion of "professing" was all but irrelevant. Instead, professors were (and still are) expected to set forth well-authenticated factual data and to do their best to avoid expressions of personal opinion and conviction, under which dispensation it became increasingly difficult for them to deal with the ethical or religious convictions of artists themselves.

The new outlook was not moralistic or religious; in keeping with the orientation we associate with the words *Kunstgeschichte* ("art history") and *Kunstwissenschaft* ("art science"), professors aimed at putting the study of the arts on as intellectually respectable a basis as that of the natural sciences, of which the one that presented the most useful model was biology, with its preoccupation with classification and with patterns of evolutionary development and change. Equally important was the new conception of an objectively scientific historiography (with which we associate the names of men such as Leopold von Ranke)—a conception that carried with it a new concern for documentation, for meticulously careful attributions, for an increasingly precise definition of styles and style-periods, and, above all, for the centrality of *research*.

One of the relatively few aspects of the art of painting that has lent itself to an ostensibly scientific analysis is perspective, because of its apparent relation to geometry and measurement. While it is true that once one has assigned a numerical value to one of the squares in a perspective grid, one can assess with considerable accuracy the sizes of objects resting upon that grid and the distances between and among those objects, it does not follow that that was the prime purpose of the artist who employed the grid, or that his laying out that pattern was itself a mathematical feat. By beginning his book *Della Pittura* with a description of the "visual pyramid" and of the way light passes from an object to the eye of an observer, Alberti appears to be concerned with establishing a lucidly intellectual (scientific?) basis for the painter's art; but then toward the end of his first chapter he says *"Laying all that aside,* let me tell you what I do when I paint a picture" (my italics). He then gives us, albeit in somewhat obscure Italian, a recipe for inscribing on his picture surface the pattern of a receding gridiron pavement.

But Alberti made a fateful omission. Archetypal and prototypical academic that he was, he described his method without mentioning his subject matter. He has much to say about *istorie,* but he does not cite specific stories that he

himself had illustrated, nor does he take account of the fact that many, if not a majority of, Renaissance perspectival paintings are iconic rather than narrational. In his recent book on perspective, *The Science of Art,* Martin Kemp makes the same omission: he assumes throughout that the artist-as-scientist accords no primacy to his subject matter—though surely every Renaissance commission began first of all with an agreement between artist and patron about the subject to be dealt with.

In order for this indifference to the generally religious subject matter of Renaissance imagery to become established, primacy had to be given to something else: the idea of *space.* Perhaps no single bit of writing was more important in accomplishing this shift than Erwin Panofsky's early essay "Die Perspektive als 'symbolische Form,' " which was written in the early 1920s and published in 1925.[1] By putting the words *symbolische Form* in quotation marks, Panofsky acknowledged (sotto voce) his indebtedness to the thinking of Ernst Cassirer, the first volume of whose *Philosophie der symbolischen Formen* had been published in 1923. Both men were at the Warburg Institute in Hamburg at the time.

In one application of the concept of "symbolic form" Cassirer discusses myth, religion, art, and science; in another, space, time, and number. In his first volume he devotes several pages to the idea of space, and this is the "form" that was chosen for further investigation by Panofsky (whose article might better have been entitled "Der Raum als 'symbolische Form,' "—"Space as 'Symbolic Form' "—since it has much more to do with the concept of space than with the technics and uses of pictorial perspective). Yet when it comes to the actual content of Panofsky's argument, his thinking was shaped less by Cassirer's thought than by Alois Riegl's, for it was in the latter's *Spätrömische Kunstindustrie* that the discussion of perspective was shifted away from the notion of focal vision and onto a new, abstract plane where no attention had to be paid to the specific perspectival usages of specific artists in relation to specific kinds of subject matter.

Hegel had averred, according to Cassirer, that "the philosophy of an epoch contains within itself the consciousness and the spiritual essence of its whole condition," or, as Cassirer himself declared, "In order to understand the order of human things, we must begin with a study of the cosmic order." This is precisely Panofsky's procedure: in seeking to understand the nature of ancient perspective he begins not by examining specific ancient paintings but rather by citing Aristotle's assertion that it is better to regard cosmic space as being limited rather than infinite. On the basis of that one statement Panofsky concludes that not only did the ancient painter not develop a one-point focal perspective but he could not have done so, since he did not understand the notion of space as an infinite continuum. Never mind that many ancient philosophers disagreed with Aristotle and thought the universe to be of infinite

extent, and that Panofsky didn't trouble to show why either conception of the cosmos should affect the way one sees a street scene, a building, or an interior room (for surely Aristotle's eyes worked in the same way as Alberti's or as our own). Panofsky goes on, then, to characterize the idea of "modern space" in terms of the thinking of Copernicus and of Descartes, with special emphasis upon the latter's conception of space as *res extensa,* as something having real being because it could be measured. (Never mind, again, that many of Descartes's contemporaries rejected his notion.) Panofsky never retreated from these high levels of intellectual abstraction. As late as 1953, when he published his *Early Netherlandish Painting,* he saw fit to summarize his 1920s' argument without change.

Yet there are no grounds whatever for supposing that ancient artists were preoccupied with the idea of space, and Renaissance critics and theorists—Alberti, Ghiberti, Piero della Francesca, Vasari et al.—made no use of the word at all. The appeal of "space" to modern writers lies partly, I believe, in its having given rise to an almost mystical fascination with nothingness (Aristotle described space as "non-being," *mē on*)—it may perhaps be related to the decline of "objective" subject matter and to an underlying strain of nihilism that pervades much of the history of modern art—and partly in "space" having made it possible for the modern critic and historian to avoid taking seriously the subject matter of the art of former generations. "Space" makes no ethical or spiritual demands upon anyone; it is as totally uncharged a "substance" as can be imagined.

The very nebulousness of the term has encouraged modern critics and historians to attribute significances to the word that will no more bear close scrutiny than will space itself. Consider, for instance, the following passage by Giulio Carlo Argan, for whom perspective "is not a constant law but a moment in the history of the idea of space." Speaking of the original blocklike, seven-bayed form of the Palazzo Pitti, surely one of the most massive of Renaissance buildings, Argan declares that "this edifice, the prototype of the lordly palace of the Renaissance, marks the highest and most 'metaphysical' moment in Brunelleschi's spatial thought: the thought of an architecture that weaves its 'proportional' plane to the ultimate limit of space that can be measured in terms of perspective (*dello spazio prospetticamente misurabile*), and in the succession of its planes, in the proportionality of its solids and voids, of the verticals and horizontals, interposes a passageway between the opposite elements of earth and sky."[2] Though Panofsky would not have indulged in flights of spacemanship such as this, his own inflated use of the word is scarcely more defensible.

But perhaps all this is irrelevant. The trouble with Panofsky's mode of analysis, whether philosophical or scientific, lies in the fact that it does not enhance our understanding of any specific work of art. And that holds true for the prin-

cipal studies of perspective that have been brought forth since his time. Let me briefly consider two of them.

The first is John White's *The Birth and Rebirth of Pictorial Space*. "There is already a sufficiency of attractive but conflicting general theory," White avers, wherefore he proposes a "strictly historical approach," based upon a careful examination of the "visual and literary documents . . . without undue entanglements in matters of opinion."[3] (One could hardly state more succinctly the ideals of post-Ruskinian *Kunstgeschichte*.) Throughout his book he takes it for granted that ancient and Renaissance artists were no more entangled in matters of opinion than he and that their only real problem was that of finding an adequate way of dealing with "the relationship between the two-dimensional surface and the three-dimensional world." Like other writers in this vein, White ignores the fact that all ancient and Renaissance pictures (with two exceptions I shall come to shortly) are imaginary inventions having to do with the meaning and content of the very idea of "world"—that they are never transcriptions of the data of direct observation.

The word *world* refers to a comprehensive wholeness of things, analogous to that "turning of the many into one" that is expressed in the word *universe* (*unum + versare*); it does not refer to something that is visible in our immediate environment. One's world includes at least some knowledge of an ancestral past and of the conventional wisdom of a human community, by virtue of which one is enabled to be an ethical human being and to cherish expectations concerning individual and collective destinies. All such considerations are "matters of opinion"—matters of *doxa* rather than of *epistēmē*, the words by which the Greeks distinguished between "opinion" or "conjecture," on the one hand, and "knowledge" or "scientific knowledge," on the other. Devotees of *Kunstwissenschaft*—"art science"—may seek to gain the kind of well-documented information that might qualify as *epistēmē*, but painters deal only with matters of *doxa*.

Setting aside all such considerations, John White proceeds to make scores of careful and dispassionate observations concerning the technical usages that were employed by fourteenth- and fifteenth-century Italian painters, to which he appends, almost as an afterthought, a brief consideration of the "birth" of pictorial perspective, or "space," in classical antiquity. But since "rebirth" precedes "birth," no compelling connections between the two are adduced, nor are any causative differences of conviction or opinion that might illuminate the dissimilarities between them.

The second book, Martin Kemp's *The Science of Art*, I have already mentioned. Under his dedication of the book to the Scottish Royal Society we find inscribed the sentence *Ars sine scientia nihil est*. But since the only science the book deals with is that of optics, together with the relation of optics to perspective, we must conclude that the only *scientia* without which art is "nothing" is perspective—but that is self-evidently an indefensible proposition.

In the latter part of his book the author, under the heading "Looking at Space," devotes several pages to surveying a variety of theories of perception, all the while ignoring the fact that the one thing we cannot look at is space. Between me and the wall across the room there lies a black void, as dark as the one that separates the earth from the moon. The nocturnal sky is filled with blazing sunlight, but until that light hits something and is reflected back to our eyes, we can see neither light nor space. I can see the walls of my room and objects in the room, but I cannot possibly look at the space as a separate entity. The modern penchant toward transforming space into a mysteriously flowing fluid or toward attributing to it the substantiality implied by Bruno Zevi's conception of "architecture as shaped space" simply has no foundation in reason or experience.

And so it has gone. With the scientism of the *Kunstforscher* ("art researcher") and with the indifference to subject matter (and specifically to religious subject matter) that has attended what K. B. MacFarlane has rightly called "the Agnostic Ascendancy," the study of perspective has been grievously restricted. In the following chapters I propose to consider the matter from an altogether different point of view. I mean to explore the proposition that the crux of the matter lies not in vanishing point but in *standpoint*—that the central issue in those paintings that involve perspective (as, for instance, the art of portraiture generally does not) is inseparable from the assertion "Here I stand!"

We cannot understand the practices of the Renaissance painter unless we recognize the fact that one can meaningfully "take one's stand" only with reference to something *else* that steadfastly stands. When Martin Luther concluded his defense at Wittenberg with the ringing declaration "Here I stand!" he was not asserting his right, as a matter of civil liberty, to hold whatever personal opinion he might choose to adopt, nor was he concerned with men's freedom to have "private viewpoints." Instead, he was affirming that Holy Scripture is, quite objectively, our one and infallible guide in spiritual matters, that he had the ability to understand what its words plainly mean, and that he was prepared to stake his life on the validity both of his comprehension and of what it was that he comprehended. Only on the basis of a right understanding of Scripture, he asserted, could one know what was required in order that one's sins might be forgiven and one's soul saved from everlasting hell-fire. If those words, or that Word, were not unshakably reliable, then no man could know where he stood with regard to the all-encompassing sense of things. Sir Thomas More, while remaining a loyal Catholic, was to demonstrate in the following decade a similar consistency and steadfastness, choosing martyrdom in preference to ethical compromise.

So it is, then, with the Renaissance artist. Typically he takes his stand with regard to something that matters, both to him and to his patron, more than his

painting, more than art, more, sometimes, than life itself. This did not prevent his work from being valued for its aesthetic qualities: King David was no doubt justly proud of the literary quality of the Psalms, but ethical stance is the all-important factor that justifies the rhetorical eloquence and gravity of concern that make the works not only beautiful but powerful and moving.

In fact, the painter's attitude toward discourse and communication was like that of every educated man in the Renaissance. As Professor Walter J. Ong has demonstrated, all teaching and formal discourse were essentially polemical, beginning with the stated or unstated assertion "Here I stand!"

> In accord with the rhetorical outlook, students were almost never taught objec-
> tive description or reportorial narration: the object of education was to get them
> to take a stand, as an orator might, and defend it, or to attack the stand of
> another. . . . The whole purpose of speaking or writing about anyone, as one can
> see in so standard a manual as Aphthonius' Progymnasmata, was to praise or
> blame him. Even in treating with inanimate objects, training in cold, objective,
> uncommitted description is by and large not a part of formal education in the arts
> of language at least through the seventeenth century. Consequently it is very dif-
> ficult to find a real connection between any pedagogical system, based as these
> generally were upon training in the language arts, and an experimental frame of
> mind. The pedagogy of the time bore hard on personal relations.[4]

Much the same can be said of the purposes and training of the artist. The popular notion that Renaissance perspective was devised so as to make possi-ble an accurate transcription of the data of objective, protoscientific observa-tion is hopelessly wrongheaded.[5]

At this point it is only right and just that I should make it clear that I am myself writing from a distinctive standpoint. In the chapters that follow, I shall be concerned with the dialogical argumentation that underlies works of art that invite *us* to take our stand. Those works were made for churches, family chapels, country estates, middle-class living rooms, governmental buildings—for settings in which they defended commonly held convictions. Today almost all such works have been wrenched loose from those settings and have been refrigerated in museums or in coffee-table art books or in academical text-books where they are no more challenging to the viewer than are the wild ani-mals that are safely caged in zoos. Like the animals, the works of art have been converted to the purposes of entertainment; no one is ever invited in a museum to *take his stand* or to contemplate the fact that what is affirmed in a Duccio or a Baldovinetti cannot be reconciled with what is affirmed in a Monet or a Picasso. The directors of museums collect specimens; they have no coherent purpose in mind, other than that of providing the Sunday afternoon museum-goer with the widest possible variety of stimulating experiences. The perspectival works of Renaissance art were not made with that end in mind.

So let us begin . . .

# The Lost Tavolette

Martin Kemp begins his book *The Science of Art* with the statement "Linear perspective was invented by Filippo Brunelleschi." Two objections come to mind immediately. In the first place, it is well known (to Kemp and the rest of us) that perspectival rendering was widely used in antiquity (Decio Gioseffi believes it was understood already in the time of Democritus) and in the trecento by artists such as Giotto and the Lorenzetti—whose work Kemp later discusses. We come to see, then, that Kemp is using the word to refer only to the device commonly known as the *costruzione legittima*. Second, there is no compelling evidence that Brunelleschi was the inventor of that device. One reason for thinking that he was lies in the fact that Alberti dedicated his book *Della Pittura* to the architect, and it is in that book that the scheme is described for the first time. But Alberti may have had other reasons for his dedication. The other reason for thinking Brunelleschi to have been the inventor is to be found in Antonio Manetti's biography of Brunelleschi, wherein the author states that it was Brunelleschi who "propounded and realized what painters today call perspective. . . . He originated the rule that is essential to whatever has been accomplished since his time in that area." Manetti had once been acquainted with Brunelleschi (we don't know how well), but he was writing at about the same time that Piero della Francesca was composing his *De Prospectiva Pingendi* (i.e., c. 1480–85, or about thirty-five years after Brunelleschi's death), at a time when the theory or rules of perspective perhaps seemed more important than they did even to Alberti, who does not pursue the matter further in the rest of his book.

In point of fact, however, Manetti tells us nothing about a rule or system

that Brunelleschi may have invented. Instead, he proceeds to describe two panel paintings Brunelleschi had made (both now lost), with the clear implication that it was in them that there was to be found the very kernel of Brunelleschi's contribution to the perspectivist's art. In this he was correct, I believe, though he did not understand wherein the originality of the works lay. For if one considers the "essential rule" to be the scheme Alberti described, with its gridiron pavement and its central vanishing point (or "point of center"), then one can hardly avoid seeing that neither of the two paintings involved either a gridiron pavement or a central vanishing point—or any vanishing point within the area of the painting.

> Brunelleschi first demonstrated his perspective [Manetti writes] on a small panel about half a *braccio* [about eleven inches] square, on which he made an image of the exterior of San Giovanni in Florence. . . . In order to paint it it seems that he stationed himself some three *braccia* inside the central portal of Santa Maria del Fiore. . . . In the foreground he painted that part of the piazza encompassed by the eye, that is to say, from the side facing the Misericordia up to the arch and corner of the sheep market, and from the side with the column of the miracle of St. Zenobius up to the corner of the straw market, and all that is seen in that area for some distance. And he placed burnished silver where the sky had to be represented, that is to say, where the buildings of the painting were free in the air, so that the real air and atmosphere were reflected in it, and thus the clouds seen in the silver are carried along by the wind as it blows. Since in such a painting it is necessary that the painter postulate beforehand a single point from which his painting must be viewed, taking into account the length and width of the sides as well as the distance, in order that no error would be made in looking at it (since any point outside of that single point would change the shapes to the eye), he made a hole in the painted panel at that point in the temple of San Giovanni which is directly opposite the eye of anyone stationed inside the central portal of Santa Maria del Fiore, for the purpose of painting it. The hole was as tiny as a lentil bean on the painted side and it widened conically like a woman's straw hat to about the circumference of a ducat, or a bit more, on the reverse side. He required that whoever wanted to look at it place his eye on the reverse side where the hole was large, and while bringing the hole up to his eye with one hand, to hold a flat mirror with the other hand in such a way that the painting would be reflected in it. The mirror was extended by the other hand a distance that more or less approximated in small *braccia* the distance in regular *braccia* from the place where he appears to have been when he painted it up to the church of San Giovanni. With the aforementioned elements of the burnished silver, the piazza, the viewpoint, etc., the spectator felt that he saw the actual scene when he looked at the painting. I have had it in my hands and seen it many times in my days and can testify to it.
>
> He made a perspective of the piazza of the Palazzo dei Signori in Florence, together with all that is in front of it and around it that is encompassed by the eye when one stands outside the piazza, or better, along the front of the church of San Romolo beyond the Canto di Calimala Francesca, which opens into the piazza a few feet toward Orto San Michele. From that position two entire

façades—the west and the north—of the Palazzo dei Signori can be seen. . . . One might ask at this point why, since it was a perspective, he did not make that aperture for the eye in this painting as he did in the small panel of the Duomo of San Giovanni? The reason he did not was because the panel for such a large piazza had to be large enough to get down all those diverse objects, thus it could not be held up with one hand while holding a mirror in the other hand like the San Giovanni panel: no matter how far it is extended a man's arm is not sufficiently long or sufficiently strong to hold the mirror opposite the point with its distance. He left it up to the spectator's judgment, as is done in paintings by other artists, even though at times this is not discerning. And where in the San Giovanni panel he placed burnished silver, here he cut away the panel in the area above the buildings represented, and took it to a spot in which he could observe it with the natural atmosphere above the building.[1]

Manetti plainly regarded the *tavolette* as demonstration pieces, as exercises in the application of a method, and they have been so regarded by any number of writers from that day to this. Vasari states that Brunelleschi "found by himself a method whereby perspective might become true and perfect— namely, that of tracing it with the ground plan and profile by means of intersecting lines." Alessandro Parronchi and Richard Krautheimer, arguing at some length that this was the technique used in making the panels, have made detailed drawings of the Baptistry, using the projectional method of descriptive geometry. However, there is nothing in Manetti's account to suggest that Brunelleschi employed this method. He makes it clear, instead, that both images were renderings that the artist had made from specific viewpoints; they were not drafting-board constructions of the kind for which, and only for which, the plan-and-elevation system is useful.

The projectional method was worked out in exhaustive and exhausting detail by Piero della Francesca, and it has been used by modern architects in making presentational drawings of buildings that do not yet exist, but the artist who draws directly from things seen has no need of it. If Brunelleschi had employed the system for his two panels he would have had to make exact measurements of plan and elevation not only for the Baptistry but also for the large and irregular buildings on three sides of the Piazza della Signoria—a task so difficult that if it had been carried out it would surely have been remembered and recorded.

Krautheimer puts the invention of the panels within the framework of drafting-room practice. "Brunelleschi proceeded along lines strictly architectural in thought. His aim was architectural and practical. . . . His methods of architectural representation were those of a practicing architect; that is, he worked only from ground plans and elevations drawn to scale on a mathematical basis. . . . His perspective method was fundamentally an architectural tool."[2] But if this had been Brunelleschi's method, there would have been no need for

his having worked in each case from a specific point of view, either inside the Cathedral or at a specific street corner. The *tavolette* were not renderings of buildings that Brunelleschi had designed and was proposing to build. As Krautheimer surely knew, we do not have a single presentational drawing from the hand of any fifteenth-, sixteenth-, or even seventeenth-century architect; like Parronchi, he perpetrates an anachronism in suggesting that the two images are related to a development in the shop-practice of builders. In Brunelleschi's time an architect's proposals were judged not on the basis of perspectival renderings but of large wooden models that could be walked around and looked at from all sides.

It seems odd that on this occasion Krautheimer should have stressed so insistently the utilitarian aspects of "architectural thought," for elsewhere (as we shall presently see) he has written eloquently and with insight about just such medieval buildings as the Baptistry of San Giovanni. He seems to have wanted to impute merit to Brunelleschi by making him out to have been more modern than his contemporaries, a forerunner, so to speak, of the architectural engineer of the twentieth century.

Others have called Brunelleschi an engineer because of the ingenuity with which he accomplished the construction of the great cupola of the Duomo. But why is it that the ingenious engineering of the thirteenth-century Gothic cathedral is universally regarded as an expression of a profound religious concern on its builders' part while Brunelleschi's completion of a Gothic cathedral, at a time when the Gothic was still a popular style and when many of the great cathedrals were still being constructed, is looked upon by virtually all architectural historians as merely *practical* engineering? The issue is of the greatest importance, for it bears directly upon the problem of interpreting the meaning of the two lost panels.

As a matter of fact, we cannot be at all sure that Brunelleschi *was* an architect or had any intention of becoming one at the time he painted the panels. Manetti does not say when they were made, but he clearly implies that it was before 1401, when Brunelleschi "stava e facieva el mestieri dello oroficie (was practicing the trade of goldsmith)." Though Manetti states that while still a young man Brunelleschi gave advice on architectural matters, he was practicing the craft of the goldsmith. We know of no building he designed before the year 1418, when he entered the competition for the construction of the cupola (in a shape that had already been decided upon as early as the 1360s, though no one then knew how to build it). Parronchi would place the panels as late as 1425 so as to associate them with the instruction in geometry that Brunelleschi is thought to have received at that time (or later) from the young mathematician Paolo del Pozzo Toscanelli, who, both Parronchi and Lemoine would have us believe, also imparted to the much older man an extensive knowledge of the theoretical optics of Peckham, Bacon, and Witelo. Samuel Edgerton,

accepting this argument in toto, speaks without qualification of Brunelleschi's "experiment of 1425,"[3] even though there is no evidence for that date or for any connection between the panels and Toscanelli. Neither Parronchi nor Edgerton admits to any other possibility than that the panels were made solely for the purpose of demonstrating the optical and geometrical principles of the "science" of perspective—no matter that, as Ong observes, the experimentalist's mind-set was quite unknown in the quattrocento. Besides, *what* would the panels have proved or demonstrated? That the human eye can comprehend a wide piazza? That mirrors reflect? No one has ever bothered to say.

If we may leave Toscanelli and Witelo aside, it seems reasonable to accept an early date for the two paintings—perhaps as early as 1398, the date that has been proposed by both Roberto Longhi and Giulio Carlo Argan. But if they were made by a twenty-one-year-old goldsmith who would not design a building for another twenty years, and if they involved neither a constructed gridiron pavement nor a focal vanishing point, wherein does their significance lie? One cannot answer that question without raising a much broader one: what are Renaissance perspectival paintings *about?*

The panels make us mindful, first of all, that systematic perspective is useful for rendering not space but architecture—for picturing streets, city squares, buildings, rooms. Whatever one may think the true principles of perspective to be, they are plainly useful for hardly anything except the depiction of the geometrically regular, durable, man-made objects with which we surround ourselves in *cities*. It follows, then, that we cannot rightly understand any given application without considering the nature and significance of the buildings an artist may have chosen to represent.

Krautheimer has observed that "from the fifteenth century . . . a gradual process of draining the edifice of its 'content' seems to begin. It is by no means a continuous development and is constantly interrupted by countermovements, but it grows stronger and reaches its peak in the late nineteenth and early twentieth centuries."[4] It is at just that time that writers such as Riegl and Panofsky shift their attention away from the substantiality and symbolic significance of architecture and focus if instead upon space. Yet Krautheimer himself, when he writes about the *tavolette,* seems to suppose that for Brunelleschi that process of draining had already taken place. To suggest, however, that the greatest church architect of the fifteenth century was indifferent to the religious significance of churches and the civic significance of other buildings seems hardly credible. In Brunelleschi's day buildings had not yet become the abstract art objects they may now seem to be. They were rather the symbols of institutions that were still conceived to possess a higher order of *reality* than did the buildings themselves.

With that in mind, one will immediately be struck by the fact (though so far as I know it has never been mentioned by any art historian) that the two

buildings Brunelleschi chose to contemplate are representative of the two principal institutions of medieval and Renaissance Europe, the Church and the State. That is to say, the two paintings had to do with a duality that constitutes one of the distinctive peculiarities of Western civilization, for nowhere but in the West have there existed, side by side, two law-giving institutions, both embracing the whole body of the citizenry, demanding loyalty and obedience yet making radically different and in good part mutually exclusive claims.

In the Levantine traditions of Judaism and Islam, religion and law were virtually inseparable conceptions; the "binding up" (*religio*) of the community of the faithful depended upon the common acceptance of a set of prescriptions that governed even the small details of daily conduct. The Christian gospel, however, freed men from such legalistic observances and enjoined them to understand the meaning of ethical conduct in a way that demanded the highest order of personal self-consciousness and loving intention.

But what about Christian obedience to the laws of pagan Rome? St. Paul declared that "Every person must submit to the supreme authorities. There is no authority but by act of God, and existing authorities are instituted by him; consequently anyone who rebels against authority is resisting a divine institution" (Rom. 13:1–2). Still, with the persecutions that occurred between the time of Nero and that of Diocletian, Christians came to have abundant reason to doubt the divine ordination of the Roman state and to reject the divinization of the emperor's office and person—even to identify the emperor with the *antiChrist.* In the fourth, fifth, and sixth centuries the Empire, under Christian leadership, became "bound up" in a quasi-Levantine manner, so that it was possible for Justinian and his successors to regard themselves as head of both Church and State—though the two institutions still preserved their separate identities.

In the West a sharper separation had already been established by the time of Pope Gelasius I (492–496), who clearly enunciated the principle of duality—a monarchical caesar on the one hand, a monarchical pope on the other, the one ruling the temporal affairs, the other the spiritual lives, of the same people. During the Merovingian era, when there was nothing that could have been called a government (no capital city, no administrative organization, no judiciary), kings such as Clovis accepted Christianity as an external and perhaps somewhat magical system that need not deeply change people's lives. Only with the coronation of Charlemagne in Rome in the year 800 and the founding of the Holy Roman Empire did the Gelasian duality once more become an effective reality in European life. A period of some four or five hundred years then followed during which both emperors and popes held their respective offices, often in situations of intense rivalry that stemmed from the claims of the one or the other to superiority.

Beginning with the rise of the communes after the year 1000, a new factor

entered the equation: cities or city-states that increasingly claimed the right to govern themselves. For reasons of expediency the cities sometimes allied themselves with the forces of the papacy (Guelphs), sometimes with those of the emperor (Ghibellines), but mainly, in either case, as a means of securing their own independence. Not until Marsilius of Padua wrote his *Defensor Pacis* in the 1340s was the citizens' right to self-government explicitly formulated, though for many generations before that time they had struggled to free themselves from the suzerainty of feudal lords and feudal bishops. Within the communes themselves, and especially in Italy, there were often intense struggles between rival factions and rival families, more often than not involving those contending alliances, Guelph vs. Ghibelline—factions that existed in many Italian towns but nowhere more rancorously, perhaps, than in Florence.

The ancient square-shaped city of Florentia had at its center a forum, an open area around which the civil, religious, and commercial activities of the town were concentrated (see figure 1). During the Dark Ages that site was largely filled in with houses, and the forum shrank to the size of the Mercato Vecchio (which was obliterated in the 1880s to make way for a square that is not at all a forum, the Piazza della Repubblica.) From the early Middle Ages there had existed in the northeast corner of the original square city an ecclesiastical center comprising the Baptistry, the church of Sta. Reparata, a cemetery, and, eventually, the bishop's palace. Only in the second half of the thirteenth century did there come into being a civil center in the southeast corner of that original square, beginning with the construction of the Palazzo del Podestà (now the Bargello museum) in 1255. After the destruction of the houses of the Uberti that followed the ousting of the Ghibellines in 1258, way was made for the full realization of the civic center. First was the institution of the Ordinances of Justice (1292) which provided that the city should be

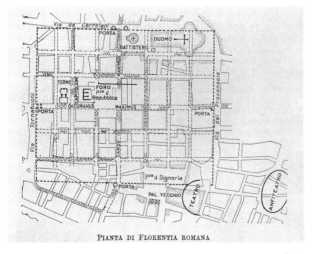

PIANTA DI FLORENTIA ROMANA

FIGURE 1. Map of the center of Florence, from *Firenze e Dintorni* (Milan: Touring Club Italiano, 1964).

governed by six priors, one from each of the *sesti,* the six districts into which the city was divided. Members of the priorate were to be chosen from among the memberships of the major and middle guilds, though in fact the political power remained always in the hands of the great merchant and banking guildsmen, *il popolo grasso,* the fat burghers. The Ordinances stipulated that the priors should hold office for a period of only two months, during which time they should live together in a single house. It was this latter consideration that prompted the building of the Palazzo dei Signori, which was thereafter the center of city government, while the Piazza della Signoria became the principal place of assembly in the civil life of the community.

The Palazzo, having the form of a betowered and fortified family house, was begun in 1296 under the direction of the architect Arnolfo di Cambio. Three years later work was begun on a new cathedral church, Sta. Maria del Fiore, which was designed by the same architect. The chief monuments of both the civil and religious centers of the city were begun concurrently, though the cathedral was finished long after the town hall. It was this duality that Brunelleschi felt compelled to contemplate at the very end of the fourteenth century.

Before we consider the *tavolette,* however, a word needs be said about the sociopolitical situation in Europe in the late 1390s. The year 1398 marked approximately the midpoint of the Great Schism, during which there were two popes, Boniface IX in Rome and Benedict XIII in Avignon. If the paintings were made as late as 1409, as Gioseffi thinks may have been the case, then at that time and for six years thereafter there were *three* popes, the third one in Pisa. Heresy and disaffection were rife. Lollardry was rampant in England in the wake of the reformist preaching of John Wyclif. Wyclif's teachings had lately been carried to Bohemia, where they quickly inspired the rise of John Hus, who, like Wyclif, attacked in its entirety the dogma and sacraments of the Roman Church.

Even among the orthodox the damage done by the Schism is scarcely imaginable. As John of Spoleto wrote in 1394,

> The longer this schism lasts, the more it appears to be costing and the more harm it does: scandal, massacres, ruination, agitations, troubles, and distur- bances . . . this dissension is the root of everything: divers tumults, quarrels between kings, seditions, extortions, assassinations, acts of violence, wars, rising tyranny, decreasing freedom, the impunity of villains, grudges, error, disgrace, the madness of steel and of fire given license.

Corruption and simony were so widespread within the Church that church- men found themselves in no position to speak out against moral corruption among the laity. Neither councils nor kings seemed able to remedy the ills that had overtaken the world. In 1398 Charles VI of France and the Emperor Wen-

zel met in Reims to find some way of healing the Schism, but since the king was seized by one of his fits of madness while the emperor was so dissolute a man that he had to be deposed from office shortly thereafter, they were hardly a pair from whom constructive diplomacy might have been expected; their meeting came to nothing. Everywhere there prevailed what Huizinga has so well described as "the violent tenor of life."

To think, then, that Brunelleschi was merely concocting an optical or mathematical "experiment" is to ignore every human circumstance, every religious and emotional consideration that we have good reason to suppose was on his mind. The evidence is to be found in the panels themselves.

## II

And so Brunelleschi took his stand a few feet inside the newest church in Florence (in 1398 the Duomo was about two-thirds finished) and looked out through its central doorway at the oldest one. Even today, after extensive investigation, there is no consensus as to the age of the Baptistry. It has been dated as early as the fourth century and as late as the twelfth. The truth of the matter is less important than the belief in Brunelleschi's day that the building was of Roman foundation and that it had once been a temple of Mars. Being the oldest church, it could also lay claim to being the most sacred site in the city. As Thomas Molnar has observed, "Continuity is the concrete, mundane translation of the presence of the sacred . . . [which] always refers to a reality beyond itself."[5] We have no reason to doubt the seriousness with which Brunelleschi addressed both the ancient building and the reality it stood for.

At this point we need take note of the nearly universal difficulty that art historians experience in coping with the phenomenon of belief. Richard Sennett writes that "The inability to imagine secularity as an independent social force comes, I think, precisely from the present-day inability to conceive of the act of belief as real in itself. And this in turn derives from our peculiar inability to comprehend the sociological realities of religion—religion being, as Louis Dumont has observed, the primary social structure for most of human society during most of its existence."[6] Though that is perhaps an excessively sociological was of putting it, for Renaissance men and women there still existed two realities, one temporal and the other spiritual, the latter every bit as real as the former. In Brunelleschi's day the ordering of church architecture and of Christian paintings was still believed to point to, or to reflect, an ultimate and unchanging truth.

With all that in mind, let us turn again to the first *tavoletta* (see figure 2). Its square form frames a front view of a building that does not ordinarily present itself frontally. Most striking is its silver ground. Manetti does not tell us all we would like to know about that "burnished silver where the sky had to be

represented." Had Brunelleschi applied silver leaf to a gessoed panel or was the whole image executed on a silver platen? Gioseffi has proposed that the artist painted directly upon the surface of a mirror, so he regards the image as having been hardly more than a photograph and not a perspectival invention at all. Yet plainly one cannot paint a frontal image on a mirror without having the center of the field completely filled by the reflection of one's own face. While recognizing this difficulty, Edgerton accepts Gioseffi's proposal but suggests that the problem could somehow have been solved by Brunelleschi bobbing his head back and forth—even though the slightest movement of his head would have changed the location of the reflection on the mirror.

Manetti says nothing about a mirror's having been used in the execution of the picture. Instead, he implies with his reference to the drifting clouds one could see reflected in the *ariento brunito* that the purpose of the silver sky was to achieve a heightened effect of "realism." Yet there is good reason to believe that he was stretching the truth when he said that one could see wind-blown clouds in the mirrored reflection of a reflection in the silvered sky—for of course the painting itself was meant to be seen only in a mirror image, and we

FIGURE 2. Brunelleschi, Baptistry Tavoletta, c. 1398; author's reconstruction.

may reasonably suppose that it was not meant for outdoor viewing. We shall return to the matter of the mirror in a moment. For the time being, it will suffice to suggest that Manetti, like many a writer since, was groping for a credible explanation of something that seemed eccentric and inexplicable. At no point does he say that Brunelleschi had in fact told him why he made the panel as he did.

The most fruitful suggestion that has been made so far, I believe, is that of Giulio Carlo Argan, who proposes that the silver surface may constitute "an allusion to those shining backgrounds of fine gold in which the devout painters of the tradition sought to mirror the mystic light of God." However, because of his Marxist antipathy toward that tradition and toward the institutions for which Brunelleschi produced his life's work, Argan goes on to assert that any such allusion must have been "satirical and almost irreligious." Throughout his extensive writings about Brunelleschi, Argan persistently assumes that the architect had no interest in the Church or even in the subject matter of the Abraham relief but was solely concerned with "space" and with abstractly theoretical conceptions of proportion and of mathematical harmony.

Though we no longer have the *tavoletta* itself, we can easily simulate it by pasting a cut-out photograph of the Baptistry upon a surface of shiny foil. Having done that, I can vouch for the fact that the burnished ground does indeed lend the frontal image a strikingly iconic appearance. As to why the young goldsmith used silver rather than gold we do not know; probably he was making the image for his personal use (surely it was not commissioned) and did not want to invest in expensive gold leaf. However, the gold ground was still in use for religious icons until long after Brunelleschi's death, even among painters as "advanced" as Mantegna. We have every reason to believe that our artist was consciously working within a tradition—indeed, that the continuity of the tradition, in regard to sacred things, lay at the very heart of his concern, and that in endowing his picture with the static, frontal, and architectonic characteristics of the trecento icon he had a serious purpose in mind.

The silver sky was by no means the oddest aspect of the painting. It must be seen in conjunction with the curious peephole through which one was to contemplate a mirrored reflection of the image. Manetti avers that the hole-and-mirror arrangement was devised so that the observer's eye would have to be located at a point precisely opposite what we would call the vanishing point. Thus, there might be no distortion because of the obliquity of one's line of sight, though again he does not tell us that Brunelleschi had told him that that was his intention. As a matter of fact, M. H. Pirenne has demonstrated by careful investigation and experimentation that an observer's angle of vision has little to do with the way one interprets the architectural perspective of a panel painting. We can look at such images from a markedly off-center position and yet experience no significant effect of perspectival distortion (any more than

we do in looking at a television screen at an angle).[7] If that is true of the general run of architectural views, it must have been doubly so for the Baptistry *tavoletta*. First, an octagonal building, like all polygonal and circular structures, is relatively unaffected by changes of viewpoint, tending to look much the same from any angle. Second, since there were no lines that converged toward a determinable vanishing point within the painting, the observer would have felt no strong sense of spatial orientation toward a point of center.

Moreover, if the hole was in fact located at a point opposite the eye of someone standing on the floor of the Duomo, it would have had to lie in the bottom quarter of the panel rather than at its center, where it is placed in Parronchi's schematic drawing (see figure 3) that purports to show that Brunelleschi's painting was intended to demonstrate one of the optical theories of Witelo. Under any circumstances it would have been difficult for one to hold the mirror, at arm's length, exactly parallel to the picture plane—and all so as to achieve a kind of optical precision that so many writers have thought so important, all on the basis of Manetti's trivializing theory.

But then what was the mirror for? Let me suggest that one factor, at least, had to do with the difference between monocular and binocular vision. When one looks at a small painting with two eyes, one is fully aware of the fact that the painting itself is seen to be a flat object within a larger field of stereoscopic vision, and that the image on the flat surface does not participate in that larger three-dimensionality. But when one eliminates that effect by closing one eye and by limiting one's field of vision to the painting alone, the image does seem to loom up in a decidedly more vivid way (reminiscent of the loom in Masaccio's *Pisa Madonna*). Now the contrast between the flatness of the picture and the greater proximity and remoteness of other objects in view disappears.

Yet Brunelleschi could have achieved the same result by mounting his panel at one end of a topless box and drilling his peephole, with much greater precision, at the other end—so why the mirror? Without exception, so far as I have been able to discover, everyone who has written about the matter has assumed that the mirror Brunelleschi used was like the silvered plate glass ones we are

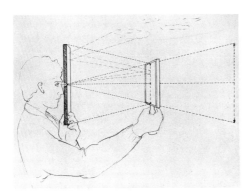

FIGURE 3. Alessandro Parronchi, diagram showing use of mirror, from his *Studi su la Dolce Prospecttiva*.

familiar with today, so perfect as to introduce no noticeable deviation from the quality of direct vision. But we know beyond a doubt that such mirrors did not exist in his lifetime. There were hammered and burnished plates (and anyone who has tried to see his reflection in a silver tea-tray or in the side of a silver teapot knows that such surfaces make poor mirrors), and there were mirrors made by rolling out a bit of blown glass and coating one surface with lead. Not until the sixteenth century did the Venetians perfect the technique of making plate-glass, bevel-edged mirrors coated with a tin amalgam, at which time such mirrors were more costly than fine paintings by great artists.

It seems, then, that by means of the mirror Brunelleschi was deliberately introducing a factor of unclarity into one's experience of looking at his image of the Baptistry. Keeping in mind the relation of the silvered mirror to the silvered sky, we may surmise that he possibly had in mind a verse from the Book of Job (37:18) in which Elihu urges Job to recognize the limitations of his own capacity to understand: "Can you, like him [God], spread out the skies, hard as a molten mirror?" (RSV). Or, as the New English Bible puts it: "Can you beat out the vault of the skies, as he does, hard as a mirror of cast metal?" The Vulgate, which is the only translation Brunelleschi could well have known, speaks of the skies as being "most solid" and spread out as if made of copper (*quasi aere*). Elihu's reminder of the inadequacy of our human understanding of God's will was restated by St. Paul (I Cor. 13:12) when he declared that "Now we see through a glass darkly" (Auth.) or "in a mirror dimly" (RSV)—darkly or dimly because ancient bronze mirrors were no better than the ones that were available in Brunelleschi's day in Florence. It is here, I am persuaded, that we find our best clue to the quintessential meaning of the first *tavoletta*.

*Videmus nunc per speculum in aenigmate.* In taking his stand before the oldest church in the city, the one most easily apprehended as a simple, self-contained object, and in devising a means whereby one might contemplate a hazy reflection of his small painted image of that large building, Brunelleschi was at once celebrating something and at the same time, I believe, raising a question or expressing a doubt as to the adequacy of his or anyone's ability to comprehend the mysteries pertaining to birth and death, the beginning and ending of all things to which the Baptistry bore witness.

For it must be borne in mind that he knew the whole building, the interior no less well than the exterior that he chose to paint. In the mosaics of the dome, which had been made about a hundred and fifty years earlier, there is set forth at the highest level an abridged version of the celestial hierarchies as they had been described by the Pseudo-Dionysius in the sixth century and reaffirmed by John Scotus Erigena in the ninth. Below these heavenly beings are four bands of narrative imagery dealing with (1) the Creation of the Universe, the Creation and Fall of Man, and the story of Noah, (2) the story of Joseph, also from the Book of Genesis, (3) the life of Jesus, reduced, as in

almost all Renaissance art, to Nativity scenes and Passion scenes, and (4) the life of John the Baptist, to whom both the building and the city of Florence are dedicated. These stories occupy five of the melon-rind sections of the dome. The remaining three are given over to an immense image of the Last Judgment, presided over by a twenty-five-foot-high seated figure of the all-powerful and all-judging Christ. In this it is avowed that God is the God of history and that history is governed by *telos*—that it is purposeful and leads inexorably to a final conclusion. In facing the Baptistry from inside the Cathedral, that is to say, from a standpoint that only the Church itself could provide him (which is not at all the standpoint of the tourist or of the modern, secularized citizen as he or she wheels around the Piazza San Giovanni in a No. 11 bus), Brunelleschi was surely cognizant of all these meanings that are encapsulated within this mysterious building.

He confronted the building alone, and there was still another way in which it bore directly upon his personal being: it was in the Baptistry, or by the sacrament of baptism, that the newborn child was initiated into the community and into the eternal Communion of Saints by being given his *name,* the name that established his membership in the family, in his native city, and in the Church, and that linked him forever with a particular patron saint. Brunelleschi no doubt had many things to think about as he reflected upon the significance of the Church of St. John.

## III

In painting the first *tavoletta* (if it was the first—no doubt the two were conceived as a pair from the outset), Brunelleschi chose the position of someone standing in the great assembly hall of the Duomo in order to face the closed and enigmatic shape of the Baptistry. Now the Palazzo Vecchio can also be seen frontally and is so seen by anyone who approaches it from the short Via Vacchereccia. For the second panel, however, Brunelleschi chose a diagonal view, that of a man in the act of entering the Piazza from the Via de Calzaiuoli. The viewpoint was not determined by the asymmetrical Palazzo or the irregularly shaped Piazza. Rather, it arises out of the mobility of the viewer himself.

Manetti clearly states that the subject matter of the panel was not simply the Palazzo but the Piazza as a whole. Vasari reports that Brunelleschi's angle of vision was so wide as to include the Tetto dei Pisani, a wooden structure that had been built several years earlier by Pisan prisoners and that formerly stood on the west side of the square, opposite the Town Hall. His view was essentially the one we see in the accompanying image that was made in the eighteenth century (see figure 4). Whether the *tavoletta* included horsemen, carriages, and miscellaneous figures we are not told, but it would have been entirely appropriate if it had—for like the Duomo it is a place of assembly, though of a different kind

than that of the Cathedral. Certainly the architect was not trying to represent a "space" but rather a *place*. A horizontal stone surface is no less a real thing than are the stone walls of a building. In fact, if one is to understand the sense of the Palazzo, one must see it within a setting that includes a sufficiently large number of buildings to provide a sense of the larger city. The open square is a great unroofed meeting place, its surface area very nearly the same as that of the floor of Sta. Maria del Fiore. People came together here as participants in the ongoing daily life of the city. We are invited by the *tavoletta* to reflect upon the act of entering into this arena of public life.

The public square is the domain of "public man," that public-spirited citizen whose decline has lately been chronicled in literature by Richard Sennett in *The Fall of Public Man*. Mikhail Bakhtin surmises that that kind of man first made his appearance in the public squares of the earliest Greek city-states, for surely there was no place for him in the monarchical states of Egypt and Mesopotamia. The Greeks clearly distinguished between public man (politēs) and private man (idiōtēs). The former participated in the life of the polis (he is perfectly exemplified in the person of Pericles), while the latter was self-seek-

FIGURE 4. Brunelleschi, Piazza della Signoria Tavoletta; author's reconstruction based on an anonymous eighteenth-century image.

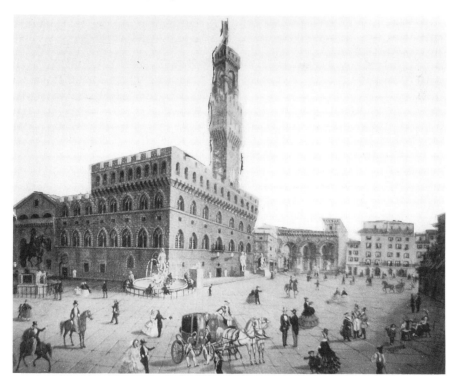

ing and self-absorbed (as we meet him in Plato's character Callicles). The ideal governing the life of the citizen is most tellingly set forth in the *Gorgias:* "Philosophers tell us, Callicles, that communion and friendship and orderliness and temperance and justice bind together heaven and earth and gods and men, and that this universe is therefore called Cosmos or order, not disorder or misrule, my friend. But although you are a philosopher you seem to me never to have observed that geometrical equality is mighty, both among gods and men; you think you ought to cultivate inequality and excess, and you do not care about geometry" (Jowett). Though Brunelleschi may not have known that passage, nothing could make clearer the grounds for his devotion to architecture, the equality of the columns in a classical colonnade, or the pervasive importance of geometry.

If the Baptistry panel prompts us to meditate upon the meaning of the sacred, then the Piazza picture leads us to contemplate the significance of the secular, or, better, of the *temporal,* for nothing more clearly distinguishes the sacred from the secular than do their respective attitudes toward *time.* Church time is long-lasting; it embraces ideas of transcendence and of eternity. One's baptism, like one's confirmation, one's marriage, one's appointment to a bishopric, or one's elevation to the papacy, is for life. The dogmas of the Church are not subject to repeal; they are established *in secula saeculorum,* forever. State time, on the other hand, has to do with matters that are both temporal and temporary, and never more conspicuously so than among the Italian city-states of the Renaissance. Florence, as we have seen, was governed by six priors who held office for only two months. Their time was that of Chronos, the time of "current events," of daily happenings, while Church time is centered upon Kairos, the time of eschatological revelation and of final things—whence the importance of the immense images of the Last Judgment both in the Baptistry and in the dome of the cathedral, between which loci Brunelleschi took his stand as he painted his first tavoletta (though at that time the cupola had not yet been built).

Plainly people felt that it was better that the State should have no long-range policy, no ruler who might take it upon himself to plan for the distant future, than to run the risk of tyranny that long tenure in office seemed to invite. Karl Popper has argued at length that political liberty and long-range planning are inherently incompatible—that all state planners, beginning with Plato, are quasi-fascists at heart. Like modern planners themselves, however, Popper exaggerates the extent to which even the most determined planner can actually control the course of events, even for so brief a period as five years. The history of all states, whether despotic or democratic, has been one of circumstantial contingency, as Brunelleschi surely came to know when he briefly served as one of the priors in the 1420s.

The explicitly temporal dimension of his dialogical argument is revealed most directly in what constitutes the most striking feature of each of the *tavolette*—his handling of the sky. In the one case it is silvered, in the other, cut

away. Convinced (as are most modern critics) that perspectival imagery is essentially a matter of "naturalistic representation," Manetti conceived that both these devices resulted from the artist's desire to incorporate an actual view of the sky into the observer's experience of looking at each of these pictures. But Brunelleschi recognized, I believe, the inherent ambiguity of the sky as symbol or idea. On the one hand, it serves as the commonest metaphor for the heavens or the heavenly, for a transcendent order of things that stands above mundane transiency. On the other hand, because of its association with the unpredictable vagaries of the weather, it is a prime symbol of all that is changeable and uncertain in mortal existence. The "heavenly" meaning of the sky would have been appropriate to the first panel, a suggestion of tempestuousness, to the second. But there is no way of representing the sky, with or without clouds, that can separate the one set of associations from the other. Only by means of a radical transformation could Brunelleschi show the different relationship that each of the two buildings had to *il tempo*—a word that, like the French *le temps,* means both "time" and "weather."

The sense of Brunelleschi's argument becomes clearer when we recognize that one effect of this cutting away of the sky over the Palazzo Vecchio is the destruction of the simple geometrical shape of the picture surface that has traditionally been imposed on virtually every painted image. Until very recently that shape has almost always been re-emphasized by affixing a separate picture-frame. During the Renaissance such frames were often architectural in form, replete with cornices, colonnettes, podia, and the like—shapes that enabled the paintings to fit comfortably and congruously within the architectural settings for which they were generally intended. For of course buildings, too, may be regarded as referential frames that have customarily enclosed disciplined and regulated kinds of behavior comparable to that of the figures who act out the pivotal events or are grouped into the ideal social patterns one sees in works of Renaissance art. Unlike what happened in the Baptistry and the Cathedral, what occurred every day on the broad surface of the Piazza della Signoria was neither regulated nor predictable. And so Brunelleschi chose to represent that Piazza in the only painting of the Renaissance era, so far as I know, that could not possibly have been put inside a frame.

Most important, the cutting away of the sky affirms the essential secularity of the government of Florence. So long as the Republic endured, it stood firm on the principle of popular sovereignty. Though that never entailed universal popular suffrage, it did mean that political power rested with the guilds, both major and minor. That is to say, it moved from below upward. It did not involve a descent through hierarchies from above downward—the principle that is set forth in the dome of the Baptistry and in the structure of the Catholic Church. Ideally, if not in the turbulent practice of Florentine politics, the Piazza constituted a "level playing field" on which every citizen could play his part as a "public man."

## IV

How, then, should the Christian citizen take his stand before these two unlike orders of things? In the midst of the crises of the late 1390s and early 1400s, Brunelleschi had as much reason to be concerned for the well-being of the Republic, which was facing a potentially disastrous war with Milan and, internally, the threat of oligarchy posed by the machinations of Maso degli Albizzi and his associates, as he had to be alarmed, what with the ongoing Schism, at the breakdown within the Church. At this point he may well have perceived that the Town Hall could easily become the seat of a despotism that would deprive men of their freedom no less than did the inquisitorial restrictiveness of the Church. Indeed, the most thoroughgoing argument in favor of tyranny had its origins, one might say, in the Palazzo Vecchio itself, for it was on the basis of his fourteen years' experience as secretary and envoy of the *Dieci di libertà e pace* that Machiavelli conceived his project of writing *The Prince*. Having had occasion to observe firsthand both the ruthless effectiveness of Cesare Borgia and the ineffectuality of Florentine democracy under Piero Soderini, Machiavelli came to see, as has lately been argued by Sir Isaiah Berlin, that

> There are two worlds, that of personal morality and that of public organization. There are two ethical codes, both ultimate: not two 'autonomous' regions, one of 'ethics,' another of 'politics,' but two (for him) exhaustive alternatives between two conflicting systems of value. If a man chooses the 'first, humane course,' he must presumably give up all hope of Athens and Rome, of a noble and glorious society in which human beings can grow proud, wise, and productive. Indeed, he must abandon all hope of a tolerable life on earth; for men cannot live outside society; they will not survive collectively if they are led by men who (like Soderini) are influenced by the first 'private' morality; they will not be able to realize their minimal goals as men; they will end in a state of moral, not merely political, degradation. But if a man chooses, as Machiavelli himself has done, the second course, then he must suppress his private qualms, if he has any, for it is certain that those who are too squeamish during the remaking of a society, or even during its pursuit and maintenance of power and glory, will go to the wall. . . . In choosing the life of a statesman, or even the life of a citizen with enough civic sense to want his state to be as successful and splendid as possible, a man commits himself to the rejection of Christian behaviour.[8]

But is morality personal and private? If a man were to live in total isolation, like the anchorites celebrated in Brunelleschi's day by painters such as Starnina, he would have no *moral* problems, for morality has specifically to do with what are now called "interpersonal relationships." John the Baptist appeared in the wilderness preaching repentance to a "generation of vipers" and warning of the wrath to come. People flocked to him from Jerusalem and all the cities of Judea, but his message was anti-urban, and he himself was the arche-

typal hermit. That is in good part the message of the Baptistry: its narrative mosaics deal with the lives of men who were not *citizens.* Yet the Christian leaders of Florence were capable of resorting to brutality and torture and warfare in the name of the state. It was just this disparity between "personal" conduct and "state" conduct that was the problem, I believe, with which Brunelleschi was wrestling as he devised in his mind, at a critical juncture in the history of both Florence and the Roman Church, the project of painting his two panels.

Where, then, did he take his stand? What he understood, I am convinced, is that both perspectives are necessary. Eugen Rosenstock-Huessy astutely observed that no man is free who does not have two loyalties—that "two allegiances are the secret of civilization. . . . Every monism leads to slavery."[9] In the twentieth century we have seen the truth of that assertion validated time and again. Those men who have sought to play the role of *Principe* according to Machiavelli's prescription have invariably reduced their peoples to the condition of frightened enslavement. Only by virtue of his commitment to two powerful, judging, but separate institutions was it possible for Brunelleschi to experience the genuine freedom that derives from being able to belong within, but also to stand apart from, both those ethical frames of reference, to judge each one from the standpoint of the other, and thereby to defend both himself and his community against the proclivities toward tyranny latent in both those institutions, the Church and the State. Perhaps the greatest loss the modern world has suffered is the loss of that perspectival duality.

# T W O

# On the Relation of Perspective to Character

We have been discussing a dialogical polarity that the Christian citizen Filippo Brunelleschi (and no doubt many others besides) felt compelled to confront in addressing the principal institutions of the city of Florence. But, as Paul Tillich has observed, world-consciousness and self-consciousness are two sides of the same coin—wherefore it is just as important that we consider the qualities of character that must be looked for in the practitioner of quattrocento perspective. What sort of man should we take him to have been? We have already seen that his underlying concern was ethical, turning upon the question "How shall I take my stand?" Or, better, and this brings us to the heart of the matter, "How shall I take my stand with consistency and integrity?"

In order to grasp the crucial importance of integrity, let us examine two paintings of the era, one earlier and one later than the *tavolette,* that were not made from Brunelleschi's standpoint, though both of them involve the rudiments of perspective. The first is the view of Florence that was painted on one wall of the Bigallo, which lies across the Piazza San Giovanni from the Baptistry (see figure 5). Obviously the fresco was not painted from an identifiable standpoint; it constitutes an imaginary aerial view of the city. Toward the center of the image we see a good likeness of the Baptistry viewed from above; beyond that, a perfectly frontal rendering of the partly finished facade of the Cathedral (but with the still unvaulted nave extending diagonally to the right behind it), and to one side, the lower half of Giotto's still-unfinished campanile, which we are looking up at from below. Most interesting, however, is the artist's placement of the Palazzo

Vecchio, which seems to lie beside and to the north of the Cathedral, though in fact it is located several hundred yards to the south. The painter thought it appropriate to place at the center of the city (somewhat in the manner of the ancient Roman forum) both the Duomo and the Town Hall, as if they formed a single cluster. Fifty years later it had become fully evident, at least to Brunelleschi, that those buildings did not constitute a unified group that could be comprehended from a single standpoint, that they entailed two different perspectives upon the nature and purpose of the citizen's life, a dichotomy with which the Bigallo painter (Alberto Arnoldi?) saw no need to be concerned.

Our second painting also involves a perspectival image of a specific and identifiable building. It is the Limbourg Brothers' picture, in the *Très riches heures du Duc de Berry,* of Christ being tempted by the devil (see figure 6). "Again, the devil taketh him up into an exceeding high mountain, and sheweth him all the kingdoms of the world, and the glory of them; and saith unto him, All these things will I give thee, if thou wilt fall down and worship me. Then saith Jesus unto him, Get thee hence, Satan; for it is written, Thou shalt worship the Lord thy God, and him only shalt thou serve" (Matt. 4:8–10). Now anyone familiar with the Italian perspective of the *costruzione* will be struck by the inconsistencies one sees everywhere in the scene. In the immediate foreground we see the Duke's new chateau at Méhun-sur-Yèvre, which we seem to be looking up at from a low point of view (that is to say, from the standpoint of the artist as he made his preliminary sketch). But at the same time we are looking down into the boat on the river, while we are facing both Christ on the mountain-top and the lion in the lower-right corner from a directly frontal position. Between us and the mountain Jesus stands on there lies another hill, surmounted by a tiny castle. Yet the figure of Jesus is drawn to so large a scale that he could not possibly squeeze through the main doorway of the chateau.

One may say, of course, that this is a matter of poetic license, or that the invention is more charming and freely imaginative than it would have been if a more "correct" perspective had been used. Whoever makes such an assertion

FIGURE 5. View of Florence, c. 1360, detail from the *Madonna della Misericordia.* Loggia del Bigallo, Florence.
PHOTO COURTESY OF ALINARI/ART RESOURCE, NEW YORK.

thereby indicates that he is not seriously concerned with the subject matter of the painting but only with the artists' quaint and colorful conceit—and that was probably the attitude of the Duke himself. Is it conceivable that either he or his artists were aware of the fact that the splendid chateau is the perfect symbol of the worldly power and riches with which the devil was tempting Jesus? For surely no one was more extravagant than Jean de France, Duc de Berry, in his headlong pursuit of the glories and treasures of this world. The Duke had at least fifteen other chateaux besides the one at Méhun and several magnificent books of hours in addition to this one, to say nothing of tapestries, jewels, exotic animals, fifteen hundred dogs, and costly furnishings of every kind, all of which he periodically loaded into wagons as he migrated from chateau to chateau in the manner of a Merovingian king. According to Froissart, "Le duc

FIGURE 6.
Limbourg Brothers, *Temptation of Christ on the Mountaintop,* from *Très Riches Heures du Duc de Berry.* Musée Condé, Chantilly.

de Berry fut le plus convoitteux homme du monde." If a "Temptation" such as this had been painted by Pieter Bruegel, one would not hesitate to say that its purpose was satirical. Yet it is hardly conceivable that Pol and his brothers intended anything of the sort or that it would ever have occurred to the Duke to think that his favorite artists were mocking him. Did he ever pause to think that his insatiable desire for riches and power might be wholly incompatible with the Christian piety that his beautiful books were ostensibly designed to reinforce? Or that his conduct was in direct violation of biblical injunctions extending from the Mosaic commandment "Thou shalt not covet" through Christ's "Lay not up for yourselves treasures on earth"? The Duke's Christianity was essentially that of King Clovis: it did not demand of him that he examine himself or the nature of the life he was leading. Yet within ten years of his death in 1416 the standpoint of artists (and at least the more important of their patrons) had so changed that no major artist could ever again have brought himself to paint so naively inconsistent an image as this.

Let me propose, then, that the unintegrated perspective we see here is closely related to the lack of *integrity* that was so obvious an aspect of the Duke's nature—a virtue to which the painters themselves were indifferent, for no one had ever brought to their attention the possibility that Christian illustrations might have a higher order of meaning than what we see in the *Très riches heures.* When we turn to the images of the first great masters of perspective in Florence, working in the immediate wake of Brunelleschi's breakthrough, we cannot help but be struck by the forceful integrity of their figures. Those masters were Masaccio and Donatello.

We have only to examine the faces of the disciples in *The Tribute Money* to recognize that something new has been introduced into Italian art (see figure 7).

FIGURE 7.
Masaccio, *The Tribute Money*, detail. Chiesa del Carmine, Florence (postrestoration). PHOTO COURTESY OF ALINARI/ART RESOURCE, NEW YORK.

Faces such as these are to be found in ancient Roman portrait busts, the severe, gravely serious, unsmiling faces of responsible public men, each one the face of a distinctive person. Just as Brunelleschi was turning, as church architect, to a type of building that had been invented in the early days of the Roman Empire and later adapted to Christian use at a time when the Church had more or less joined forces with the state, so Donatello (as in the Campanile prophets) and Masaccio were bringing to life again a type of face and a conception of character that had not been seen in European art for a thousand years (see figure 8). We see in the disciples and the prophet men who, by choosing to be followers of Jesus, have "taken their stand" and are prepared to accept the consequences of that decision—indisputably men of integrity.

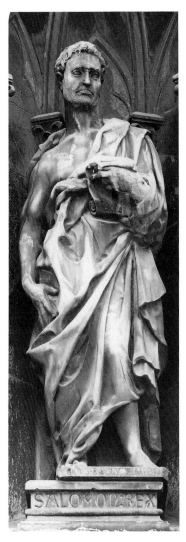

FIGURE 8. Donatello, *Prophet Jeremiah*. Museo del Opera del Duomo, Florence.
PHOTO COURTESY OF ALINARI/ART RESOURCE, NEW YORK.

Just as important as the facial types is something else that reappears for virtually the first time in *The Tribute Money,* the contrapposto pose, so strikingly portrayed in the figure of the tax collector whose modern Florentine dress is conspicuously contrasted with the togalike robes of the apostles (see figure 9). The pose is that of the man who is capable of self-directed action, of making choices between and among alternatives, of playing a responsible role in the public square. Masaccio shows the disciples to be facing a problem that had troubled Christians from earliest times, that of paying the taxes that were demanded by the State. In this case it was a tax, the didrachma, that was exacted at the gates of Capernaum. The apostles were not sure that they were obliged to pay the tax. Jesus told them to pay it, lest they give offense, and instructed Peter to obtain the required coin from the mouth of the first fish he would catch at the nearby seashore.

As is required by the story, Peter appears three times in the scene and the tax gatherer twice, while everyone else remains unmoved. (Some have thought this to be a violation of the unity of time; what Masaccio understood, I believe, is that the picture deals with only one *event*—one episode that comes forth (*e-venire*) in the ongoing life of Jesus. (A movie camera might break down the occurrence into five thousand frames, each one a still image, but there would still be one event, the sense of which could be understood by isolating only three frames that epitomize the story.) At the center of the picture Peter is receiving instructions from Jesus. In the left middle distance he has taken off his robe and, wearing the short tunic of a common workman (or of a fisherman), he squats down beside a body of water and extracts the coin from the fish. In the right foreground, having donned again his citizenly robes, he pays the tax, at which point he stands framed within an arch that represents the stable structure and authority of the State, as arches had in Roman antiquity (most obviously in the arches of triumph which, straddling major thoroughfares, asserted the emperor's control over men's movements but also in the placement of citizenly statues in the arches of the Tabularium and of similar buildings where the arch is at once an open doorway and a confining enclosure or established frame of reference for active men).

The group of Christ and his disciples forms the original Christian community, laying the basis for the community and The Communion of the Saints. Yet by placing his figures in a deep landscape, Masaccio has affirmed his belief in the *naturalness* of human community. In the central portal of the Cathedral of Amiens we see the same twelve disciples (with Matthias taking the place of Judas) standing on either side of the Beau Dieu on the trumeau, but the positions they occupy are determined by the structure of the church building itself, not by any choice on their part. They are woven into the eternal fabric of the Church as institution. Masaccio, on the other hand, affirms that the apostles have assembled around their Master in the same way as

FIGURE 9. Masaccio, *The Tribute Money.* Chiesa del Carmine, Florence (postrestoration).
PHOTO COURTESY OF ALINARI/ART RESOURCE, NEW YORK.

might the members of a family or of a guild or of the priorate of Florence. It is in accordance with "natural law" that men should do this and that the productive laborer, the fisherman Peter, should submit to the State's demand that he pay taxes—taxes levied not by the Church but by the Town Hall whose presence in the city behind the walls must be taken for granted. But here the dialogue is not between the Palazzo Vecchio and the Baptistry but between the Palazzo and Nature, for there is no specifically Christian principle involved in the transaction.

However, as Anthony Molho has brought to light in the course of his inquiry into the iconography of the Brancacci Chapel, the biblical account of the paying of the tribute at Capernaum had for centuries been taken to bear directly upon a question that had long troubled the Church: did the State have the right to levy taxes upon the property of churches and upon members of the clergy? The position that had generally been taken by leaders of the Church was, not surprisingly, that the State did not. Yet by the beginning of the fifteenth century "the papalists did not dispute the propriety of ecclesiastical authorities paying the taxes imposed on them by the State, so long as the Church thought these taxes reasonable. Martin V, almost immediately upon his election [in 1417], granted permission to the Emperor Sigismund to levy a tax on the German clergy. . . . While many clergymen bitterly complained that their churches were being despoiled by excessive taxation, advocates of the papal position . . . turned to Christ's command to Peter to pay the taxes as an example of a situation in which the Church paid willingly, not because it had to."[1]

For a short while after his election Pope Martin V resided in Florence. When he moved to Rome in the early 1420s he found that city to be in desperate need of repair, and he proceeded to levy heavy taxes upon both secular and ecclesiastical properties. Meanwhile, the city of Florence was desperately in need of funds because of its recurrent warfare against Lucca and its allies. Though we do not now know just who was in charge of the decoration of the Brancacci Chapel and of its iconography, it seems reasonably clear that the choice of the theme of the payment of the didrachma at Capernaum was intimately related to the heated debates about taxation that were then being conducted. It is unmistakably in his role as first pope (and explicitly as agent or vicar of Christ) that Peter is paying a tax in obedience to the laws of the State. Specifically, he is paying the *gabella,* a tax that the government of Florence collected at the city gates, even as had Capernaum in antiquity. In short, *The Tribute Money* sets forth an argument, as did Brunelleschi's panels, concerning the Christian's relation to the State.

Though the small number of short orthogonal lines in Masaccio's architecture do converge to a single point located in the area of Christ's face, that is a thoroughly minor factor in this early example of the new Florentine

perspective. If the lines did not converge to one point (as they do not, for instance, in the paintings of van Eyck and van der Weyden), we would still see the figures to be standing in a deep landscape that closely resembles the Arno Valley in which Florence lies. Without knowing why, Manetti was right: it was Brunelleschi's act of taking his stand in a situation of ethical dialogue that had opened the eyes of his younger contemporaries to new possibilities in the art of painting. Not everyone understood. Masaccio's much older associate Masolino learned the method of vanishing-point perspective but, as we can see in his frescoes in San Clemente in Rome, he never grasped the relation of the technique to ethical integrity and dialogue.

## II

The dialogue between Man and Nature, or between the City and Nature, is one that has usually been expressed in the art of landscape painting, an art that lies outside the purview of this present study. However, there is at least one instance of its being expressed in an essentially architectural composition that is of such interest as to deserve to be mentioned here. The work is Domenico Veneziano's *St. Lucy Altarpiece* (see figure 10). Its perspective has been carefully analyzed by both Samuel Edgerton and Warman Welliver.[2] The latter has demonstrated (though the evidence is not unambiguous) that the artist has assumed his observer to be standing at so great a distance from the painting as to cause a pictorial space of considerable depth to appear so shallow that the head and shoulders of the Virgin seem almost to be enclosed within a niche that lies, in terms of the size of the figures, nearly twenty feet beyond her. Domenico wanted the careful observer (was Welliver the first?) to see that beyond her there lies a sunlit garden, a *hortus conclusus,* one of the traditional symbols of Mary's virginity. Because the figures block our view, we cannot see the ground plane of the garden. Its fruitfulness is only hinted at by the presence of the fruit trees that appear above the garden wall. What we discover here is a striking and unique balance between indoors and outdoors, the man-made and the natural, that lies at the heart of Domenico's concern.

   The full nature of that concern is revealed to us in the choice and grouping of the saints the artist presents for our contemplation and adoration. He has selected two saints, Francis and John the Baptist, who (in their respective predella panels) are directly associated with the countryside and the wilderness, and two other saints, Zenobius and Lucy, who (by both their costumes and their predellas) are related to urbanity and to urban institutions. In his predella panel St. Francis (see figure 11) is shown to be receiving the stigmata (in a broad river valley rather than atop Mt. Laverna), while St. John (see figure 12), in an extraordinary iconographical invention of Domenico's own, is standing nude against a rocky, mountainous background, the shapes and colors of which are closely

related to those of his body. He lays his city clothes on the ground, and he draws an animal skin about his shoulders. His nudity echoes that of the Child, who looks to his right toward the "natural" saints, giving them precedence over the "urbane" saints on his left. St. John's act of covering his nakedness would probably have reminded a worshiper in Sta. Lucia dei Magnoli of the familiar scene of St. Francis laying aside his expensive clothing (as an act of repudiating his rich father's wealth) and being wrapped in the mantle of his bishop in Assisi. In contrast to the simple costumes of the saints on our left, St. Zenobius wears the resplendent cloak and bejeweled miter of a bishop, though beneath that mantle we see a simple gray garment like that of St. Francis. St. Lucy's costume is unornamented, yet her figure presents us with the finest image in all quattrocento painting of a noble and refined gentlewoman of that era. All four saints are

F I G U R E 10. Domenico Veneziano, *St. Lucy Altarpiece.* Uffizi, Florence. Photo courtesy of Alinari/Art Resource, New York.

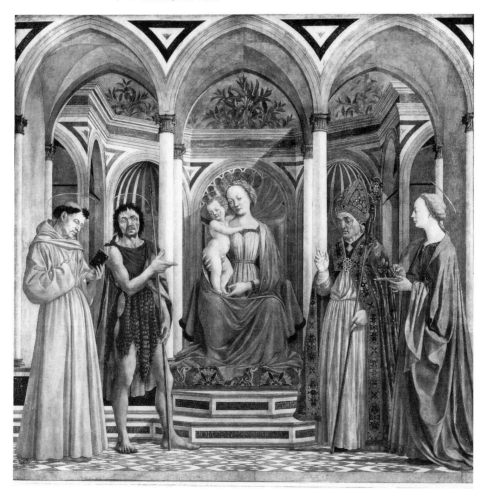

shown to be characters who have made fatefully significant choices that have led to their being accorded the status they are shown here to possess in the Virgin's heavenly court.

Yet there is another character about whom we know nothing at all, except, perhaps, that the matter of integrity was much on his mind: the artist's patron. Christians have always had trouble trying to reconcile the extremes of wealth and of poverty, of power and of powerlessness, of aristocratic nobility and of unassuming humility in the Christian community. What would Jesus and his

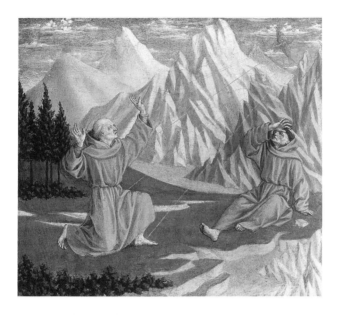

FIGURE 11.
Domenico Veneziano,
*St. Lucy Altarpiece*
predella, *St. Francis
Receiving the Stigmata,*
c. 1445.
Samuel H. Kress
Collection, 1992
National Gallery of Art,
Washington, D.C.

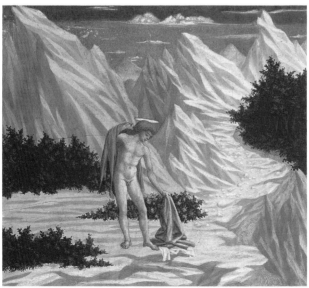

FIGURE 12.
Domenico Veneziano,
*St. Lucy Altarpiece*
predella, *St. John in the
Desert,* c. 1445.
Samuel H. Kress
Collection, 1992
National Gallery of Art,
Washington, D.C.

fisherman followers have made of the radical differences of status that were manifested among latter-day Christians? Surely it must have satisfied that unknown patron to have it affirmed by Domenico that all such disparities would pose no obstacle to community among the blessed in paradise—or on earth among persons who aspire to the different kinds of saintliness that are here exemplified. Though the saints are not shown here to be speaking to one another, it is easy to understand why this novel type of altarpiece should have come to be called a *sacra conversazione,* for communion and community, so natural to human beings, are what Domenico celebrates in this moving work.

# III

But now let us return to Masaccio and our inquiry into the relation of perspective to character. If the new usage that was employed by Masaccio and Donatello is closely bound up with the reappearance of recognizably Roman facial types, why is it that Roman painters themselves never achieved results like those of so many perspectivists of the Renaissance? The matter has been endlessly debated, the discussion turning almost entirely around one or the other of two ideas: "space" and "vanishing point." It has been carried on, that is to say, at either the highest level of intellectual abstraction or else at the lowest level of technical procedure.

All arguments of space I would dismiss out of hand for reasons I trust I have by now made clear. As for the technical question, the evidence is inconclusive. Decio Gioseffi, for instance, has asserted that perspective is not an invention but *una legge inderogabile* and that that strict law was already understood as early as the time of Democritus (d. 352 B.C.) Needless to say, Gioseffi has found no Greek painting from the fourth century (or later) in which the "law" of perspective was followed. But since the whole body of Greek easel and mural painting has been lost, leaving only thousands upon thousands of painted pots for us to study, we cannot surely say what may have been achieved by the ablest and most ambitious artists of the fourth and third centuries, working on large flat surfaces for a different clientele and occasion than those available to the vase painter.

Roman painters made extensive use of converging orthogonal lines, but so far there has been discovered only one painting in which those lines meet at a single point: the wall painting in the Room of the Masks that was unearthed on the Capitoline Hill in 1961. In this case all the lines, except for a couple of short ones in the podia in the foreground, do meet at one point. But is that degree of precision a crucial, or even an important, consideration? Though its pattern of convergences is nearly perfect, the painting does not in the least resemble a work of Renaissance art: it does not define for us an enclosing room, it has no gridiron floor plane that would enable us to locate objects in

depth, and it not *about* anything, being merely a wall decoration. In no Roman painting do we find any indication of the artist's having come to grips with the problem of the distance point—that is to say, the problem of systematizing the rate at which equal intervals seem to diminish with recession into depth. And that, after all, was the central issue for Alberti as he devised his *costruzione*.

What relation can we adduce, then, between Roman perspectival painting and the qualities of character we see exemplified in Roman portraiture? Probably none. Although Roman politics and the life of the public man in the forum called forth qualities of character such as *integritas, gravitas,* and *dignitas* that we associate with the names of men such as Cicero and Seneca, the underlying basis for those qualities is to be found in a secularized Stoicism rather than in religious conviction. But Stoicism provided no subject matter for the artist, no body of sacred narrative, nothing comparable to the Bible or the lives of the saints—nothing that might have inspired an artist to produce challenging and moving works from a *standpoint* that was as compelling for him as it was for his patron. The crucial advantage that the Renaissance perspectivist had over his ancient predecessor resided in his *subject matter,* not in his superior technical knowledge. Donatello could represent the Prophet Jeremiah as if he were an impassioned Roman senator. Cicero would probably have admired the statue, but we have no similar work from the hand of an ancient Roman sculptor. Many statues of *togati* have survived; however, they never appear to be men who have "taken their stand" in a situation of passionate dialogue.

In short, the ancient painter simply had no role to play that could be compared with the role of a Giotto, a Masaccio, or a Dürer, and no sculptor with that of a Donatello or a Michelangelo. Ancient pagan religion was not ethically demanding; the subjects it offered the artist never possessed the significance or the emotional charge that we associate with biblical narrative and Christian hagiography.

The point has been made luminously clear by Erich Auerbach. In the first chapter of his *Mimesis* Auerbach draws a striking comparison between a brief passage in the Odyssey and the even briefer account in the Book of Genesis of Abraham's aborted sacrifice of Isaac.[3] Although Homer describes his event in subtle detail, he makes it evident that even for him the story did not have the kind of "truth value" that inheres in the story of Abraham and Isaac. His poetic account was meant to be savored as literary artifice. It does not claim for itself the absolute and universal significance that the biblical writer knew his story to possess—a significance that challenges the reader to reassess his understanding of himself in relation to the very nature of the universe.

The stories illustrated by the great artists of the quattrocento claim for themselves just that kind of significance. They involve an attitude toward *seeing* that has nothing at all to do with the science of optics. No Biblical writer ever invites us to "look at" anything, to play the role of an "observer." His purpose is rather that of *bearing witness,* though his witnessing is not of a visual order.

In any court of law, however, there is no testimony that is more irrefutable than that of the person who has seen with his own eyes the event that is in dispute. As Horatio declares,

> Before my God, I might not this believe
> Without the sensible and true avouch
> Of mine own eyes.

Before my God! Just so. Between 1300 and 1430 a small number of extraordinarily gifted artists discovered a new way, not of seeing, for we all see in perspective, but of relating optical observation to religious witnessing—*eye* witnessing. As Renaissance perspective improved between the time of Giotto and that of van Eyck, the vividness of that experience of witnessing steadily increased—a kind of witnessing for which there was simply no analogy in either the experience or the practice of the ancient Greek or Roman artist.

# IV

A related development, albeit a minor one, that occurs in the first half of the fifteenth century is the artist's practice of including a portrait of himself as a bystander in his religious images. The first painter to do so in all likelihood was Masaccio; it is generally thought that it is he who appears just to the right of St. Peter in the Brancacci fresco of *The Enthronement of Peter.* Certainly Ghiberti is represented on one of the stiles of the *Gates of Paradise,* while Lippi is probably the kneeling monk on the Virgin's right (our left) in his *Coronation of the Virgin* now housed in the Uffizi. Botticelli, of course, is prominently featured in the Medici *Adoration of the Magi.* No one more persistently included himself than did van Eyck, who was also, it is commonly believed, the first artist to make an independent self-portrait—his *Man with a Red Turban,* a person who turns up in some three or four of his other paintings.

One may see these images as being nothing more than pictorial signatures. For my part, I prefer to think of them as affirmations on the part of the artist of his having "taken his stand" as a distinctive person having a distinctive personal style, a way of his claiming credit for the integrated wholeness of his act of envisioning: "This is the way I understand this subject from my standpoint." Let me point out again the connection between self-consciousness and world-consciousness. All the painters who included self-portraits, so far as I know, made extensive use of landscape. Though landscape painting does not involve the use of the Albertian grid or the vanishing point, it does afford the painter an occasion for avowing his grasp of a "wholeness of things" that corresponds to the integrated wholeness of his own self-conscious mind and being. (The correspondence between mind and landscape has never been portrayed more vividly than in the *Mona Lisa.*) Nothing more tellingly illustrates this connection

than does our first recorded experiencing of landscape vista—that of Petrarch, the most peripatetic of humanists. After climbing to the 6,200-foot summit of Mt. Ventoux, near Avignon, the poet rejoiced in the magnificent sweep of the view but then immediately engaged in a poignant act of self-examination . . . two sides, again, of the same coin.

At first, affected by the rare quality of the air and by the widespreading view, I stand as if stunned. I look about. Clouds lie far below. The noble snow-capped Alps seem close by, far away though they are. I could see clearly the Cévennes to the right and to the left the sea beyond Marseilles and Aigue-Mortes. The Rhone itself lay under our eyes.

Then a new thought came to me, rather of time than space. I said to myself: "Today ten years have passed since you finished your youthful studies and left Bologna. Oh, immortal God! Oh immutable Wisdom! What changes in your character have these years seen!" I suppress much, for I have not yet reached a safe harbor, from which to look back on the storms of the past. The time will perhaps come when I shall review all my past deeds in their order, prefacing them with the words of St. Augustine: "I wish to recall the filth of my past and the carnal corruptions of my soul, not that I love them, but that I may love thee, O my God!" Indeed an obscure and toilsome course lies before me. What I used to love, I love no longer. No, I am lying. I love it still, but more moderately. No, again I have lied. I love, but with more shame, more sadness; and now at last I have told the truth."[4]

# The Two Allegiances

Let us return now to the point at which we left our argument at the end of chapter 1. We would not have it thought that Brunelleschi was the only man in Florence to have on his mind the problematical relationship between the two loyalties. Writing in 1420 about the nature of the Parte Guelfa, Leonardo Bruni had this to say: "If you consider the community of the Guelfa from a religious point of view, you will find it connected with the Roman Church, if from the human point of view, with Liberty—Liberty without which no republic can exist, and without which, the wisest men have held, one should not live." In juxtaposing the tightly enclosed form of the Baptistry with the spaciously open "playing field" of the Piazza della Signoria, Brunelleschi had made just this point, probably some twenty years earlier: to wit, that every Florentine (not the guelphs alone) had to reckon with two different "points of view," the one defined by Christian faith, the other by the Republic, the latter not so much "human" as "citizenly." The first involves the submission of one's earthly goals and desires to the ultimate achievement of eternal rest in Abraham's bosom (in the Last Judgment mosaic of the Baptistry, the bosoms of Abraham, Isaac, and Jacob). The second involves the playing of one's role (be it as politican, banker, entrepreneur, condottiere) in the ongoing life of the city. The special quality of Florentine liberty, which was not identical with the freedom of the Roman citizen, derived from the fact that there *were* two different points of view to which all Florentines were committed. Though it is not in fact the case, it would have been highly appropriate if the building Brunelleschi designed for the Parte Guelfa had been situated on the Via dei

Calzaiuoli midway between the Baptistry and the Palazzo Vecchio, for that would have made visible the dual orientation that Bruni described.

But if the ideas that were on the minds of both Bruni and Brunelleschi are essential to the very nature and meaning of Renaissance pictorial perspective, we should expect to find them manifested in Italian painting well before the year 1398, for great strides had already been made in the development of perspective between 1300 and 1350. Surely the first great perspectivist was Giotto. Decio Gioseffi has demonstrated that the device Giotto used in representing the coffered ceilings in *The Ceremony of the Rods* and *The Prayer of the Contenders* closely approximates that of the *costruzione legittima;* while Roberto Longhi, in an essay about the illusionistic *coretti,* or simulated galleries, on the wall of the triumphal arch of the Arena Chapel, goes so far as to declare that "Here, in these 'marginalia,' it is legitimate to speak of perspective *in toto;* in the fifteenth-century sense of the word, I mean to say." Yet neither Gioseffi nor Longhi undertakes to relate the novelty of Giotto's *coretti* to the originality of his handling of the thoroughly traditional themes he was called upon to depict on the walls of the Chapel.

If we compare Giotto's frescoes with any of the mosaic images of the thirteenth century (such as those in the Florentine Baptistry), nothing is more striking than his transformation of almost every subject he deals with into a dramatic confrontation or *dialogue.* The *Nativity,* for instance, involves an almost rapturous confrontation of Mary and the Christ Child. In the *Baptism,* so commonly dealt with earlier in emblematic terms, Jesus and John look earnestly and intently at one another, while in the *Resurrection of Lazarus* Giotto arbitrarily introduces the figure of Peter to serve as a dramatic interlocutor, speaking directly to Jesus on behalf of the still moribund Lazarus. The dialogues are contained within the limits of the picture-space. The confrontations are parallel to the picture plane; hardly anyone looks out toward us, acknowledging our presence as witnesses.

Yet Giotto knew that possibility to exist. In the two *coretti* on the wall of the triumphal arch he engages the viewer in a dialogue not with the Biblical characters but with the building itself (see figure 13). The "secret chapels" are not relevant to the nature of the building, for it contains no galleries or other kinds of wall articulation; they prompt us rather to think about the meaning of the building as a symbol of the Church, whose nature is exemplified not in hierarchical offices and dogmatic formulations but in the lives and deeds of people like ourselves. The painted figures in the narrative scenes create an encompassing space by virtue of their own rotundity, but we are not invited to perceive that space as an extension of our own. Only the *coretti* remind us that we too must imaginatively and personally participate in that larger order of things that constitutes the vital reality of the Christian Church, a reality for which the Church-as-institution serves only as an articulating enframement.

Only in the *coretti* is that order of things directly linked to our own existence on the floor of the Chapel, for as Christian worshipers on that floor we share a commitment to a common standpoint—to our possession of a common understanding.

Of the forty frescoes, there is one in particular, the *Massacre of the Innocents,* that commands our attention, for here Giotto envisioned a confrontation that surprisingly anticipates the dialogue that Brunelleschi was to reckon with in his *tavolette* nearly a hundred years later (see figure 14). In the upper-left corner we see King Herod who, from the balcony of his palace, orders the brutal killing of the male children of Bethlehem so as to protect his political power from usurpation. (The deed would have been worthy of Machiavelli's Prince!) Below him are his executioners, at whose feet lie the tumbled bodies of a score of babies, so innocently vulnerable in their nudity. On the right are clustered ten weeping mothers, two of whom are having their children torn from their arms. All ten are completely contained within the outlines of an octagonal building that unmistakably has the form of a medieval Italian baptistry. Although the massacred babies are all boys, they are defended against their male executioners only by their mothers, not by their fathers. (The relation of the dialogical polarity of *Lo Stato vs. La Chiesa* to that of masculinity vs. femininity is too broad a matter to be investigated here; we shall return to the subject in another connection.)

It may well be that Giotto's fresco was an actual stimulus to Brunelleschi's thinking about the institutional polarity he dealt with in his *tavolette.* In his

FIGURE 13. Giotto, *Coretto.* Scrovegni Chapel, Padua.
PHOTO COURTESY OF SCALA/ART RESOURCE, NEW YORK.

youth Brunelleschi had lived for a while in Padua, where his father served as an emissary of Florence, so we may take it for granted that he was familiar with the Arena Chapel. Moreover, as has been demonstrated by Heinrich Klotz, he was especially interested in the Baptistry of Padua, which provided him with the general form and some of the exact measurements he later used in designing the Old Sacristy of San Lorenzo. Though there is little he could have learned from the frescoes of Giusto de' Menabuoi that adorn the Baptistry, their very lack of dialogical tension may have sharpened the young Florentine's awareness of that aspect of Giotto's invention. Nowhere is the contrast between the two painters more obvious than in their respective images of the *Massacre of the Innocents.* Instead of Giotto's dramatic confrontation of seven men and ten women across a dense heap of dead children, Giusto chose to pack his scene with more than a hundred and ten figures, all of whom

FIGURE 14. Giotto, *Massacre of the Innocents.* Scrovegni Chapel, Padua.
PHOTO COURTESY OF ALINARI/ART RESOURCE, NEW YORK.

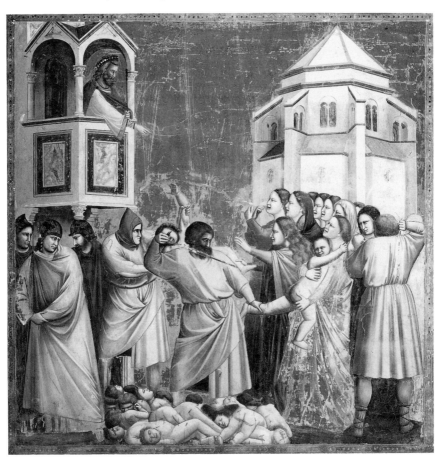

are placed, however meaninglessly, within the confines of a single symmetri-
cal room. Although by means of perspectival orthogonals Giusto has created a
deeper room than any that Giotto defined, he has no *perspective* in regard to
his subject—that is to say, he has taken no stand, assumed no *standpoint,*
toward the issues involved in the massacre. If Brunelleschi had known only
these two pictures, he could have gone a long way toward grasping the funda-
mental principle that underlay the developments in Florentine perspective that
were to occur during his lifetime.

## II

Since Giotto's example was immensely influential in the middle years of the
trecento, one can easily find a number of images from the hands of other
artists (especially the Lorenzetti) in which similar factors of dialogue in con-
junction with perspective are evident. However, I am not at all interested in
tracing lines of evolutionary development but want rather to examine a few
telling examples of the kind of ethical concern that I find to lie behind the var-
ied inventions of Renaissance perspectivists.

Let us begin with two images that Parronchi has rightly associated with the
*tavolette.*[1] The first is a little silver plaque, now in the Louvre, on which there
is depicted in relief (quite possibly from Brunelleschi's own hand) the story of

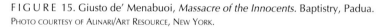

FIGURE 15. Giusto de' Menabuoi, *Massacre of the Innocents.* Baptistry, Padua.
PHOTO COURTESY OF ALINARI/ART RESOURCE, NEW YORK.

Christ's healing a demoniac (see figure 16). The second is the painting in the Johnson Collection in Philadelphia (attributed by Schmarsow and Oertel to Masaccio, by Berenson to Andrea di Giusto—though it is not inconceivable that the invention, at least, was Brunelleschi's) in which two events are shown, the central one being Christ's healing the lunatic son (Matt. 17:14–20; see figure 17). When put side by side, the two images bring to mind almost as many issues as do the *tavolette*.

It is in keeping with the perspectivists' concern for ethical integrity that they should have been drawn to subjects exemplifying Christ's power to bring wholeness, sanity, and order into the world that perennially lacks just those qualities. This is the burden of Masaccio's frescoes in the Brancacci Chapel, which deal with the powerful presence of the man Peter as he brings to bear the force of his authority upon the sicknesses, both spiritual and economic, of the Christian community of Florence—an ethical concern that is quite lacking from the then-fashionable art of the International Style which, as we have seen, does not demand that we "take our stand." Masaccio clearly understood that the very sense of the *costruzione legittima* is regulating and rectifying,

FIGURE 16. Brunelleschi (attributed to), *Christ Healing a Demoniac.* Louvre, Paris. COURTESY OF R. M. N.

revealing to us the possibility of a world that is lawful, lucid, and intelligible, but only by virtue of our being willing to accept a responsive and responsible position within the order of things.

The image on the silver plaque is as symmetrically frontal as is Brunelleschi's view of the Baptistry. The participants in the event are gathered in an open square before a church that is strikingly similar to San Lorenzo. Christ's head is exactly enframed by its central doorway, which lies at the center of the rectangular relief. As the observer to whom the image is addressed, I find myself to be standing on the same central axis, apparently as far removed

FIGURE 17. Andrea di Giusto (here attributed to), *Christ Healing the Lunatic Son.* Courtesy of the Philadelphia Museum of Art; The John G. Johnson Collection.

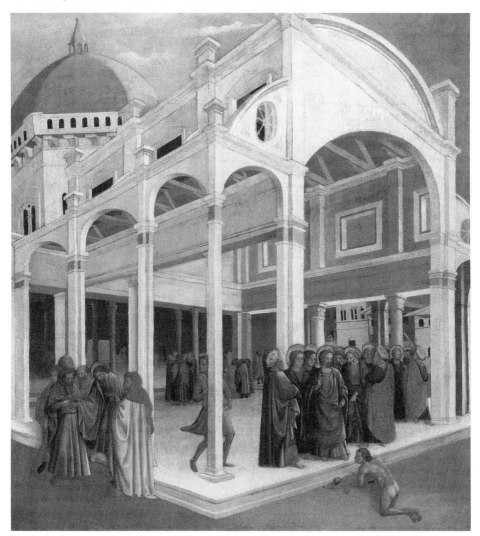

from the central figure as he is himself removed from the facade of the church. I am strongly tempted to imagine that I am standing in the portal of a baptistry on that same axis, and that I am looking through its rectangular frame at the figure group that lies halfway between the two buildings. That is to say, I must assume my own position to be as closely defined or enframed as is that of Jesus; I cannot imagine that I am a casual bystander like one of the marginal figures, for I am compelled by the event to "take my stand," to recognize in the miracle an integrating significance, a wholeness of meaning, that is not apparent to any of the witnesses but only to Jesus—and to me, by virtue of my standing in that doorway and on that axis.

My relation to the second scene, which, like the Palazzo Vecchio *tavoletta*, is viewed diagonally, is totally different. My position is not aligned with any axis or aspect of the large basilica. There is no figure, but only a gap, on the central axis of the painting, while the figure that comes closest to being central is that of a nonparticipant who is partially obscured by one of the pillars of the building and is moving rapidly to the right while looking back sharply toward the cluster of figures at the left that probably represents the payment of the tribute money (though not the story illustrated by Masaccio.) Relationships among the many figures are complex and not easily grasped. The disciples are divided into two groups—an allusion to the fact that the distressed father had first taken his son to a separate group of the disciples who, unaided, had found themselves unable to cast out the demon. My own position, physically and psychologically, is unmistakably that of a mobile passerby who sees that something is going on within the precincts of an imposing building; but, as an outsider who happens to be strolling down the street, I am quite unable to grasp the meaning of what I see.

Though the inferior quality of the painting's *facture* possibly justifies its being attributed to Andrea di Giusto or, as Mesnil suggests, to some nameless follower of Masaccio, the invention itself is so thought-provoking that it surely must have been the work of someone familiar with the *tavolette*—not merely with the geometry of their formal design, as Paronnchi would have us believe, but with the ethical insights that Brunelleschi revealed by means of his dialogical panels. This being the earliest painting we know of in a fully systematic diagonal perspective (the second *tavoletta* having been lost), it could hardly have been made in some routine or perfunctory way, but must have involved, instead, a deliberated departure from the familiar convention of the frontal view. There are precedents, of course (as in the frescoes of Taddeo Gaddi), but those contain none of the provocative ambiguities of the Philadelphia panel.

Take, for instance, the matter of time. In the frontal image on the silver plaque we are made mindful of the "eternal" time of divine revelation. The church in the background is at once the oldest kind of church and the most modern—a fact that greatly illuminates Brunelleschi's purposes in regard to

both the design of San Lorenzo and of the relief (if it is indeed his). What he had gone to Rome to see was a group of churches that had been erected by Constantine and his immediate successors. All Brunelleschi's architectural classicism can be traced simply to them, not to works of the Augustan age. It seems probable that he was as much concerned with discovering the authentic and original form of the Christian edifice as Hus was concerned (and, later, Luther) with returning to the original Christian *ecclesia* or assembly of the faithful, purged of all the alterations and accretions that had so transformed the concept of that assembly as the disciples had received it from Christ himself.

In Rome Brunelleschi found churches that were indeed designed in a style that had been more or less familiar to the contemporaries of Jesus, though it was not used then for church buildings. That meant, of course, that the style had been familiar to Vergil, Horace, and Seneca, for what Christian humanist could have questioned the Providence that had brought it about that the time of Biblical fulfillment should have coincided with that of the crowning achievements of Graeco-Roman antiquity? The city we see in the relief is at once an ancient city, looking the way Florence itself might have looked in the first century, and a modern city as Brunelleschi and his followers would have liked to make Florence modern, freed at last from its ugly clutter of fortress towers and of the partisan violence so closely associated with those towers—a city restored to health and sanity even as the man possessed by demons is being healed by the word and presence of Jesus (and as Florence is shown to be healed by the presence of Peter in Masaccio's fresco of *St. Peter Healing by His Shadow*). In both cases the meaning of the miracle is timeless, transcending the limits of historical circumstances. I am invited to take my stand with regard to something that is as constant and abiding as Sta. Sabina and Brunelleschi's San Lorenzo. The difference in date or "style period" that so separates those two buildings for the modern historian is something that Brunelleschi probably wanted to obliterate.

The time of the Philadelphia painting is temporary or transitory. The cutaway building consists of an odd amalgamation of classical, medieval, and modern elements. Though it has the basic form of a church and appears to be equipped with an altar under its Brunelleschian dome, its unwalled openness is like that of a Florentine market building. Its broad, square floor resembles a piazza both in its form and in the use it is being put to. There are several groups of people, all seeming small within this large public place. As in any piazza at almost any time of day, various conversations and activities are in progress, no one of which can be identified with the institutional or established function of the building. If we observers were standing a few feet farther to the left or to the right, one or the other of the two foreground groups would seem to be centrally located in our visual field. Yet this very fact reminds us

that that kind of centrality is momentary and contingent, the familiar experi-
ence of the passer-by. The striding, twisting figure behind the near-central pil-
lar is the key the artist has given us to his perspectival insight and intention.

If the silver plaque was idealist in conception, the painting defends the
stance of the nominalist. In the former, the miracle is open to allegorical, ana-
logical, and even anagogical interpretation; it points to the central significance
of Christ and his Church for all mankind. The second image may at first seem
almost belittling by comparison, bringing the revelatory miracle down to the
level of a street corner happening, though that was certainly not the artist's
intention. The painting reminds us that the miracles of Jesus actually were per-
formed on street corners, at roadsides, in the houses of ordinary men, rich and
poor, and that they were addressed not to members of the institutional estab-
lishment (neither to Pharisees nor to baptised and confirmed church members)
but to the "man in the street," to passers-by such as ourselves, and to people in
desperate need, as is the father who kneels over his stricken child. What is cel-
ebrated here is not the power of the Church to bring sanity to mankind, but
rather the power of faith to heal this child and to relieve the suffering of this
father. Significance resides in this event as it affects these persons, including
the singular "me" as I pause in the street to witness this manifestation of the
miracle-working power possessed by this man named Jesus. The painting
defends the liberty of the Christian citizen against the tyranny of ecclesiastical
idealism that even then, in the 1420s, was sending Hussites to the stake for
their anti-institutional nominalism. The panel is small in size and was almost
certainly made to be displayed in the intimacy of someone's household. In
many ways its sentiment is proto-Protestant.

### III

That the *costruzione legittima* was on the side of idealist orthodoxy was under-
stood by the better artists of the quattroccento. Alberti does not tell us what
kind of subject matter he dealt with when he employed the system he
describes in *Della Pittura*, nor does he discuss the relation of style to meaning;
painters never do. Whoever casts about to find the classic application of
Alberti's system will turn inevitably, I believe, to Perugino's fresco *Christ Giv-
ing the Keys of the Church to St. Peter*. The painting addresses itself to much
the same concerns that Brunelleschi's *tavolette* dealt with, except that Perug-
ino places the Baptistry in the middle of the Piazza—for reasons having to do
with the standpoint of his patron, Pope Sixtus IV.

Though all twelve of the paintings in the side-wall series in the Sistine Chapel
deal with the history of the Law, or with analogous aspects of the old dispensa-
tion and the new, Perugino's is the only one that makes tellingly effective use of
focal perspective. The others seem, by comparison, a muddled lot, one of the

least satisfactory of all Renaissance cycles. For reasons having to do, perhaps, with a larger crisis that was taking shape in the 1480s, the other painters—Botticelli, Ghirlandaio, Pinturicchio, and Rosselli—seem to have lost their grip on the firm architectonics of the perspective idea as it had been understood by an earlier generation. They were not averse to introducing, however arbitrarily, a good deal of architecture into their compositions, but they were undone by a taste for episodic historicity that quite overshadowed their concern for what should have been the unifying idea behind the whole series, the conception of Law. Even Rosselli's *Last Supper,* for all its architectural setting, seems weak and unfocused by comparison with either Castagno's or Leonardo's version.

Perugino had one great advantage, of course: it fell to him to deal with the only subject in the series that in its very nature had more to do with an idea than with an event. Needless to say, the picture is based upon two familiar lines from the Gospel of Matthew: "And I say unto thee, that thou art Peter, and upon this rock I will build my church; and the gates of hell shall not prevail against it. And I will give unto thee the keys of the kingdom of heaven: and whatsoever thou shalt bind on earth shall be bound in heaven; and whatsoever thou shalt loose on earth shall be loosed in heaven" (Matt. 16:18–19). The meaning of the words (and even their authenticity) may seem problematical, since the word *church* is not elsewhere used in the gospels (except for one other instance in Matthew where its meaning is rather different), but it did not seem so to the men who have occupied the Chair of St. Peter. They have taken this passage to be the indisputable authorization of their monarchical power as heads of the Church. Though the other artists in the Chapel may have felt an understandable uncertainty as to how to deal with subjects such as the Burning Bush and the Temptation of Christ, it was obvious to Perugino that what was wanted from him was an affirmation of the supremacy of papal authority (see figure 18).

Perugino invented for Sixtus IV a composition that has all the formal symmetry of a French Gothic facade. Across the lower part of the fresco there runs a frieze of large, passive standing figures, similar to the embrasure figures at Amiens and Reims (except that the group includes not only Christ and his disciples but also the artist himself and a number of members of the papal circle). At the center, as on the Gothic trumeau, are two figures who are the embodiment of ecclesiastical authority. Immediately above the heads of the standing figures are small active ones, engaged in acting out two biblical events, even as do the little figures on the capitals and in the tympanum of the cathedral portal, while the composition as a whole is cast into a tripartite (a-b-a) form, like that of the cathedral facade, by virtue of the three large buildings that occupy the space above the narrative actors.

By 1482 the era of cathedral building had all but ended. The implacable "objectness" of one of those mountainous medieval edifices, so out of scale with the size of a man, would not have suited the taste or the religious outlook of the

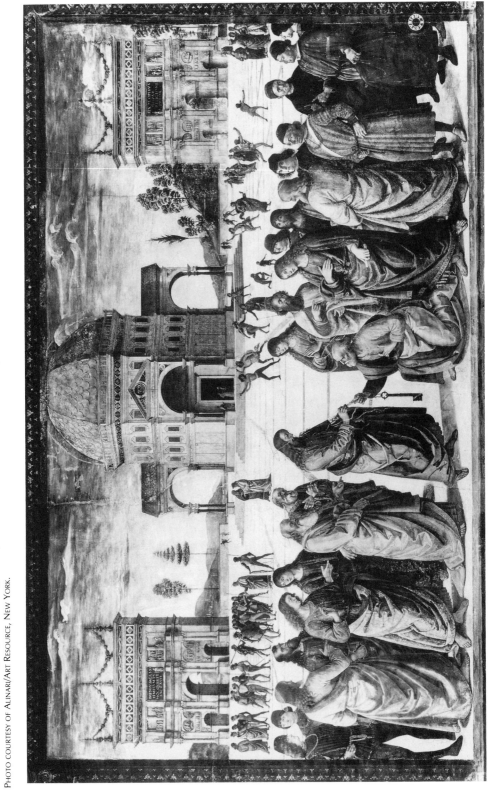

FIGURE 18. Pietro Perugino, *Christ Giving the Keys of the Church to St. Peter.* Sistine Chapel, Vatican.

PHOTO COURTESY OF ALINARI/ART RESOURCE, NEW YORK.

urbane humanists of the last quarter of the fifteenth century. Perugino seems to have sensed, however, that if that kind of scheme could be projected horizontally into the world, by means of a perspectival vista that depended upon the individual's act of comprehending, it might be given a new lease on life—though not a very long one, as it turned out. Sixtus and his retinue may well have felt some twinge of disappointment on seeing the other eleven frescoes unveiled, believing that the great tradition of Italian wall painting was over. If so, their confidence was surely restored by *Christ Giving the Keys,* for it is one of the few pictures of its era that stands squarely in the tradition of the great works of the time of Masaccio, not so much because of the personal style of Perugino as because of the ideas the commission gave him occasion to deal with.

What gives Perugino's fresco its cogency is not merely its architectonic simplicity, for that alone would not have linked it with the paintings of Giotto and Masaccio. Its power stems, instead, from its dialogical nature. The artist was fortunate in having received a subject that lent itself so well to this kind of treatment, but it is probably fair to say that any number of lesser artists of his generation would have failed to see the possibilities in the theme. As Michael Baxandall points out in his *Giotto and the Orators,* humanist rhetoricians had a special predilection for paired opposites. Brunelleschi's *tavolette* constituted such a pair, as we have seen, but only in Raphael's work in the Camera della Segnatura, and especially in *The School of Athens,* do we find a richer development of rhetorical pairing than Perugino's. Raphael learned well what his master had to teach him.

The principal opposition is symbolized by the keys themselves: a bright golden one points upward toward heaven and toward Christ's heart, while a dark one (silver, tarnished or in shadow?) points downward toward the plane of the earth, which here takes the form of a wide, paved piazza. Jesus is not performing a deed in the course of his earthly ministry, for of course no keys were exchanged. We see instead the eternal Christ of whom each pope is vicar on earth and from whom he receives his authority. The golden key that is passed directly from Christ's hand into Peter's symbolizes the spiritual authority with which the papacy is endowed. However, the isolated downward key, located exactly on the central axis of the composition, is the item around which the argument of the painting turns, because for centuries it had been the pope's claim to temporal authority that had been disputed. The dark key is not placed directly into Peter's hand; instead, it hangs from a loop that passes through the bow of the golden key. That is to say, the popes' temporal power is an ineluctable corollary of their spiritual authority.

In the Middle Ages the dispute had been conducted at the highest levels of institutional power—emperor against pope, pope against emperor (or king or other secular power). It had not been a matter in which the individual

townsman or farmer had had much of a voice. Charlemagne had held that the Empire was the protector of the Church, while Gregory VII proclaimed the absolute supremacy of the spiritual power over the temporal. One of the great accomplishments of Brunelleschi was to bring the matter of the rivalry of Church and State down to the level of a single person's reflection and stand-taking. In his small and mysterious image of the Baptistry he had affirmed the importance of the individual Christian's admission, by virtue of his own faith, into the Communion of Saints, a communion that embraces all Christian souls, living and dead, other than those who have been consigned to hell.

Perugino's painting, enormously larger and more public than Brunelleschi's, also centers upon a building for which there is no analogy other than the Italian baptistry (though unmistakably it harbingers the coming of that greatest of central church designs, Bramante's proposal for St. Peter's, by means of which Pope Julius II would have reaffirmed exactly the position or standpoint that Pope Sixtus IV had avowed a generation earlier). It is inconceivable, however, that one should be invited to behold Perugino's building "through a glass darkly," for there is no element of uncertainty here, any more than there is in the facade of Amiens. What matters in this case is not the idea of being baptised into the eternal Communion of Saints; rather, it is the regular and regulating gridiron pattern, determined by the rigorous application of Alberti's system, that seems to radiate from and to converge upon the central building. The paved area brings to mind the word *piazza*, but that term refers to an urban area defined or delimited by city buildings, of which there are none here, the plane being bounded in the middle distance by a low wall, beyond which there lies an open landscape. The plane stands for "the world" or for "Christendom"—for that theoretically unlimited domain over which the popes claimed jurisdiction. Ordinary city buildings here would be irrelevant.

Instead, the oneness and centrality of the Church is contrasted to the multiformity of the symbols of the state, two slightly modified versions of the Arch of Constantine whose "laterality" makes plain their subsidiary status. Yet the fact that their top cornices are on the same line with the cornice beneath the central dome affirms the idea that all three buildings are parts of a single pattern—that is to say, that all authority, as St. Paul declares, is from God, be it secular or ecclesiastical. It matters greatly, needless to say, that the model for the arches was Constantine's arch, for it was he who had brought together the Roman Imperium and the Christian Church and, according to the forged *Donatio Constantini,* had ceded the supreme imperial authority to the apostolic succession of the popes. Although the *Donation* had been subjected to serious critical analysis and attack in 1440 by the humanist grammarian and rhetorician Lorenzo Valla, a slightly older contemporary of the man who was

to become Pope Sixtus IV, clearly the latter had not abandoned the validity of the document's declaration.

Perugino's choice of the triumphal arch is a telling one. Ancient Rome had produced, in its basilicas, a civil or civic architecture for governmental purposes, the forms of which were in many ways related to the architecture of the earliest churches. Both the Basilica Ulpia and Old St. Peter's were essentially meeting halls, places of assembly, where the principal symbol of their institutional significance was to be found in a multitude of relatively small columns that stood together on the common floor, the place of "under-standing." The triumphal arch, by contrast, symbolized only the power of the single emperor, specifically, the power of the autocratic ruler to control the roads, the passageways, the comings and goings of the citizens. It was in no way associated with public assembly, any more than were the domed, central tombs that some of the emperors had commissioned, thereby linking themselves with the "dome of heaven" (cf. E. Baldwin Smith's *The Dome*) and with the divinization of their office. Those tombs were probably formal prototypes for Christian baptistries—a type that goes back to the time of Constantine and his immediate successors. For Brunelleschi the domed, central building was associated with birth, death, resurrection, and Last Judgment; for Pope Sixtus it was associated with imperial power.

The power of the Apostolic Succession was, as Jesus explicitly declared, the power to bind and to loose. This is the dialogical opposition with which Perugino deals in the middle distance, in a pair of scenes that are addressed not to Christian citizens in general but to the secular rulers of the various European states—a point that is made clear by the relation of the two scenes to the two arches. On the right-hand side of the building, or on our left (see figure 19), we

FIGURE 19. Pietro Perugino, *Christ Giving the Keys of the Church to St. Peter,* left detail.

see a group of some nineteen or twenty men who exemplify the "binding." The subject has sometimes been identified with that of the Tribute Money, though there is no need for our finding a scriptural source for the simple idea the artist deals with. Most of the men are arranged along one of the horizontal lines of the gridiron pattern, while a few of them at the right end of the group are aligned with the orthogonals, thereby giving the gathering the shape of a cross. Christ himself is situated at the point where his head would be located on a crucifix. All but three of the men are armed with spears or swords, but while they attend to what Jesus is saying there is no conflict among them. They are engaged in peaceful conversation—for when worldly men accept God's word and law, it is argued, they will find themselves at peace with one another and with the lucid order of creation itself.

On the other side of the painting (see figure 20) we see about the same number of figures, but here they are scattered in disarray around Jesus who, standing with his arms extended in a gesture that is perhaps premonitory of crucifixion, occupies a spot that closely corresponds, in relation to the axis of the painting, to the one he occupies on our left. The scene is thought to illustrate an attempted stoning of Christ that is described in the tenth chapter of the gospel of John, where it is recounted that on a certain occasion the Jews charged Jesus with the sin of blasphemy and took up stones so as to administer the punishment prescribed by the Law. After Jesus had defended what he had said and done, they tried to seize him, but he "escaped out of their hands" (*exivit de manibus eorum*). In other words, as they converged on him, he slipped away from them. According to Perugino, however, it was the would-be executioners who were flung outward and away from Jesus. What we see here is the "loosing" or dispersion, the "scattering abroad upon the face of the whole earth," that will be visited upon the enemies of Christ and his Church.

The standpoint Perugino chooses for his ideal observer is like that of the witness to the scene on the Brunelleschian silver plaque, except that it is raised

FIGURE 20. Pietro Perugino, *Christ Giving the Keys of the Church to St. Peter,* right detail.

a few feet above the plane of the piazza so as to enable him to see the figures in the middle distance and the junction between the buildings and the ground. The painter has used the perspectival stage-space of narrative illustration, but in fact no event is taking place except in the background, and the significance of those events is not historical. No course of dramatic action has led up to the configuration in the foreground, and it is unthinkable that Peter should subsequently rise to his feet and go about his business in the world, keys in hand. Like a cathedral facade, the painting has to do with constancy rather than with change, with architecture rather than with drama.

The brief period between *Christ Giving the Keys* and the Camera della Segnatura marks the high point in the history of perspective as Alberti himself understood it. Later painters continued to use vanishing points (though less and less as time went on), but the special balance between visual experience and an architectonic schema "out there" rapidly changed after 1512. Some years ago I asked one of my colleagues, the painter Robert Jordan, to make for me an image of Perugino's scene as it would look to one of the bystanders in the right background of Perugino's fresco (see figure 21). From that point of view (I hesitate to use the word *standpoint,* since no stand-taking is involved) the ordering of the scene makes no sense whatever. One cannot even see the presentation of the keys, nor can one grasp anything at all of the dialogical

FIGURE 21. Robert Jordan, *Perugino's Giving of the Keys, as Seen by a Bystander in the Right Background.*

oppositions that constitute the very substance of Perugino's argument. In the far distance we can see the man who is seeing the scene from Perugino's point of view. With the sensitivity of a good artist, Mr. Jordan has grasped the fact that that standpoint is itself determined by architecture, for plainly Perugino's viewer has not wandered in from the open fields and happened upon this remarkable scene. Its meaning depends entirely upon its being seen from a particular standpoint, to which nothing is more important than center. In fact, there are three centers: that of the church building, that of the figures of Christ and Peter, and that of the viewer, to whom the whole scene is addressed.

The vantage point of Mr. Jordan's marginal viewer is a familiar one: it is that of the photojournalist who makes the meaningless and unilluminating photographs that adorn the pages of every daily newspaper in the world. For one thing, the photographer is never at the right place at the right time. See, for example, the picture that appeared in the pages of the *New York Times* (figure 22). What it shows us is a small crowd of curious spectators who are gathered in the street outside a building inside which a shooting has just taken place. The photographer has arrived too late. But even if he had witnessed the shooting itself, it is most unlikely that the visual configuration of that nonevent would have conveyed any more in the way of meaning than does the picture the editor chose to publish. No photograph could have conveyed any understanding of the underlying human purposes, emotions, and consequences of the shooting.

With any narrative illustration one has to know the whole story in order to make sense of any illustration thereof. In all Renaissance narrative paintings it is always presupposed that anyone likely to see them will already know the story, so the paintings are not intended to be informative. Pictures cannot *tell* a story. In the *Times* "story" the shooting may have been an unintended incident in a robbery or it may have resulted from a longstanding family feud. A reporter's written account might tell us what the circumstances were, but no photograph could convey that information. The photojournalist, in short, is a professional bystander. The attitude of the disengaged and uncommitted onlooker is one that poses, or perhaps should pose, compelling problems for

FIGURE 22. News photo from the *New York Times.*

both the journalist and the art historian, both of whom are caught up in episte-mological difficulties that are peculiar to modern thought.

Between the sixteenth century and the nineteenth the function of the image maker underwent, however gradually, so fundamental a change that in 1836 it was possible for the painter Paul Delaroche to declare, on first seeing a daguerreotype, "From today painting is dead!" Though it is hard to know just what he meant by "painting," he apparently sensed immediately that the camera was capable of making a kind of image that he and at least some of his contemporaries were already committed to making. In this con-nection it is rewarding to compare, however briefly, *Christ Giving the Keys of the Kingdom* painted by Ingres in 1820 for the church of Sta. Trinità dei Monti in Rome with Perugino's fresco and with the eleventh-century version that is to be found in the Pericope of Henry II (see figures 23 and 24). Although Ingres was a master of the techniques of perspective, his composi-tion has more in common with the Ottonian invention than with Perugino's, even though it descends genetically from the Sistine fresco by way of Raphael's cartoon for *Feed My Sheep!* and Poussin's *Ordination.* Both Raphael and Poussin shared Perugino's concern for relating the full group of the disciples to a continuously receding ground plane and a deep and varied landscape. But Ingres has reduced the group, minimized the men's contact with the ground (showing three feet for eight men, somewhat as the medieval artist shows eight feet for thirteen men), and has compressed the landscape into a shallow affair that, for all its optical verisimilitude, oddly approximates the Ottonian artist's background, which consists of a golden square against lighter and darker bands of blue-gray. Although Ingres's large painting was made for a church, it is devoid of Perugino's kind of dialogical argumentation: it shows divine power to descend from upper left to lower right, through Christ to Peter, but it does not invite us to "take our stand" with regard to any definable issue, nor does it in any way bring new insight into the meaning of Matthew's text. It no more reveals the artist's possession of a distinctive standpoint than does the average newspaper photograph. I would not give Delaroche credit for having understood all this in the 1830s—only for seeing that the camera's "eye" could be used for the render-ing of a kind of disinterested onlooking that preoccupied some of the best-known salon artists of his day but that had very little to do with the Renais-sance uses of perspective.

Perugino's image of the world is still firmly pre-Copernican, not because of his conception of space but because of his attitude toward Center. It is a cliché of popular historiography to say that "Renaissance man" still believed himself (and the earth) to be at the center of the universe, though little is said about the meaning of that pronouncement. All of us have shared the landscapist's expe-rience of finding a wide vista to be both comprehensible and comprehensive,

FIGURE 23. J. A. D. Ingres, *Christ Giving the Keys of the Kingdom to St. Peter*. Louvre, Paris. COURTESY OF R. M. N.

something that we comprehend and within which we are ourselves comprehended. In his forty-first letter to Lucilius, Seneca describes for us two experiences of natural interiors, the first in a deep forest, the second in a cave, both of which inspired in him an intuitive awareness of a divine presence—that is, of being embraced within a world in which human consciousness is of transcendent significance. In all likelihood that intuition was unrelated to Seneca's acceptance of either a geocentric or a heliocentric theory of the cosmos, both of which were probably known to him. So, too, with Perugino: his fresco constitutes an eloquent defense of a conception of Center that painters found increasingly difficult to affirm after about 1520. That difficulty is usually associated in our minds today with the term *Mannerism,* though that art-historical designation throws no light upon the nature of the difficulties that made their attitude toward Center queasily ambiguous. Only in his day could Copernicus put forward again the heliocentric image of the solar system, which had been known to the ancients and probably to medieval scholars, and have it capture people's imaginations as it had never done in earlier centuries.

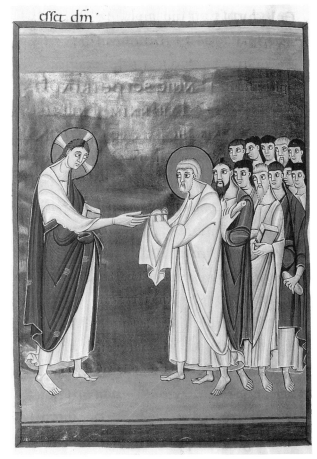

FIGURE 24.
Pericope of Henry II,
*Christ Giving the Keys of the Kingdom to St. Peter.*
Courtesy of Bayer.
Staatsbibliothek, Munich.

Not that the difficulties were then resolved, nor have they been resolved since that time. The great astronomer Johannes Kepler, discoverer of the elliptical orbits of the planets, felt a "mysterious horror" at the "mere thought" of Bruno's "limitless and centerless infinitude." We have learned to live with that centerless vastness, but the problem of Center is still with us. The results of the modern artist's effort at transferring "center" to the mind of the solitary individual, without reference to anything of "central" importance out there in the world, have been less than generally satisfying.

The adoption of Perugino's (or Sixtus's) standpoint magnifies or enhances certain aspects of one's distinctive selfhood but it diminishes or suppresses others. Whoever takes the stand that the fresco urges upon us will recognize that this order of things composes a balanced and harmonious totality only for someone who accepts the limitations of that position. All those aspects of his or her individuality that pertain to passion, sensuality, a potentiality for violence, and whatever we ordinarily mean by self-expression are necessarily minimized. The self that stands here is one's public self, closely corresponding to the impersonal image we commonly encounter in the profile portraits of the quattrocento. From this standpoint it was possible for Perugino to look at himself, standing there just behind the apostles on the right, as a man among men, a citizen among his fellow citizens, his face as blandly conventional as all the others'. That is to say, he possesses only those characteristics by virtue of which it has become possible for all these different persons to *convene*. The painting was made, of course, for a convening place—one in fact, as it later turned out, where the agreements reached among men (viz., the College of Cardinals) were to have especially weighty consequences. (Perhaps we do well to think, in this connection, how greatly both convening and Center have been trivialized in that structure without which no modern city is complete, the Convention Center.)

## IV

Perugino used the *costruzione legittima* to address with great vigor the duality of Church and State, but from a point of view that was heavily weighted in favor of the Church. So as to put the issues in the clearest possible light, let us consider briefly another composition that is of about the same date as Perugino's and that is similar to his in a number of ways—the *View of an Ideal City* that is now in the Walters Gallery in Baltimore (see figure 25). Though a great deal has been written about its date, provenance, and authorship, no one seems to have shown much interest in what is represented—that is, in what the "ideal" is that the design exemplifies.

The painting is similar to Brunelleschi's first *tavoletta* in its symmetry and central focus, like his second, in the weight it gives to a wide urban piazza. At

the center stands a triumphal arch. Perugino used the form in a somewhat eccentric way to stand for the secular authority of the leaders of the states that made up the divided Christendom over which Sixtus wished to preside. But the painter of the *Ideal City* (Luciano Laurana?) has held fast to the original meaning of the structure, for here it seems in all likelihood to refer to the centrality, in Italian city-state politics at that time, of the single despot: it is through his eyes that we are viewing the piazza and the buildings that surround and define it. Through and beyond the arch we see a towered city gate, reminding us, perhaps, that the defense of the city is the first responsibility of any man who would aspire to possess autocratic authority. Our own act of lucid and complete comprehension amounts almost to a conquest of the city—though a conquest that has been made possible by the activity of architects over a long period of time. The painting would surely have delighted Alberti and all those Renaissance writers who were so given to apotheosizing the art of architecture.

On either side of the triumphal arch we find once more the architectural symbols of Church and State—two buildings of central design, a baptistry-like church on the right and a miniature Colosseum on the left. The former is an example of the most closed kind of church, its door shut and its clearstory windows blocked by perforated stone grilles. The latter is the most open kind of secular urban structure, roofless and its exterior defined entirely by arcades. Again, the one has to do with lifelong commitments, with the maintenance of ethical standards and the enforcement of moral prohibitions. The other has to do with ephemeral pleasures, worldly spectacles, and the ritual release of passion and violence. It is almost as if the citizen were faced with a "choice of Hercules," except that it was plainly the purpose of the artist and his patron to argue that there is no irreconcilable conflict between these two aspects of urban life.

Though the stance would have seemed an abomination to a Savonarola or a John Calvin, it appears to have been a popular one in the second half of the

FIGURE 25. Luciano Laurana (?), *View of an Ideal City.* Walters Art Gallery, Baltimore.

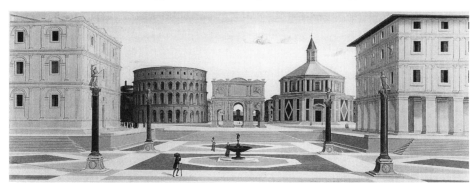

fifteenth century—witness, for instance, Il Magnifico's taste for writing both bawdy and devotional poetry. While the Church undertook to weld men into a community by providing them with a common frame of reference and a sense of ultimate destiny, people were drawn to the city (as they still are) by its promise of richly varied experiences and differentiated modes of self-fulfill-ment. Though one cannot say that a harmonious balance between these two modes of "communification" has ever been achieved, there was perhaps a brief period when men imagined that it could be attained—that the Commu-nion of Saints and the community of citizens might truly be one and the same. Though it may not have been made there, we associate the picture with Urbino, for it was in the court of Duke Federigo da Montefeltro and, even more so, in that of his son Guidobaldo that this Christian-humanist ideal was, however briefly, most perfectly realized. But that period ended well before the death of Leo X in 1521, whereafter it would hardly have been possible for any artist to design an ideal city of the kind we see in the Baltimore panel.

Although the picture is neither signed nor dated, it has long been thought to have been made by an architect—possibly Luciano or Francesco Laurana, possibly Giuliano da Sangallo—for who but an architect would have dreamed of achieving so harmonious a duality within the institutional framework of his society? But in fact the Italian cities of that day had nothing comparable to the Roman Colosseum or circuses, while among the buildings of ancient Rome there was no building that corresponded to the Christian baptistry. Today the principal occasions for public assembly have again come to be associated with stadiums, arenas, and theaters—occasions of spectacle and entertain-ment—while no provision is made, by any significant body of modern archi-tecture, for people's assembling for the kind of "high" purpose that pertains to religio-ethical commitment and affirmation. It is not surprising that during the Renaissance men should have used churches as political meeting places, for the modern divorce of politics from religion, of religion from politics, had not yet occurred. Nor is any such divorce advocated by our panel painting, only an articulation and clarification of an ideal that some men, at least, were pre-pared to take seriously.

We may think it odd, on first contemplating the Baltimore panel, that there should be no *state* building on this ideal square—no capitol, no town hall. At least two explanations for that omission occur to me. We may conjecture that our own vantage point is inside that missing building—in other words, that this is explicitly the despot's image of the city as he comprehends it from his offi-cial position in the Palazzo Comunale. Or else it may be that by framing the scene between two great palazzi the artist was asserting that the real seat of political power was to be found in the family rather than in civil institutions, for in city after city it was a family—Visconti, Medici, d'Este, Gonzaga—that had got the political power into its own hands. And that leads us to consider a

third allegiance that shaped the perspective of "Renaissance man," for a man's first loyalty was to his family.

This is another institutional loyalty for which one finds no real parallel in Roman antiquity. The Roman family, in the early days of marriage *cum manu,* was a severely patriarchal institution that put total authority in the hands of a father for as long as he might live. Perhaps for that very reason there never emerged, either in Rome or in Byzantium, a clear principle of hereditary succession or consanguinity. Adoption back and forth between families was not uncommon, and men were not so obsessed with the inviolability of family honor as to be willing to resort to the bloodthirsty practices of the vendetta. In imperial times, when marriage *sine manu* was the order of the day, there was even less reason for regarding the family as the bulwark and guarantor of one's identity as a person.

Concomitantly, the Romans never developed a family-affirming domestic architecture. If we may take Pompeii to have been a typical Roman town, we can see that the Roman house was generally invisible from the street, since it possessed no external form whatever. Often screened or defined by a series of adjacent shops, it was simply a hollow, with lesser hollows opening off its inner courts. For both social and architectural reasons, therefore, it would not have occurred to the Roman painter to challenge us to "take our stand" with regard to the significance of the family's discrete existence within the urban fabric. Though streets and buildings are often represented in Roman wall paintings, the buildings never represent institutions toward which we are invited or expected to feel loyalty or any other kind of emotional involvement that might arise out of our experience of membership. No work makes it plainer than does the Baltimore panel that Renaissance perspective was not, and was not then understood to be, simply a technical device. Nor was it in any sense whatever, *pace* John White, a "rebirth" of Roman perspective. Rather it involved, and was known to involve, the act of taking one's stand with regard to an established order of things in the world.

What has been said so far has pertained exclusively to Italian art. Yet it is common knowledge that the developments in perspective that were taking place in northern Europe in the first half of the fifteenth century were as rapid and as striking as those that were occurring in Tuscany, even though they did not involve a similar concern for an explicit technical method. In many a northern city the polarization of town hall and cathedral as centers of institutional authority and ethical meaning was as clearly manifested in architecture as was the case in Florence and Siena. And in the genres of portraiture and landscape, both of which bear directly upon the development of the self-consciousness of the self-centered person, northern artists were somewhat ahead of their Italian contemporaries, as they were, also, in their perception of the religio-political significance of bourgeois domesticity. In all that pertains to

the "two allegiances," however, the most telling invention of the fifteenth century is surely to be found in Jan van Eyck's *Madonna of the Chancellor Rolin* (see figures 26 and 27). In no other work, so far as I know, is the confrontation of the temporal with the eternal, of the secular with the sacred, the State with the Church, so deeply meditated upon.

To begin with, be it said that we have no reason to doubt the utter sincerity of Rolin's Christian faith, even though it may seem to us, as it did to his contemporaries, that he was the most worldly of men. But that is the very point of the painting: the chancellor's relation to the *world*, one might say, is what the painting is about. In Roger van der Weyden's portrait of Rolin (in Beaune) we see a thoughtful and almost kindly old grandfather, but van Eyck, no doubt with his patron's full consent, had the honesty to show the man as the hard-

FIGURE 26. Jan van Eyck, *Madonna of the Chancellor Rolin.* Louvre, Paris. COURTESY OF R. M. N.

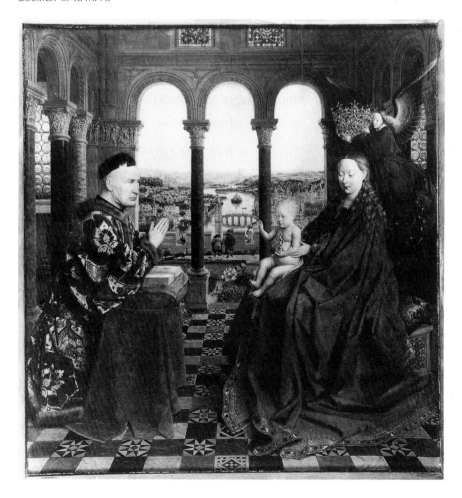

faced and implacable official that he was (or that his loyalty to both his duke and his family required him to be).

During his own lifetime Duke Philip was not called "the Good" but "the Steady" (*l'asseuré*), and, though the surviving evidence is inconclusive, we have reason to suppose that the steady hand that steered the duchy's devious but generally successful course for forty years was more Chancellor Rolin's than Duke Philip's. It was up to the chancellor to make the hard and ruthless decisions that made it possible for the duke and his courtiers to lead the sumptuously extravagant and fancifully chivalrous life that was the envy of every court in Europe at the time. As Chastellain says, "The chancellor was in the habit of controlling everything himself; he alone handled and bore responsibility for everything in matters of war, peace, or finance; all decisions rested first and foremost with him. The duke relied on him for everything, and there was neither office nor benefit, in town or in country in all his territories, and neither gift nor anything borrowed that would not be done entirely through him." Though he was of modestly middle-class origin, Nicholas Rolin had made himself the most powerful official in Burgundy. Jacques du Clercq reports that his rents amounted to more than forty thousand florins, his sons were great lords, his daughters were married to men of high position, and there was no prince who did not fear him.

In assessing Rolin's character, both Chastellain and du Clercq express themselves in terms of an ethical polarity or dualism that is essentially the one Brunelleschi had wrestled with at the beginning of the century. Said du Clercq, "The said chancellor was reputed to be one of the wise men of the kingdom, to speak temporally; with regard to the spiritual, I keep silent." And Chastellain: "In as much as regards the world, this man was very wise, but his

FIGURE 27.
Jan van Eyck,
*Madonna of the
Chancellor Rolin,*
detail.

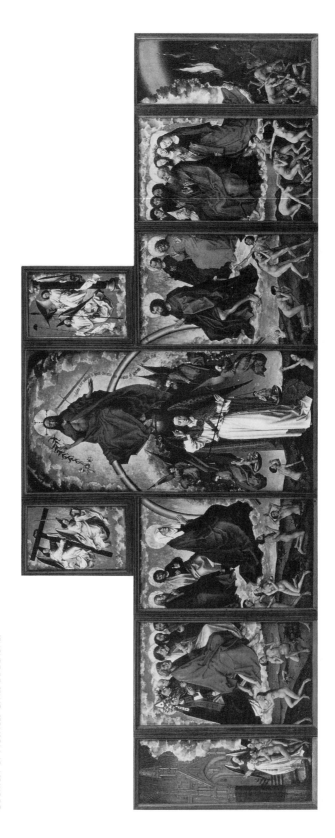

FIGURE 28. Roger van der Weyden, *The Last Judgment*, detail. L'Hôtel-Dieu, Beaune. COURTESY OF HOSPICES CIVILS DE BEAUNE.

way did not seem to embrace both kinds of wisdom (*les deux sapiences*); for in giving himself over too much to the one that was decrepit and fallible he seemed to remove himself from the most certain and memorable one, and harvested always from the earth as if he were in perpetual possession of his lands. . . . He strove to rise continually and to multiply (what he possessed) up to the very end and to die with sword in hand, victorious over fortune." Since both writers quite naturally thought in terms of an ethical opposition, we may fairly assume that van Eyck would have regarded the chancellor from a similar point of view—and, moreover, that Rolin would so have regarded himself.

For all his worldly success, Nicholas Rolin was obviously aware that wealth and power could not be counted upon on Judgment Day; he founded the Hôtel-Dieu in Beaune (a hospital in Burgundy), and he commissioned Roger van der Weyden's great image of *The Last Judgment,* in which it is made plain that we are not the victims of devilish machinations but are free to choose for ourselves in this life between good and evil (see figure 28). As did Michelangelo a hundred years later, van der Weyden perceived that on Judgment Day there is no far horizon, with all its implications as to future, hope, and expectation, for historical time will then be at an end. In van Eyck's *Rolin Madonna,* on the other hand,

FIGURE 29. Roger van der Weyden, *The Last Judgment,* detail.

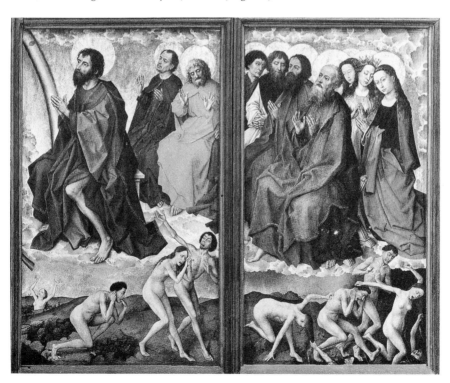

there is a wide landscape and a sweeping horizon, because the painting has very much to do with the world and with Chancellor Rolin's fervent hopes.

Although the chroniclers considered Rolin to be a ruthless man, they did not accuse him of criminal malfeasance. He was an excellent lawyer, and his conduct, so far as we know, was lawful at all times. The Christ of the Last Judgment, as van der Weyden depicts him, is as implacably just, as merciless in his recognition of the inexorability of St. Michael's objective determinations, as Rolin himself must often have seemed to be to those who suffered the consequences of his lawful decision making. It would be interesting to know how he himself responded upon first seeing the painting unveiled (see figure 29). The anguish of the damned, as they are propelled by their own choices toward the fiery hell-pit, is truly terrifying. Did it terrify Rolin? Could he in good conscience have placed himself among the virtuous souls who are being led toward the gates of heaven? Had van der Weyden consulted with his patron as to just how the latter wanted the subject to be dealt with? Was Rolin's conduct changed in any way afterward? The relation of patron to painting is more troubling, more puzzling, than in any other case that comes to mind.

He knew that he had cause to be uneasy, caught as he was between the conflicting demands of his two loyalties; and so he turned to his painters and asked them to help him make something clear, and, in so doing, to give him reassurance. For one thing, there was his wealth. Like Jodocus Vydt and others among van Eyck's patrons, the chancellor wanted to believe that the symbolism of wealth, with its extravagant display of gold, pearls, jewels, and splendid textiles, was divinely sanctioned, an earthly reflection of the inconceivable splendors of the Heavenly City. Just as that celestial magnificence reached its culmination in the throne of God, so too it was appropriate that earthly wealth should be increased in accordance with one's standing in the hierarchy of earthly rulers. But unlike King Clovis, Rolin could not have been indifferent to the fact that such wealth is acquired in this life by the kind of greedy self-seeking that is explicitly condemned in the Christian gospel. The chancellor would have known, too, that the ostentatious extravagance of the ruling classes was bitterly resented by the merchants and artisans of the towns, on whom the prosperity of the duchy increasingly depended.

On the other hand, Rolin could have defended himself on the grounds that he was performing the function of the "faithful and wise steward, whom the lord shall make ruler over his household" (Luke 12:42), or of the servant to whom his master entrusted five talents in the expectation that his investment would be doubled (Matt. 25:14–30). Or he could have contended with some justice that he was the defender of the purest tradition of Christian chivalry, according to which the man of forthright action was expected to play a militant and aggressive role in the world so that ultimately the world might be made secure for those specifically Christian virtues that were held to be ideally exem-

plified in the life and character of the noble princess, whom van Eyck shows the Virgin to be—the virtues of gentleness, compassion, loving kindness, patience, and so on. The polarization of masculine and feminine virtues, for which no basis whatever is to be found in either biblical or classical thought, made it possible for Christians of the later Middle Ages and of the Renaissance to cope with the ethical dichotomy that Brunelleschi had squarely confronted in the midst of the Schism—a spiritual dilemma that might have seemed to cry out for the single-minded consistency of either a St. Francis or a Machiavellian despot. In hardly any other work of Renaissance art are masculinity and femininity so sharply contrasted as they are in the van Eyck's *Rolin Madonna.*

In his frescoes in the Brancacci Chapel Masaccio had just made an earnest plea (especially in *The Tribute Money* and in *The Death of Ananias*) for a radical Christian communalism, based upon the straight-forward rigorousness of apostolic preaching. His affirmation is as powerfully moving as any in Italian art, yet one cannot help suspecting that his rich patron, Felice Brancacci, did not really mean it—that he was not in the least prepared to give all that he had to the Christian community and to take back only what was needed in order for him to live like Jesus and his barefooted followers. Admirable though it is, Masaccio's ethical idealism seems rather remote from the actual lives of Florentine businessmen in the 1420s.

In the *Rolin Madonna,* however, van Eyck composed a prayer to Christ and the Virgin that the chancellor could have offered, and indeed did offer, in perfect honesty. No attempt is made at glossing over the hard and potentially brutal severity of his countenance. In the simulated relief above his head it is made clear that the world he finds himself in is not of his own making or choosing: it is the world of fallen man who must wrest his living from a resistant earth, the world of murderous Cain and of drunken Noah. The frieze ends with two unidentifiable figures who seem to be gazing at the small new moon that lies directly in front of them on the surface of the panel. In composing his little painting of the *Crucifixion* now housed in the Metropolitan, New York, van Eyck had already shown himself to be attentive to lunar symbolism: as the sun rises into the sky on Christ's right (as we can tell from the direction of the cast shadows), an old moon is setting beside the blindfolded face of the bad thief and above the jagged, snow-covered peaks that characterize that aspect of the world that is farthest removed from the warmth of God's love. In the *Rolin Madonna* too there are snowy peaks under the moon but none on the side of Christ and his Mother. For van Eyck the moon referred, it would seem, not only to the fallen condition of Rolin himself but to that of the degraded world in which he had to live, from which degradation no man who was called upon to play the role of executive officer to the Duke of Burgundy could possibly have disengaged himself. Certainly no one could be a wise and faithful shepherd while maintaining the childlike innocence that Jesus had unequivocally

declared to be required of anyone who would enter the Kingdom of Heaven (Matt. 18:3), and that is exemplified in his own incarnation as a little child, even as we see him here in the picture. In praying that he might be found acceptable in spite of his unacceptability (even as Noah is shown in the relief to be on his knees as he is visited by the dove of the Holy Spirit despite his goatish proclivity toward drunken depravity), Rolin himself was appealing to the authentic apostolic word, for as St. Paul had written, we are saved "not according to our works, but according to his own purpose and grace" (II Tim. 1:9).

What is at stake in all this is not a Mariological typology, as Heinz Roosen-Runge would have us believe,[2] but the spiritual condition of a specific man who found himself torn between his religious and his political obligations. Rolin was compelled to offer his prayer because of his relation to the *world*— that is, to the territories of Burgundy over which he exercised his authority and from which he derived his wealth. If the spiritual significance of his devotion to the world was so much on the minds of his contemporaries, such as Chastellain and du Clercq, then surely it must have weighed even more heavily on his own mind and conscience.

There are grounds for arguing, I believe, that the development of Renaissance perspective (especially as we see it in the second *tavoletta*) is related in some ways to the emergence of the territorialism that was so conspicuous a feature of European politics from the thirteenth century onward. Whereas men had once been united by their having been baptized into a common faith, their membership came increasingly to depend upon their having been born in the same territory—a circumstance that provided the basis for a new kind of *religio,* or "binding up," about which human beings have shown themselves capable of extraordinarily strong feelings. The policy that the Duke of Burgundy and his chancellor were pursuing was plainly territorialistic, aimed at creating a state that could stand on an equal footing with England, France, and the Empire. It was perhaps in the light of such considerations that van Eyck was inspired to introduce, as an unprecedented novelty in this kind of devotional picture, the vast landscape that is the chief glory of the painting. Had Rolin been a shopkeeper, even a rich one, he could hardly have had himself represented as occupying the fortified *castellum* that presides over this extensive and manifestly modern-European territory.

Historians have now and again debated the question of whether the building the figures occupy is the chancellor's palace, to which the Virgin and Child have descended in visionary apparition, or is the palace of the Queen of Heaven, to which he has been transported in visionary anticipation of heavenly bliss. But to put the question in this way is to ignore entirely the dialogical and hortatory nature of the image. Any fifteenth-century Christian, we may reasonably suppose, would have understood that the relationship van Eyck has depicted amounts to an argument in defense of the Pauline doctrine that all

political power is of divine origin and ordination. The relation of the castle to the town is by no means a visionary one; it corresponds exactly to the one that is to be seen in two slightly earlier Flemish paintings from Tournai, which lies about forty miles south of van Eyck's city of Bruges. Both in Campin's *Nativity* and in van der Weyden's *St. George and the Dragon* we see in the middle distance a walled port town, above which there rises a steep hill that is crowned by a stone fortress, from whose ramparts one might look down upon the cathedral square and the marketplace just as we do from the castle in van Eyck's painting (see figures 30 and 31).

We do not know for whom these pictures were made, but I think it likely that Campin's was commissioned by a prosperous burgher in Tournai while van der Weyden's was made for someone whose sympathies, at any rate, were more nearly on the side of the chivalrous aristocracy. I say this because the meaning of the two hilltop fortresses is quite different. Van der Weyden's castle is, in the overall composition of his tiny painting, by far the larger and more prominent of the two, and it has an obvious relation to the subject matter, since both the princess in distress and her knightly rescuer presumably reside in just such a chateau. The Christian knight is represented as the defender of gentle (and genteel) virtue against bestial evil. In defending the princess he is also defending the residents of the town, who live in peace because of the

F I G U R E 31. Roger van der Weyden, *St. George and the Dragon*, c. 1432/1435. Alisa Mellon Bruce Fund, 1992 National Gallery of Art, Washington, D.C.

F I G U R E 30. Robert Campin, *The Nativity*. Courtesy of Musée des Beaux-Arts, Dijon.

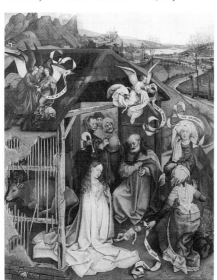

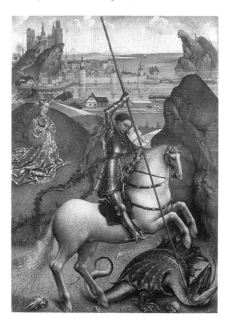

protection afforded them by the castle-dwelling nobility. The polarity of masculine and feminine is as conspicuous as, though less problematical than, it is shown to be in the *Rolin Madonna.*

In Campin's *Nativity,* however, the meaning of the castle is altogether different. The composition is unusual by virtue of its inclusion of the two apocryphal midwives, Zebel (here called Azel) and the wickedly skeptical Salome, who was guilty of adopting the standpoint of the protoscientific experimentalist. Doubting that Mary remained a virgin after the miraculous birth, she says, in the banderole above her head, "I shall believe what I can prove." Having reached out her hand in order to find out for herself, she has had her right hand withered or paralyzed, whereupon an angel above her says "Touch the Child and be healed." Of crucial importance, however, is her costume. She is dressed as if she were a member of the highest aristocracy, wearing a dress that would have put the Duchess of Burgundy to shame. Campin makes no reference to the protecting function of the feudal lord; he identifies the castle only with the reprehensible worldliness and extravagance that were all too characteristic of the Burgundian court in his day. Salome's skepticism is sharply contrasted with the unquestioning faith of the simple shepherds at the Child's right, while he himself lies naked on the ground. In Campin we find at last an artist who fully appreciates the fact that Joseph was a townsman and a carpenter, a point made even more emphatically in the Merode Altarpiece. We feel no need to identify the town in the middle distance as either Nazareth or Bethlehem; it is obviously a modern Flemish seaport that in no way owes its prosperity to a class of aristocratic overlords. The nativity takes place in the countryside, not in order to suggest an association with noble and elegant landowners, as we commonly find to be the case in the works of the French manuscript painters of the previous generation, but rather to establish the relation of the event to nature and the universality of its message, symbolized by the golden sun that is rising on the horizon: "For now in the tender compassion of our God is the morning sun risen upon us, to give light to those who sat in darkness and the shadow of death, and to guide our feet in the paths of peace" (Luke 1, 78:80).

To ask whether the *castellum* in the *Rolin Madonna* belongs to the chancellor or to the Virgin is to miss the point of the picture. It belongs to neither. It represents, instead, the seat of the aristocratic ruler who claims suzerainty over the city below and all the surrounding countryside. But the ruler was not Rolin himself, for he was a burgher, the prototype of the middle-class civil servant who was to play an increasingly important role in European politics during the following centuries as power was gradually withdrawn from the hands of an hereditary aristocracy and placed in those of bourgeois statesmen. Yet the chancellor well knew that it was he who wielded the power, albeit in the duke's name—and perhaps put his soul in jeopardy in doing so. Was it suffi-

cient justification for him to say that he was only doing the will of the duke?

Plainly the *Rolin Madonna* does not defend (as Campin's painting just may) the thesis of Marsilius of Padua, that political power should ultimately derive from the people themselves. Having committed his life to the service of Philip, Nicholas Rolin was compelled to affirm his faith in the doctrine that all power descends from the throne of God. Therein lies the significance of the Child's holding the *orbis mundi,* on which the Virgin's gaze is intently fixed, as he simultaneously blesses, empowers, and forgives the chancellor, for in obeying the duke, Rolin was doing God's will—or at least he is praying that God in heaven will understand his service in that light.

Yet he was not a nobleman, so was it not arrogantly presumptuous to have himself portrayed in the situation of a royal personage, and with his head on the very same level as the Virgin's? Clearly it mattered to Rolin that the painting should declare the commoner's right to be present at the very center of an essentially personalistic and nonhierarchical order of things, even as was Rolin when he dealt in fact as an equal with the kings, dukes, counts, and bishops with whom he had continually to negotiate. In a subtle way that would have appealed to van Eyck, who was himself then playing a role that transcended the conventional notion of the artist-as-artisan, the painting argues for an equalitarianism that is again in keeping with the nature of the apostolic Church and that anticipates the thinking of Luther and the Reformers—and of Albrecht Dürer, whose great "protestant" self-portrait of 1500 is first foreshadowed in van Eyck's *Man in a Red Turban* (also in all probability a self-portrait) and in his painting of the *Sainte Face.* Rolin wanted in all honesty to be recognized as being the distinguished official that he was and at the same time to be forgiven for being the man that the world had compelled him to become.

For his part, Philip the Good never lost faith in the old formulas of chivalrous aristocracy. His characteristic response to a rising sea of troubles was to resort to pageantry. In the fall of 1429, during a wintertime truce in the Hundred Years' War, he decided to take Isabella of Portugal as his third wife. Rolin was put in charge of conducting from Burgundy to Brussels, by way of Paris, a wagon train that was laden with rugs, tapestries, jewels, ornaments, and fine gifts, to which train there was added at Lille another wagon-load of fine cloth and precious objects, plus fifty more wagon-loads of wine. The marriage took place on January 7, 1430, and was followed by eight days of sumptuous feasting. To add a special splendor to the occasion, the duke announced at that time the founding of the Order of the Golden Fleece, a reaffirmation on his part of the primacy of the feudal class and of the feudal tradition in maintaining the peace of Europe. Twenty-five years later, when Burgundy again had an opportunity to consolidate its position by decisive action, Philip responded by announcing a new crusade and by conducting a resplendent procession through Germany as far south as Regensburg in order to solicit support for that stillborn venture.

Though he was showered with lands and honors by his duke, Nicholas Rolin was never made a member of the Order of the Golden Fleece. His rivals and opponents in the Burgundian court were so honored; he was not. As Roman Berger suggests, he seems to have had little confidence in the value of such feudal trappings. Even though he had thrown in his lot with the aristocracy (and had profited enormously thereby), Rolin was at heart a product of the solid and respectable middle class. Had he become a member of the Order he would have become a vassal indeed, rather than the respected civil servant or prime minister that he seems to have understood himself to be. He acknowledged the necessity of there being a *castellum,* a seat of authority that could maintain a lawful peace over wide territories. But what was ultimately needed within the castle was the wise and tender humanity of a Virgin Mother who finds it unnecessary to wear the crown that an angel holds over her head.

Like all prayers that are uttered aloud in church, this one is addressed simultaneously to the Ruler of the Universe and to the ruled—that is, to the lay congregation whose members would regularly see the image and be affected by it. What little evidence there is (and it is admittedly inadequate) would indicate that the painting was intended from the outset for display in one of the churches of Autun, where it would have declared to the populace something about Rolin's righteous piety (concerning which the burghers may well have had reason to be skeptical) and something about the way he understood his role in relation to the welfare of cities. For surely the most beguiling and engaging element in van Eyck's composition is its image of a splendid, prosperous, peaceful modern city, thriving amidst a bountiful countryside.

De Tolnay and Panofsky, among others, have identified the city as the Heavenly Jerusalem. The sublimation seems not only needless but ill founded. Van Eyck had already had occasion to take account of the fact that St. John saw no "temples" in the Heavenly City: although there are magnificent towers in the background of *The Adoration of the Mystic Lamb,* none of them adjoins a church or any building that can be associated with a specific use. In the *Rolin Madonna* there are at least eight recognizable church buildings; the city cannot possibly be the New Jerusalem.

Roosen-Runge sees the city to be the visible embodiment of one or another of the innumerable metaphorical images or emblems of the Virgin herself, as in the following *Salutatio* he quotes from a Carthusian manuscript of around 1400:

> Salve, Sion sublimata
> Hierusalem urbs beata
> Vivae pacis civitas.

For the illustration of that kind of medieval religious thought, however, one needs nothing more than the rudimentary architectural symbols that are so

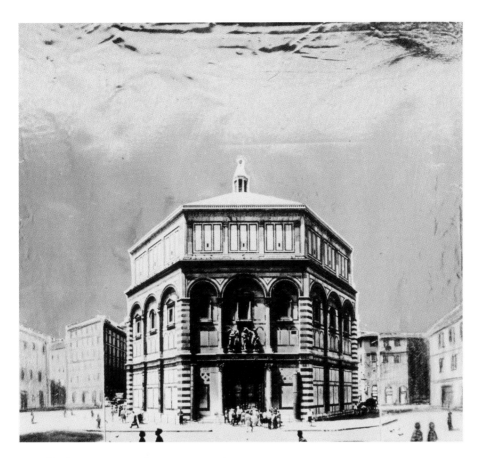

Brunelleschi, Baptistry Tavoletta, c. 1398; author's reconstruction.

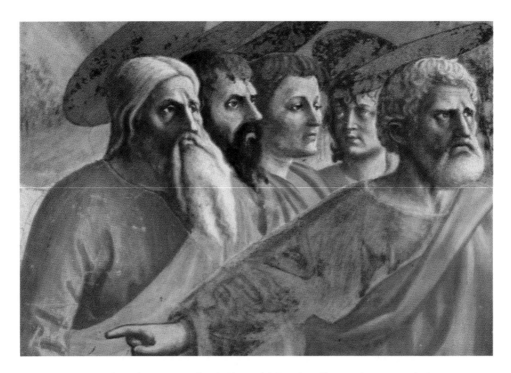

Masaccio, *The Tribute Money,* detail. Chiesa del Carmine, Florence (postrestoration).

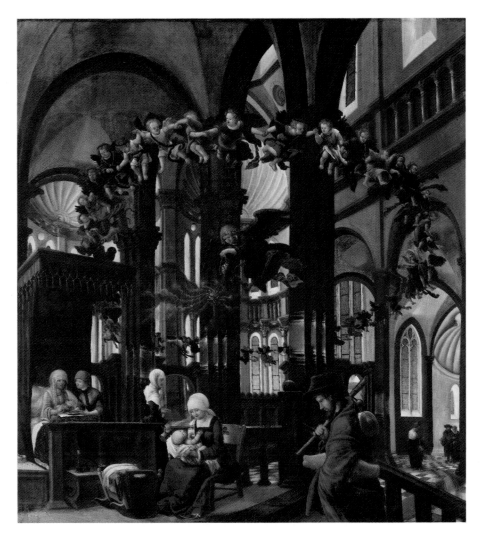

Albrecht Altdorfer, *The Birth of the Virgin*. Alte Pinakothek, Munich. Courtesy of Bayer. Staatsgemäeldesammlungen.

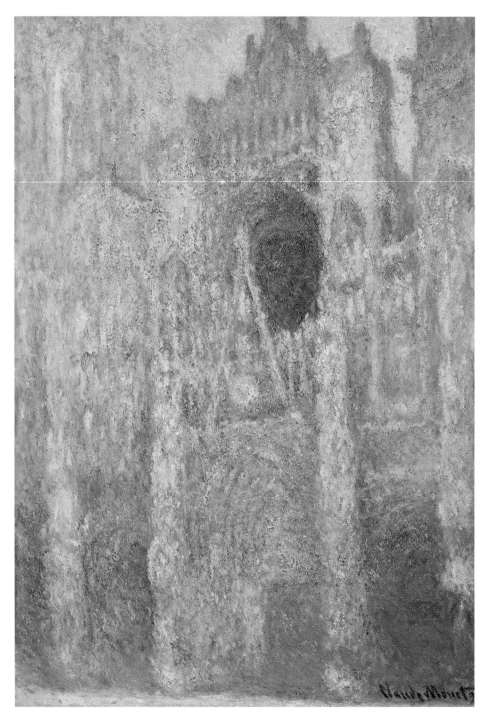

Claude Monet, *Facade of Rouen Cathedral*. Sterling and Francine Clark Institute, Williamstown, Massachusetts.

commonly met with in medieval mosaics and illuminations. To equate the religious concerns of the chancellor with those of a cloistered monk would be to ignore everything we know about the man himself and his spiritual predicament. Just as the intensely personal presence of the specific man, Nicholas Rolin, sets van Eyck's painting apart from the formulary works of medieval art, so, too, does the nature of this city view announce to us that a new stand has been taken with regard to certain religio-political issues and concerns.

This city is so vividly present to us, so concretely detailed in its realization, that it has long been thought to represent a specific European city as it looked in the 1430s. The principal candidates have been Liège, Maastricht, Prague, and Lyon. Though there is no consensus among art historians as yet, a convincing case has been made by Jean Lejeune, on the basis of exhaustive investigation of archival records, for its being van Eyck's own city of Liège. In fact, the view of the city from its Parc de la Citadelle is similar, despite its being largely obscured today by trees, to the view we see in our painting. There is not now in that park, nor have we any reason to believe that there ever was, a building of the kind van Eyck shows us, but that the artist, a former resident of Liège we suppose, should have chosen that site for the location of his *castellum* seems wholly credible.

Why Liège? Since that ecclesiastical principality was not directly under the jurisdiction of the dukes of Burgundy, it might seem at first glance that there would be little reason for alluding to it in a painting made for the duke's chancellor. Perhaps it is enough to suggest, as does Lejeune, that van Eyck probably lived in Liège prior to 1422, during which sojourn he presumably made sketches of the city, and that he may have been motivated, moreover, by the fact that he was almost certainly a native of the diocese of that city and of the county of Looz. That would be to explain the allusion as being merely a matter of personal reminiscence on the artist's part; it would not explain why Rolin, too, may have wanted such an image to be incorporated into his prayerful address, and his preferences were certainly more important than van Eyck's.

The only reason we have for supposing that van Eyck may have lived in Liège lies in the fact that his first recorded patron, for whom he worked in The Hague between 1422 and 1424, was John of Bavaria. How long he may have been in John's service we do not know, but it is entirely possible that their association dated back to the time when John was bishop-prince of Liège, from which post he resigned in 1418. The county of Looz was a fief of the bishop of Liège, and in 1390 the pope in Rome, seeking allies in the midst of the Schism, had given the bishopric and the fief to John of Bavaria, the seventeen-year-old son of the Count of Hainault-Holland. While that high-handed act was itself an affront to the dignity and independence of the city, in which the power of the thirty-two artisan guilds was especially strong, relations between the bishop and his flock became increasingly strained as it became

evident that that unordained and thoroughly unclerical princeling cared much less about the welfare of the community than about using his extensive revenues in pursuit of exceedingly worldly pleasures.

It is hardly surprising, then, that a crisis should have been reached in 1407–8, at which time the artisans, following the example that had been set in Ghent in 1382, led an uprising against the detested rule of John and took advantage of the Schism in order to install a bishop of their own choosing, with the ratification of the pope in Avignon. No doubt they would have gained control of the city if Bishop John had not been able to call upon his relatives for military aid. That was promptly provided by his brother, William of Bavaria, and, more importantly, by his brother-in-law, John the Fearless, Duke of Burgundy. Thanks to the intervention of the feudal aristocracy, the citizen militia of Liège was utterly defeated near Othée, whereafter the rebellious burghers were punished and humiliated for their indiscretion. The lesson was not well learned, however, for sixty years later the city revolted again against its overlords, only to be defeated far more disastrously and subsequently looted, burned, and all but annihilated in a repression conducted jointly by Duke Charles the Bold and King Louis XI of France.

Writing of the Burgundian situation at the time of Charles's accession, Richard Vaughan observes that "the real enemy of Duke Charles the Bold, opposing him with a bitter and consistent hatred, was urban. It was not, as the chroniclers and many modern historians would have us believe, King Louis XI of France; it was the towns."[3] Needless to say, the townsmen's hostility toward the arrogant and extravagant aristocracy, both feudal and ecclesiastical, was deep-seated and of long standing. Even before the time of Philip the Bold the city of Ghent had rebelled against its masters, and in the days of the *Chaperons Blancs* its burghers had apparently looked forward to establishing a Republic of Flanders in which the position of Ghent or Bruges would have been like that of Florence in Tuscany.

During the long reign of Philip the Good, relations between the ducal government and the towns were sometimes good, sometimes bad. In the early 1420s Philip had extended his possessions to include Holland, Zeeland, and Friesland in the north and had pursued a pro-English policy that had worked to the advantage of the Flemish towns, whose wealth derived mainly from the manufacture of cloth made from imported English wool. As a result of that policy, however, the Duke was drawn into a close collaboration with his brother-in-law, the Duke of Bedford (regent for Henry VI), in supporting the English claim to the French crown against the forces of Charles VII, whose apparently hopeless cause was being so victoriously championed by Joan of Arc.

It was the Burgundians who took Joan prisoner at Compiègne, and Nicholas Rolin himself drew up and read out the decree that turned her over to Pierre Cauchon and the English for trial and execution. Joan's popularity among the

townspeople was enormous, so that Philip's role in bringing about her down-fall hardly redounded to his credit in the streets of his cities, where the war with France had never met with favor. In the midst of the siege of Compiègne, in fact, Liège had defied the duke's authority and had sent its militia against the adjoining county of Namur, which had just passed into Philip's hands on the death of Count John III, while at the same time hostilities had broken out between Bruges and Ghent.

After Joan's martyrdom Philip found himself swept along by a wave of pop-ular emotional fervor that made it expedient for him to acknowledge the legit-imacy of Charles's coronation and to seek a reconciliation with his cousin that was later embodied in the Treaty of Arras. Though he expressed the hope that the English would take no offense, London was outraged and wreaked its resentment on Flemish merchants and Flemish shipping. In the mid-1430s the Duke of Bedford sent letters to the bishop of Liège in an effort at fomenting rebellion against Burgundy, and he sought alliances with other Flemish towns as well. In 1436 feelings in Bruges ran so high that when Philip and his retinue sought to enter the city, they were openly attacked. A few of the duke's courtiers were killed, including the Marshal Isle-Adam, and the duke found it advisable to withdraw. Later the burghers were harshly punished, the duke (or Rolin?) going so far as to stipulate that the townsmen should nominate forty of their number for execution—though it seems that in fact only a smaller num-ber were put to death. Such, however, was the tenor of relationships between the Christian Duke and his Christian burghers in the middle of what Vaughan describes as "The Critical Decade." This was, in all likelihood, the very time when Rolin engaged van Eyck to devise the city-oriented message that is set forth in our painting (which is neither signed nor dated).

Being himself a middle-class townsman, Rolin appears to have understood (better than did Philip, at least) the importance of the cities in the economy of Burgundy. The policies that were pursued during his long tenure in office were leading in the direction, it would seem, of establishing the kind of centralized administrative monarchy that was to dominate European politics in the six-teenth, seventeenth, and eighteenth centuries. At the very center of his reli-gious concern, we have reason to suppose, was his vision of a certain kind of reconciliation between the Baptistry and the Town Hall—between the seat of ultimate and ultimately monarchical authority, on the one hand, and the lives of busy men in the urban marketplace, on the other. How understandable it is, therefore, that he should have assented with enthusiasm to suggestion that a radiantly idealized image of Liège, peaceful, prosperous, and secure by virtue of its submission to God's will and to his appointed vicars on earth, should be included as an essential element both of his prayer to the Virgin and of his address to the duchy's townspeople. Perhaps an image of any other city would have done as well, or perhaps what we see here is a composite of elements

drawn from various sources, but it is not improbable that van Eyck was inspired to choose Liège not only by his personal ties with Looz but also by his knowledge of the history of defiant resistance that had set that city at odds with its ducal, episcopal, imperial, and papal overseers.

Being fully aware of the hortative nature and purpose of the picture, and of its relation to the matter of seeing things from a certain standpoint, van Eyck chose, with astonishing subtlety, to place at the ramparts of his hilltop castle two burghers, one of whom (the man in the red turban) is almost certainly the artist himself. While the anonymous man to our left leans into the crenel and gazes at the incomparably beautiful scene spread out below him, seeing it all from the viewpoint of the duke's chancellor, the other man is shown (like the chancellor) in profile, looking neither at the town nor at the palace but serving as a thoughtful intermediary, so to speak, between the two. Though it is important for both an artist and a governor to have the breadth of vision and the concern for the particularities of modern existence that are manifested by the little man on the left, what matters in the long run is one's capacity for reflective contemplation, one's personal identity, one's inwardness, even as those traits are exemplified in the chancellor himself—and in Jan van Eyck.

Van Eyck invites us to take our stand within the circle of these battlements, and therewith within the circle of a certain religious and political "theology," and to see for ourselves what the results of our assuming that standpoint might be. They have to do with the most intimately personal aspects of sin and forgiveness, with self-awareness and world-awareness, with aristocracy and equalitarianism, with ancient traditions and restless modernity, with the grievous limitations of temporal existence and with an eternal blessedness that yet finds its reflection in the lives and affairs of men.

# Perspectives on the Last Supper

In order to make it perfectly clear why so little is gained by raising the discussion of perspective to the level of the abstract idea of "Renaissance space" or by reducing it to mechanical matters of technique and of vanishing points, and in order to be aware of the importance of the specificities of a given subject and a given commission, let us deal with a small number of images that are devoted to a single theme but conceived from different points of view. Because of the central significance of the subject, and because it is invariably represented within an architectural context, the Last Supper lends itself especially well to our purposes.

Interestingly enough, no major image of the Last Supper has come down to us from the time of Masaccio and van Eyck. There was something about the theme, apparently, that made it unappealing to those artists and patrons caught up in the first wave of enthusiasm for the *ars nova,* as Panofsky calls it. In this respect they were like the men who made and bought the manuscript and panel paintings of the earlier International Style; they, too, were not drawn to or challenged by the problem of representing the subject. In the *Très riches heures,* for instance, we find nearly a dozen Passion scenes, but *la Cène* is not among them. In the light of what has been discussed in the preceding chapters, we can perhaps understand why this should have been the case.

Of all the events in the Passion, only the Last Supper has been endowed with a liturgical or sacramental significance that necessitates its being understood within the framework of both temporal and eternal time. The flagellation could be looked upon as a familiar kind of sociohistorical event, and the Resurrection as a visionary and transcendent one that was not witnessed by

mortal eyes, but the Last Supper was both a historical event, taking place in the upstairs room of a certain man's house in Jerusalem, and a sacramental one, the first celebration, in effect, of the Eucharist. It occurred at one place and at one time, yet the Roman Church has always held that it was physically charged with a soul-saving power that is reproduced thousands of times every day in the celebration of the Mass, which subsumes, symbolizes, and actualizes within itself the theory and means of Christian salvation as they were universally understood in the fifteenth century.

Like other artists of his generation, Alberti knew that the new perspective was closely bound up with a concern for storytelling—with the illustration of *istorie* of a kind with which the Bible and the Golden Legend are filled to overflowing. But nothing Alberti says in *Della Pittura* would prepare an artist for wrestling with the theological and emotional considerations that are raised so uniquely by the Last Supper. It is relatively easy to accommodate the story of St. Peter healing with his shadow (Acts 5:15) to the familiar conditions of direct optical perception, but it is not at all easy to achieve an equally direct visual apprehension of the significance that the Last Supper possesses for a devout viewer, who must perforce be put in the position of being a disengaged spectator or onlooker. An artist as naive as Sassetta (see figure 32) may have had no qualms in the mid-1420s about squeezing the scene into a nine-inch-high predella panel, but then Sassetta was content to work within the tradition

FIGURE 32. Sassetta, *The Last Supper.* Pinacoteca, Siena.
PHOTO COURTESY OF ALINARI/ART RESOURCE, NEW YORK.

he had received from the trecento; it seems never to have crossed his mind that composing a painting might have required him to *take his stand* with regard to the significance of some theme or idea or body of thought as it bore upon his own, or any man's, personal existence. Though he was perhaps responding to the new ideas about seeing when he shifted Jesus from the end of the table to the center, where he confronts us as we confront the image, Sassetta's interpretation of the story was as uncharged as Giotto's had been, for even Giotto had not been able to infuse that quasi-liturgical subject with the kind of narrational intensity that distinguishes most of his Paduan frescoes. It is the most inert of all his compositions.

I

The first artist to understand the necessity of defining a consistent perspectival standpoint in terms of which to interpret the Last Supper was, so far as we now know, Andrea del Castagno. In the mid-1440s he was commissioned by the nuns of the Convent of Sant' Apollonia to adorn the north wall of their long refectory with the fresco that is now his most celebrated work (see figure 33)—though as Frederick Hartt has observed, it was not well known during the Renaissance, since the convent was closed to the public. The artist was about thirty years old when he finished the painting.

All of us are accustomed today to supposing that an artist's style is an expression of his personality, of something that is uniquely characteristic of his own mental and emotional makeup. If there is any truth at all to Vasari's characterization of Castagno as a violent and irascible man, then it may seem surprising that his *Last Supper* should be so remarkably restrained, so conspicuously inexpressive in nature. But we may be reasonably sure that the artist was not trying to express his own attitude toward the subject (if he even had one); the painting was not made for him but for a group of Camaldolite nuns. It was thus *their* standpoint that had to be taken into account, and theirs would have been very different from that of the worldly businessmen who were typically the patrons of Florentine artists in the quattrocento.

Among the revisions of the Benedictine *regula,* that of the Camaldolites was especially severe. The order had been founded in the eleventh century by San Romualdo, who is reputed to have subjected himself to so austere a regimen that for fifteen years he ate only twice a week and then had only a handful of chickpeas. Fasting, therefore, was an important aspect of the Camaldolite discipline; both monks and nuns were expected to abstain from food at least three days a week. Members undertook to observe a vow of silence and to devote themselves entirely to meditation, prayer, and psalmody. The ideal that had been defined in the earliest constitutions of the order called for a unique merging of the anchoritic and cenobitic strains of Christian monasticism: the new

member was received at first into a communal monastery, but as he progressed in self-discipline he could look forward to moving into a separate hermitage, where he might bring to the peak of perfection his practice of mortification, self-denial, and single-minded devotion. Though separate hermitages were probably not a feature of conventual practice at Sant' Apollonia, the regimen was undoubtedly ascetic to an extraordinary degree.

Rightly enough, Pierre Francastel has stressed the relationship between the development of Renaissance perspective and that of the drama—that is to say, of both those developments to the basic metaphor of the-world-as-a-stage and of man-as-an-actor. Such notions are plainly relevant to our understanding of many works of Renaissance art. But should an artist make a narrative illustration for a group of women who had explicitly renounced all such ideas in order to embrace a religious life that wholly excluded the very possibility of dramatic role-playing? Although we cannot trace the origins of San Romuoldo's spirituality, his outlook was based, it would seem, upon a Levantine mode of thinking that is decidedly remote from the one that focal perspective was intended to sustain. Speaking of another but not unrelated Eastern tradition, Lawrence Brown has observed:

> It has always been difficult for Westerners to comprehend the core of Indian religiousness, ancient or modern. The perishable "I" of modern materialism . . . assumes that all consciousness rests upon the relation between a personality—a discrete, utterly separate individuality of some kind—and all the rest of the universe. This is so evident to us that it appears to require neither thought nor specific language capable of differentiating such an understanding of self and reality from any other point of view. The intense personal focus in which Westerners have always lived makes it difficult for us to sense the pluralized personality of the Levant, the "we" of the community of the faithful, and almost impossible to grasp the "anti-I," the "de-selfing"—naturally no word in a Western tongue exists for a thought almost incomprehensible to the Western mind—of our far-off kinsmen of India. That salvation should lie in the riddance of self seems absurd since to us nothing would be left to be saved. But such was—and to some extent still is—the basic meaning of Indian religiousness. The separateness of self, the separate existence of anything, is then felt to be the deep cause of change; and all change, soon or late, means decay and death and the end of separateness.[1]

It seems fair to say that the nuns of Sant' Apollonia had undertaken to achieve a "de-selfing," to efface their individualities in favor of a communal "we-ness," within a tradition or an ethical frame of reference that is not identical with that of the Indians Brown refers to but that has much in common with it. They had chosen to disengage themselves insofar as possible from the *historical* world—i.e.,

---

FIGURE 33. Andrea del Castagno, *The Last Supper.* Convent of Sant' Apollonia, Florence. PHOTO COURTESY OF ALINARI/ART RESOURCE, NEW YORK.

from the world of process, of change, of dramatic interaction among persons-as-characters, the world of history that is unknown to animals but that, according to the traditions of biblical thought, men had been plunged into by the Fall. How, then, should a lower-middle-class shopkeeper and perhaps angry young man named Castagno, caught up as he plainly was in the exciting ideas and potentialities of the *ars nova,* interpret the Last Supper for patrons who were so unlike himself, so unlike role-playing characters such as Pippo Spano, whom he knew so well how to represent?

First of all, he had to choose a moment in, or an aspect of, the story of the Last Supper. That story falls, of course, into two more or less separate parts, the one having to do with the identification of Judas as the betrayer, the other, with the institution of the sacrament of the Eucharist. In the gospels of Matthew and Mark the identification comes first, the institution second; in the gospel of Luke the order is reversed, while John says that the identification took place after the supper was finished. He does not deal with the institution of the sacrament. That identification is an historical and dramatic event, preceded by Judas's secret agreement with the high priests and followed by his kiss of betrayal and his suicide by hanging. As with *Othello* and *Macbeth,* it involves a vivid contrast between good and evil—the active willing of evil, it would seem, in order to bring about the destruction of goodness. The institution of the sacrament, on the other hand, is a symbolic act that was not led up to by what had happened previously, nor did it affect the course of events that unfolded during the rest of the week.

In most paintings of the Last Supper it is possible for the viewer to specify the moment the artist has chosen to illustrate. Efforts have been made at identifying Castagno's choice. G. M. Richter avers, for instance, that it is the moment when Jesus says "One of you shall betray me" and believes that the disciples are shown to be reacting to that announcement. That is, of course, a common interpretation of Leonardo's choice of moment, but there is no evidence at all for interpreting Castagno's image in the same way: the disciples are not "reacting" at all. Frederick Hartt sees it as the moment when Judas has been given the identifying sop (at which point, according to John, Satan entered into Judas) while Jesus is blessing the rest of the bread that will then be given to the other disciples—an interpretation that Hartt attributes to the fourteenth-century Carthusian monk Ludolph of Saxony, with whose writings Castagno is presumed to have been familiar. However, the interpretation does not scan, either in relation to John's text or to Castagno's painting. John prefaces his account of the giving of the sop with the words, "The supper being ended," wherefore we must suppose that Judas had shared in the breaking of the bread and the drinking of the wine, even as did the other eleven. Luke's text supports the same supposition. Moreover, the giving of the sop was accompanied by the words, "Do quickly what you have to do. . . . As soon as

Judas received the bread, he went out. It was night" (John 13:27–30). Judas is unquestionably holding a morsel of bread, but the possibility of his making an immediate and dramatic departure is ruled out, partly by the static and non-dramatic nature of the composition, partly by the fact that there is no exit. Judas could no more leave the room than could the nuns leave the convent in which they were destined to spend the rest of their mortal lives. They were even more narrowly enframed by an architectural pattern than are the thirteen men we see in this, the most architectonic of Last Supper paintings, which closely corresponds to the nuns' own situation as they sat behind long tables on either side of the refectory (tables that were elevated on a low pedestal like the one we see in the picture) and listened in silence, we presume, to readings from sacred texts during their infrequent meals. The disciples are shown to be as silent as the nuns: every mouth is closed.

What the painting amounts to, then, is a mystical meditation on the Eucharist and on Christ's Passion (for the Last Supper must be seen in conjunction with the Crucifixion, Entombment, and Resurrection that are represented on the upper part of the same wall); it is not a narrative illustration at all. Taking account of the old-fashioned orientation of the nuns, Castagno seems to have looked back deliberately to medieval, preperspectival models for his composition. The one that most readily comes to mind is *The Last Supper* that runs across the bottom of Taddeo Gaddi's fresco *The Tree of Life* in the refectory of Sta. Croce in Florence (see figure 34). That, too, is a subject for mystical meditation, the five scenes in the upper part of the fresco being unrelated to any historical sequence or unified cast of characters. Although each of the upper scenes is set within a reasonably convincing stage-space, the Last Supper itself is not, being rendered in such a way that the figures seem to be in front of, rather than behind, the painted enframement. Taddeo may have wanted to suggest that the participants in the *ultima cena* were in front of the wall, thereby occupying the same space as did the Franciscan monks who regularly ate their meals in the room, or he may have wanted to give the scene the appearance of a shallow relief, a not uncommon subject for lintel reliefs over the doorways of medieval churches. A practice that is to be found in some of the earlier manuscript paintings, but not in the doorway reliefs or the San Marco mosaic, is that of placing Judas on the wrong side of the table, all by himself.

In Taddeo Gaddi's fresco, as in Ghirlandaio's two adaptations of the same design, Judas, while being located on the opposite side of the table, is to Christ's left—a position any Italian would have recognized (and would recognize today) as being the unfavorable location. Castagno, like Leonardo, places him to Christ's right, in recognition of the fact that Christian salvation extends to him as well as to all other sinners—among whom, we must suppose, are the nuns of Sant' Apollonia. It is as if the long table were an altar, behind which are seated the presbyters of the church, while we and the nuns constitute the

lay congregation prepared to receive the saving sacrament. Surely the configu-
ration provided spiritual comfort to generations of nuns as they meditated
upon the meaning of the fresco.

Although Castagno chose to give his composition the *retardataire* appear-
ance of a medieval relief or manuscript painting, his pride and self-esteem pre-
vented him from abandoning the new perspectival usages in favor of an actual
medieval mode of rendering. And so we find him devising what was perhaps
the most remarkable application of one-point perspective that is to be found in
the whole body of Renaissance art.

Although there are inconsistencies in the design, there can be no mistak-
ing the fact that what appears to us to be a wide and very shallow stage was
conceived by Castagno as a deep room, almost as deep as it is wide. It is at
this point that we run into ambiguities. Hartt raises (but does not answer) the
question of whether the simulated marble panels on the left wall of the room
should be read as squares, like the ones on the back wall, or as vertical rec-
tangles. The evidence to be found in the ceiling tiles is also unclear, as he
observes, but then he goes on to say that we are not "permitted to unravel

FIGURE 34. Taddeo Gaddi, *The Tree of the Cross and the Last Supper.* Museo dell'Opera di
Santa Croce, Florence.
PHOTO COURTESY OF ALINARI/ART RESOURCE, NEW YORK.

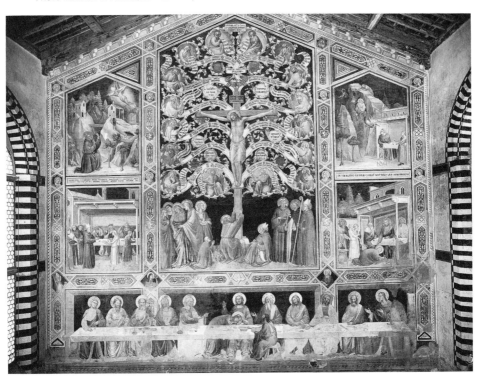

the flickering pattern of the floor lozenges."[2] This, however, is not the case (see figure 35). If we look very closely, especially under the feet of Matthew, we can see beyond a doubt that the floor is ten white squares deep (or nine black squares plus two half squares), while across the front of the painting one can discern ten black squares (or nine white squares plus two half squares). In other words, the space that is enframed by the low pedestal that runs around three sides of the room is perfectly square. Since there is no pedestal across the front of the room, however, the floor of the room as a whole forms a rectangle measuring twenty-five-and-a-half feet across the front (between the pilasters) and twenty-one-and-a-half feet in depth. On the other hand, if one interprets the marble panels on the left as squares, then the room itself is perfectly square. But if one goes by the number of guilloches, it is only half as deep as it is wide. Yet if one takes the presumably square ceiling tiles as one's standard of measure, then the room is slightly deeper than it is wide, for they number fourteen across but sixteen in depth. A modern critic, using the jargon of the twentieth century, might say that Castagno is "playing games with our perceptions," giving us a number of bits of evidence, each of which looks as if it were conclusive, though the various bits are not reconcilable with one another. Perhaps this was the artist's way of saying that it is in the very nature of the subject that no one can put the Last Supper, as revelatory and pivotal event, within a wholly rational and measurable frame of reference.

The clearest of those bits of evidence is also the hardest to read: to wit, the pattern of the floor tiles. If we draw the plan of the room on the basis of that indubitably square area, at the edge of which Judas is shown to be sitting, then we can project the lines of sight through the picture plane and locate the observer's vantage point with some precision. It turns out that Castagno's hypothetical viewer is standing about one hundred and thirty-five feet away

FIGURE 35. Diagram of floor pattern in Castagno's *The Last Supper.*

from the painting—though if we assume that the room is square, as the lateral panels would indicate, then the viewer's position lies about one hundred and fifty feet from the frescoed wall. However, neither of these vantage points can be occupied, for the refectory itself is only about ninety-three feet long.

It is commonly said that the *costruzione legittima* was used to "create space." Castagno was probably the first artist to perceive that it can also be used to produce an effect of spatial compression—that is, to eliminate or to drastically reduce an appearance of depth. (We cannot be sure of his precedence, for his sometime colleague Domenico Veneziano made a similar use of perspective, as we have seen, in his *St. Lucy Altarpiece* at about the same time that Castagno was painting his Last Supper.) The effect of compression is of the kind we commonly encounter today in photographs that have been made with a long telescopic lens, though of course the effect is apparent to the unaided eye as anyone can see who will attend closely to how things look when they are seen at a considerable distance. The same device was used some twenty or thirty years later by Mantegna in his painting *The Dead Christ* (see figure 36) in order to give the body the big-headed, barrel-chested, long-armed and short-legged appearance of a dwarf—that is, to

F I G U R E 36. Andrea Mantegna, *The Dead Christ*. Pinacoteca, Milan.
PHOTO COURTESY OF ALINARI/ART RESOURCE, NEW YORK.

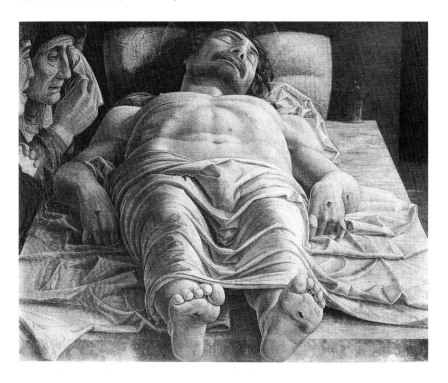

make it appear that Christ has been disfigured by death. Precisely the same effect can be produced by photographing a distant reclining figure with a 600-mm lens.

We can easily understand Mantegna's use of compressive perspective, but what was Castagno's purpose? One might argue, as Manetti would have done, that since this Last Supper was habitually observed by nuns who were seated along the side walls of the refectory an effect of optical distortion would have been introduced if the painting had involved a strong effect of central convergence and of spatial depth. Because the orthogonals are very short, the location of the vanishing point is not readily determinable; in fact, there is no single vanishing point but only a loosely defined area of convergence that lies between the bottom and top edges of the table on the central axis of the picture—i.e., beneath the figure of St. John. But if Manetti's notion (which he attributes, if only by implication, to Brunelleschi) was dismissed by Leonardo and many other major Italian painters, we may be reasonably certain that Castagno was motivated by no such consideration.

It seems probable that he chose his impossibly distant vantage point in order to achieve a sense of psychological disengagement that is related to the self-evident disengagement of the disciples from one another and of the silent and both self-absorbed and self-denying nuns from one another. Matthew and Philip appear to be communicating with one another by means of minimal gestures, while Andrew and Bartholomew may possibly be exchanging glances, but the majority of the figures seem to be rapt in earnest, silent meditation, immured within their own minds and thoughts as were the nuns themselves as they strove to concentrate upon mystical meanings and to put out of their minds all thought of the lives they had once led in the outside world and all expectations of the kind all of us normally have as to what the future may bring in the course of ongoing historical time. What Castagno was concerned to accomplish, it would appear, was the suppression not only of space but of time—the kind of time within which persons play roles, develop traits of character, bear children, pass on traditions, and pursue personal goals. This is the kind of existence the nuns had forsworn in taking their Camaldolite vows. For the rest of their lives, one day would be like another. Nothing was ever going to happen, except that they would die.

Just as Castagno could not lay aside his commitment to a modern conception of perspectival painting, neither could he ignore entirely, as did the Venetian mosaicist, the deeply emotional implications of the story of the Last Supper. But instead of conveying the disciples' emotional responses by means of facial expression and dramatic gesture, he projected them into the "abstract expressionist" color patterns in the simulated marble squares. Each pattern is subtly related to the poses and gazes of the men below it, but the configuration above the heads of Jesus, Peter, and Judas is by far the most turbulent—for of

course these three men were the only ones who were to play specific and emotionally charged roles in the course of the events that unfolded in Jerusalem that night.

Yet even their emotional perturbation is somehow external, part of a larger design predestined from the beginning of time. Castagno seems to have argued, perhaps for the nuns' sake, that people only appear to be driven by passionate emotion, only look as if they are freely making decisions in moments of dramatic conflict, whereas in fact their lives are shaped by an all-governing pattern, and if there seem to be ambiguities and irrational discrepancies in that pattern, it is only because now we see through a glass darkly.

## II

Everyone knows, of course, that Northern European painters were backward about adopting the *costruzione legittima,* continuing to use a loosely organized vanishing-area perspective for many years after the publication of *Della Pittura* (though for that matter many Italian painters clung to the old usages, too). Characteristically, Panofsky tries to explain the differences between the northern and southern preferences in terms of what he took to have been the prevailing philosophies of Italy and the North, associating the *costruzione* with the Platonic idealism of Marsilio Ficino and the unsystematic perspective of Flemish painters with a late-medieval nominalism that encouraged a "sense of intimacy" presumably incompatible with the intellectuality of Tuscan painting. As a matter of fact, however, all Renaissance art seems highly particularistic when compared with the idealist imagery of Periclean Greece. On the other hand, it does not seem in the least inappropriate that the camera, which produces the most particularistic images of all, should automatically make pictures in the strictest vanishing-point perspective. There is no inherent incompatibility between meticulous observation of the visible phenomena in the world around us and meticulous attentiveness to the phenomenon of vision itself.

We do better, I would say, to bring the discussion down from such philosophical heights and to consider closely what was distinctive about the artists, the typical subject matter, and the patronage occasions of those two principal regions of activity in the fifteenth century. The most conspicuous single factor that distinguishes Italian from Northern art is the importance of the art of architecture. Every student who completes an introductory survey course in art history should be familiar with the names of Brunelleschi, Alberti, Michelozzo, Sangallo, and Bramante, but rare is the experienced professor who can identify a single Flemish architect by name or can cite more than a tiny handful of specific fifteenth-century buildings. Just why the status of the architect-as-artist should have been so much higher in Italy is hard to say. It was not simply a matter of Roman heritage, for Roman architects were not accorded a measure

of fame remotely comparable to that accorded poets. (Who would ever have heard of Vitruvius if he had not written a book?) Nor was it because of the greater importance of the art of building in Italy, for in the twelfth and thirteenth centuries Northern architects had plainly taken the lead in inventing novel and ingenious ways of erecting enormous structures.

The crucial factor, in all likelihood, resides in a different set of attitudes toward the law-giving function of institutions. As Leonardo Olschki observes,

> In the first centuries of her formation Italy became a country of lawyers and notaries, of officials and judges, not of theologians and warriors, or of scholars and artists. This characteristic cultural phenomenon was not merely a Roman heritage but resulted also from the particular structure of early Italian society, with its inextricable entanglement of legal claims, acquired rights, judiciary customs, juridical competencies, and diversified concepts of law. The papacy was the true laboratory of a new empirical and pragmatic jurisprudence based on Roman traditions and a training in grammar and rhetoric. . . . As a mundane institution the Roman Church was protected by its awe-inspiring sacerdotal power and by the deference in which legal rights were generally held. Even the forgeries perpetrated by its jurists show the great respect of medieval society for the forms of legality.[3]

This is not at all to say that Italians were typically more law-abiding than other Europeans, for they were not. It may well have been that the Italians' proclivity toward factional violence was the very factor that made it so important that the presence of stabilizing and regulating institutions should have been symbolized by enormously durable stone edifices, the formal ordering of which was a matter of high concern to the members of just those classes that produced the lawyers, notaries, and judges.

It was from those classes that the inventors of the "lawful construction" came. However obscure the detailed facts of the matter may be, no one doubts that the prime movers behind the development of Tuscan perspective were two architects, Brunelleschi and Alberti, the latter of whom had studied law at the University of Bologna and had served as a secretary in the papal chancery in Rome, while Brunelleschi was the son of a prominent notary in Florence. Every major Tuscan painter was called upon at one time or another to adorn the walls of an old Gothic building (hardly ever a modern one) with frescoed images that bore more or less directly upon conceptions of right governance within the community of believers and that stressed the reverence for precedent and tradition.

Though little survives of that art, we know that medieval churches in the North had commonly been decorated with wall paintings. By the beginning of the fifteenth century, painting in the North had liberated itself, so to speak, from the constraints of an institutional and architectural frame of reference, while Italian painting, which was in this respect by far the more conservative of the two, preserved its physical and spiritual dependency upon architecture

well into the sixteenth century. The ingenuity and diversity of van Eyck's per-spectival renderings of architecture (ranging from the almost Brunelleschian formality of the Dresden Triptych to the Bruegelian skepticism that may well underlie the Antwerp *St. Barbara*) go far beyond anything that is to be found in the whole corpus of Italian painting from the first half of the quattrocento.

A still greater variety is to be found in the work of the man who was surely the most perspicacious and inventive of fifteenth-century perspectivists, Jean Fou-quet. Though he is known to have lived in Rome for at least a year or two in the mid-1440s (at the very time, that is, when the possibilities of Albertian perspec-tive were being explored by Italian artists, many of whose works he obviously knew) and though he made prolific use of architectural settings with converging orthogonals, Fouquet never employed a one-point, systematic perspective. He seems to have been as much concerned with the theory of perspective as was any Italian—witness his introduction into several of his later works of those "optical curvatures" that have so beguiled generations of later theorists (such as Guido Hauck and Panofsky) but which, as Gioseffi and Pirenne have made clear, are derived from an attractive but specious argument and simply do not correspond to the observable data of our visual experience. It is typically North-ern, however, that Fouquet's theoretical speculations had to do with the grasp of the comprehending eye rather than with the structural and quasi-mathematical regularities that were uppermost in Italian thinking at the time.

In his painting *St. Veranus Curing the Insane* (from the *Heures d'Etienne Chevalier,* c. 1452), wherein the miracle is shown to occur in the north aisle of the Cathedral of Paris, Fouquet produced what is surely the most astonishing architectural interior of his era (except for van Eyck's *Madonna in the Church*), anticipating the inventions of later artists such as Saenredam and de Witte (see figure 37). It is interesting to reflect upon the fact that the miniature was made not long after Fra Angelico's Vatican fresco *St. Lawrence Distributing Alms to the Poor* (see figure 38). Fouquet knew works by Angelico, and it is possible that the cycle in the chapel of Nicholas V was begun while Fouquet was still in Rome. Angelico, too, seems to have had in mind the interior of a specific local church, that of the old Church of St. Peter. However, his figures do not occupy that interior but rather are rendered so as to form a shallow frieze in front of the architecture. The image is iconic and symmetrical, its central figure flanked on either side by four adults and two children. The fresco is as totally regulated by architecture as was Fra Angelico's own life by the rule of the Dominican Order. Fouquet's figures, by contrast, are all but engulfed within a vast interior whose overall shape and dimensions we cannot even begin to grasp.

And so we should not be in the least surprised to discover that Fouquet's interpretation of the Last Supper is marked by the most radical departure from convention that is to be found in any fifteenth-century version of the subject

(see figure 39). While it is likely that the artist had seen Pietro Lorenzetti's fresco at Assisi (see figure 40), where the disciples are similarly seated on two-man benches around a circular (or polygonal) table and where there is also a blazing fire at one side, the sense of Fouquet's painting is quite different. Despite the novelty of Pietro's star-studded night sky and his adjoining kitchen scene, he preserved the liturgical stateliness of his Byzantine models, even going so far as to retain their "inverted perspective," making the figures on the far side of the table substantially larger than those in the immediate fore-ground. The shape of his figure group corresponds to that of the architectural setting as clearly as does Castagno's, and Judas is plainly identified as the ugly man without a halo. Though Fouquet's Christ is a very large man and is seated at the center of the far side of the table, the resemblance to Lorenzetti's version goes no further than that.

Insofar as its relation to architecture is concerned, Fouquet has shown the Last Supper to be what it is described by the evangelists as having been: an inti-mate gathering of companions for the celebration of the Feast of the Passover in a domestic interior that had not been designed specifically for that purpose at all. The room is large, but since we see only part of the floor and a portion of two walls, we do not know how large it may be. The wall surfaces are broken by the large fireplace, an open window surmounted by a glazed window, two small dark arches, a small illuminated doorway through which two men appear to be

FIGURE 37. Jean Fouquet, *St. Veranus Curing the Insane,* from the *Heures d'Etienne Chevalier.*

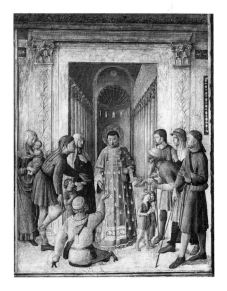

FIGURE 38. Fra Angelico, *St. Lawrence Distributing Alms to the Poor.* Chapel of Nicholas V, Vatican. PHOTO COURTESY OF ALINARI/ART RESOURCE, NEW YORK.

FIGURE 39. Jean Fouqeut, *The Last Supper,* from the *Heures d'Etienne Chevalier.* Musée Condé, Chantilly.

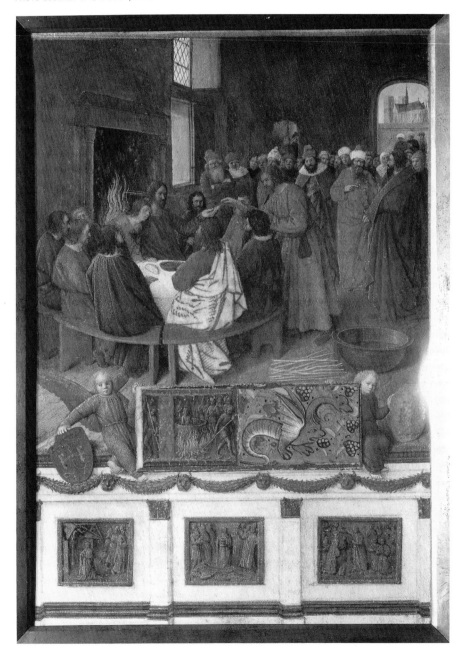

entering from an adjoining room, and a large doorway toward which three men are shown to be approaching from the street. Beyond them we see a wall and a distant view of the Cathedral of Paris. Within this room Fouquet has placed the table in the same informal and unstudied way in which he has distributed the wall openings, and he has made it so small that he has not been able to squeeze in all eleven of the disciples we would expect to find at the table with Jesus. We can see only nine, with possibly a glimpse of a tenth.

Fouquet has chosen to concentrate our attention entirely upon the identification and dismissal of Judas; no reference is made to the Eucharistic aspect of the occasion. Indeed, one might argue that this is the most explicitly sociohistorical version ever painted. Fouquet's oddest and most original aberration from convention consists in his introduction of twenty-five spectators who have come in from the street and completely fill the far side of the room. They are handsomely dressed, several of them wearing priestly or official headgear; plainly they are the worldly adversaries of Jesus who have given Judas the moneybag he so conspicuously wears at his side. Judas himself is dressed in cloth-of-gold from head to foot. When he has taken the sop and turns to depart, he will have to join their company and make his way out through the doorway and onto the streets of Paris.

FIGURE 40. Pietro Lorenzetti, *The Last Supper.* Lower church of San Francesco at Assisi. PHOTO COURTESY OF ALINARI/ART RESOURCE, NEW YORK.

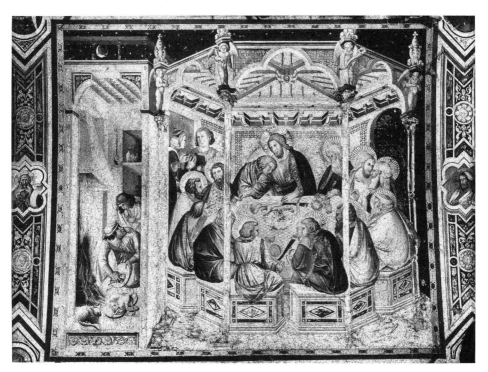

And where have those high-ranking spectators come from? Obviously from the Temple—that is to say, from the Church of Notre Dame. What we see in this tiny half-inch-high image of the church is a view of the chevet, the part of the building in which the resplendent Bishop of Paris, attended by his sumptuously dressed assistants, regularly celebrated that *other* kind of Lord's Supper that was so utterly unlike its biblical archetype, as Fouquet conceived it to have been.

We cannot be sure, of course, that this was the implication Fouquet had in mind. However, the same view of the east end of the cathedral, drawn to a larger scale, appears in the background of the miniature *The Lamentation*, which event is also shown to take place before the city of Paris (see figure 41). In this case the implications of Fouquet's composition may be even more subtle. We may easily associate the figures of Joseph of Arimathea and Mary Magdalene with the twin western towers of the cathedral (that is to say, with the end of the building that is specifically associated with the laity) and those of the disgruntled high priest and Pharisee with the chevet (or with the clerical end of the church). The latter pair are being addressed by Nicodemus, the same man who had earlier defended Jesus before the chief priests and the Pharisees (John 7:45–50), a role that was greatly enlarged upon in the apocryphal gospel of Nicodemus. What he holds in his right hand is not the hundredweight of myrrh and aloes that he is reported to have brought for the burial of Jesus, but a crystal vial of pure water—plainly a reference to what Jesus had told him when they had first met by night: "Except a man be born of water and of the Spirit, he cannot enter into the kingdom of God" (John 3:5).[4]

FIGURE 41. Jean Fouquet, The Lamentation, from the *Heures d'Etienne Chevalier.* Musée Condé, Chantilly.
PHOTO COURTESY OF GIRAUDON, PARIS.

In the immediate foreground of *The Lamentation* we see a sarcophagus flanked by angels displaying the instruments of the Passion, prominent among which are the nails and the crown of thorns (both shown within a placard that contains a large letter "S"), thus featured because they were among the relics that had been brought to Paris by St. Louis and were preserved in that most beautiful of reliquary chests, the Ste. Chapelle. On the lid of the coffin, directly beneath the three nails, we see laid out the thirty pieces of silver (here rendered as gold), neatly arranged in three rows of ten each. The money had come, of course, from the high priests of the Temple. Fouquet may conceivably have meant to associate the coins with the richly endowed clergy of Notre Dame, but in addition he may have intended the coins to serve as an admonition to his patron, Etienne Chevalier, who had only recently been appointed *trésorier* of the Kingdom of France. Like the disemboweled figure of Judas that Giotto put just at the entrance to hell in his fresco *The Last Judgment* in the Arena Chapel, the thirty coins may have been meant to serve as a warning to those who betray their commitment to Christ for the sake of money, whence Fouquet's emphasis upon Judas's golden costume, his bag of gold, and his association with rich and powerful men in *The Last Supper.* The painter's concern for ethical integrity stands in sharpest contrast to the Limbourg Brothers' lack of just that concern—for Fouquet was a great perspectivist, and they were not.

A matter that has been discussed by several writers since the turn of the century is the relation of Fouquet's compositions to the religious theater of his day. The connection has been heavily stressed by Claude Schaefer in the introduction and commentaries he has provided for the *Hours of Etienne Chevalier* (New York: Braziller, 1971). With regard to the Last Supper miniature he states that "The religious theatre has once again inspired Fouquet in his interpretation of a scene for this Book of Hours; in fact, the apostles are seated in the exact arrangement prescribed by Arnoult Gréban in the *Mystery of the Passion*." We encounter here a manifestation of the all-too-common tendency among art historians to think of the artist as an illustrator of other men's ideas or as playing a role that is essentially secondary to that of the writer. That was Emile Mâle's assumption when he first wrote about the relation of art to theater in the first edition of his *L'Art religieux de la fin du Moyen Age en France* (1912). In the course of the next ten years, as he confesses in the preface to the second edition, he was compelled to reassess the whole matter, for by 1922 he had discovered that many of the configurations he had thought to be derived from the theater were to be found in works of art that antedated the emergence of the religious theater he had had in mind. Indeed, one might argue that many of the mystery plays could better be described as "talking pictures" than as dramatic performances, for they involve very little action and a great deal of wordy recitation. The typical Renaissance passion play consisted of a succession of

*tableaux* and in some instances plays were presented strictly as *tableaux vivants* with neither words nor action. Since we know virtually nothing about the visual appearance of the religious presentations of the thirteenth and four-teenth centuries, we cannot say to what extent the typical *mise en scène* was derived from the visual imagery that was then current, but there is abundant reason for believing, as George Kernodle has demonstrated, that the theater owed much more to painting than did painting to the theater. Fouquet's enframement of *The Last Supper,* for instance, clearly anticipates the invention of the proscenium arch by about two hundred years.

Because Fouquet's paintings deal with scenes from the Bible and the Golden Legend, writers such as Mâle, Molinari, and Schaefer have taken for granted, it would seem, that the theater to which those paintings were related could only have been that of the mystery and passion plays that dealt with the same body of subject matter. Yet it was during the very years of Fouquet's activity—i.e., during the reigns of Charles VII and Louis XI—that there was brought to the stage a new kind of play altogether, the moralities and the farces, some of which were addressed explicitly to social and political issues of the day. In the farce *Mestier et Marchandise,* for example, the anonymous author deals with specific aspects of the political situation in France in the year 1440. There are four characters: Mestier, who voices the complaints of the artisans; Berger, who represents the rural population; Le Temps, who appears on stage in order to defend himself against the various charges that have been made concerning the wretched nature of "the times" and who offers to change himself in various ways, none of which proves at all satisfactory; and Les Gens, a ridiculous character who wears a face mask on the back of his head, always walks backwards, and speaks only gibberish. In the farce *Des Gens Nouveaux (qui mangent le monde et le logent de mal en pire)* the "new peo-ple" turn out to be the courtiers who gain power at the beginning of a new reign (presumably that of Louis XI) and who make brave promises but quickly settle into the same old abuses typical of their predecessors. Especially popular was the morality play *La Vie et l'histoire du Maulvais Riche* (an elaboration of Luke's story of the rich man and the beggar Lazarus), for it showed the poor man having his revenge upon the rich.

Coming back once more to *The Last Supper,* we can see that the spirit in which Fouquet has interpreted the story owes nothing whatever to the tradi-tions of liturgical and sacramental art and thought but is directly related to the sardonic and moralistic modalities of the new theater—though not, so far as we can possibly tell, to the visual apparatus of that theater. He interprets the occasion of the Last Supper as one on which a group of poor laborers and fish-ermen have been betrayed into the hands of rich burghers and powerful priests who have used their wealth to corrupt the man named Judas, even as the rep-resentatives of that same ruling class were using their power to persecute and

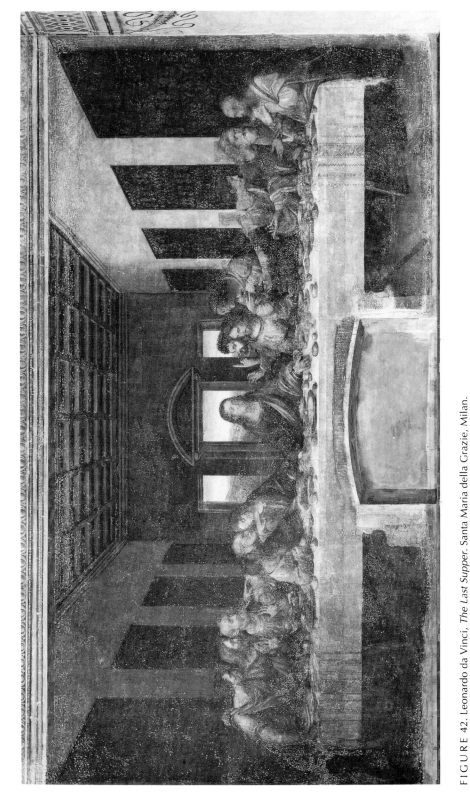

FIGURE 42. Leonardo da Vinci, *The Last Supper.* Santa Maria della Grazie, Milan.
PHOTO COURTESY OF ALINARI/ART RESOURCE, NEW YORK.

exploit poor but righteous men who had a better claim than they, perhaps, to being called followers of Christ. Nothing was more important to the expression of this new ethical standpoint than was the radical informality of Fouquet's perspective, which is completely at odds with the legalistic institutionalism that is so frequently to be associated with the *costruzione legittima.*

## III

In regard to Leonardo's *Last Supper* (see figure 42) and all that pertains to its perspective, I have little or nothing to add to what Leo Steinberg has set forth in his admirably thorough analysis of every aspect of the painting.[5] It would be superfluous for me to rehearse the observations he has made so well concerning this "polyvalent" or "polysemantic" work of art. Within the context of my own concern, let me stress only a few particulars.

The point needs be made, first of all, that although Leonardo has long enjoyed a reputation for having been a master of perspective, is thought to have written a treatise on the subject (now lost), and liked the notion that every artist should be well grounded in mathematics (possibly because of the putative relation of that discipline to perspective), he in fact made less use of "mathematical" perspective than did any major artist excepting Michelangelo. There is the awkward construction of the early *Annunciation* now housed in the Uffizi, which Kenneth Clark describes as being "painstakingly and amateurishly correct." There is the Uffizi drawing for the background of *The Adoration of the Magi,* though in that case the perspectival grid is only partially systematic, since the intervals between the horizontal lines are not governed by a fixed distance point, while the ground plane that is determined by the high vanishing point is unconvincingly related to the foreground stage on which the principal figures in the painting were meant to stand. And there is *The Last Supper.* Hundreds of drawings have come down to us, at least one of which includes a rudimentary diagram of the *costruzione,* but that construction is not employed elsewhere—not even in the several images of buildings (mostly central churches, for some reason) that we have from Leonardo's hand. Those edifices are not conceived to stand in a definable relationship to a spatial context or to the location of an observer. One can easily understand why the artist, fascinated as he was with inventions and the way things work, should have liked to tinker with the mechanics of Albertian perspective, but we can understand, too, why he made so little use of it in his art.

It has been the burden of my argument that Renaissance perspective turns fundamentally upon the relationship of a self-conscious observer to the law-giving institutions of which men considered themselves to be committed members. But Leonardo was by no means the "public man"—architect and candidate for the priorate—that Brunelleschi had been; he inclined rather

toward being a solitary and somewhat eccentric recluse. Nothing in his note-books (still voluminous despite the loss of several volumes) gives us any indi-cation of either his religious or his political convictions. We can easily under-stand why Freud would so have liked to subject the artist to psychoanalysis: it is the elusive and mysterious privacy of Leonardo that sets him apart from other Florentine artists of his day (so well typified by the matter-of-fact shop-keeper Domenico Ghirlandaio). The kind of perspective that truly appealed to Leonardo was the "perspective of disappearance"—that of light, color, and atmosphere that depends upon an infinitely subtle discrimination of sensations rather than upon an institutional and architectural order of things before which one may feel oneself challenged to "take one's stand."

In painting his *Last Supper,* Leonardo was not, like Castagno, working directly for a monastic chapter. His fresco was commissioned by Ludovico il Moro, Duke of Milan, who attended Mass every Sunday in Sta. Maria delle Grazie, dined twice every week at the prior's table in its refectory, and was resolved to establish an enduring relationship between that church and his family. But though it was commissioned by the duke, it was addressed to a gathering of Dominican monks. The picture's polyvalency derives in part, then, from the fact that there was involved in the nature of the commission itself a Church-State polarity, a dual orientation toward the way men lead their lives. Ludovico Sforza was, for his part, a thoroughly Machiavellian character, a not very competent *principe* who strove mightily to manipulate and to use to his advantage an ever-shifting array of matrimonial, military, and political alliances, in which effort his successes were of short duration, whereafter he spent the last eight years of his life as a prisoner of his erst-while allies, the French, at Loches. Leonardo had been in the duke's service for a dozen years by the time he received the commission for *The Last Sup-per.* By then he must have been well acquainted with his patron's devious-ness. Yet he knew that this was the kind of man artists had to work for. The pope himself, Alexander VI, was a much less admirable character who, while the picture was being painted, broke off his alliance with Il Moro and joined his adversaries, the Venetians. Such was the state of statecraft among Italy's professedly Christian leaders in the 1490s. Needless to say, a religious crisis was taking shape during those same years—a crisis of which the rise of Savonarola in Florence and of apocalyptic movements in Germany were not the only evidences.

No one has ever suggested that Leonardo had a clerical or theological adviser who invented a program for him in the way a papal scholar invented the program for Raphael's frescoes in the Camera della Segnatura. We can hardly doubt that Leonardo's composition resulted from his own protracted wrestling with what seemed to him to be the fundamental issues with which the commission confronted him. Certainly it was not his purpose to illustrate a

moment in a familiar story. The relation of the art of painting to that of story-
telling is never that simple. But we must not make light of the fact that Leonar-
do's *Last Supper* is the most *dramatic* image that had ever been painted in the
history of mankind, so far as we know.

Granting the polyvalency that Steinberg so persuasively argues for, and tak-
ing full account of the many ambiguities he so rewardingly points to, there is
yet one telling clue that I believe he has wrongly interpreted. It is to be found
in the fact that, unlike Ghirlandaio, Perugino, and Cosimo Rosselli, Leonardo
has followed Castagno in placing Judas on Christ's right. In view of the unusu-
ally strong feelings that Italians have with regard to the sinister significance of
leftness as against rightness, it would surely have seemed wholly natural, as it
did to Taddeo and the others, to place the evil Judas on the left side of Jesus so
that the latter might deliver the identifying sop with his left hand, as he does in
Fouquet's miniature.

Plainly Leonardo's is not a liturgical Last Supper, even though that dimen-
sion is not entirely absent. It is a dramatic version, and it is in its relation to the
metaphors of the theater that we must look for at least one important aspect of
the artist's meaning. When we see a play performed on the stage, we know, at
least in the backs of our minds, that the apparent spontaneity of the verbal
exchanges among the actors is deceptive, for in fact the lines they are reciting
were written by somebody else altogether, that the performers have been
instructed by a director to play their parts thus and so, and that the end of the
play was foreseen by the author before the first words were put down on
paper. Often we know the end in advance, as when we see a performance of
*Hamlet;* yet even so, the very fact that there *is* a denouement, a resolution of
conflicts, is deeply satisfying to us, what with our apprehensiveness about the
possibility that human existence is pointless. Leo Steinberg speaks repeatedly
of the fated and predestined aspects of the order of things Leonardo asks us to
contemplate, yet his interpretation of Judas is consistently negative, as if that
one of Christ's chosen disciples had been predestined to spend all eternity in
hell from the very beginning of time. If, however, we are seeing acted out a
drama that was plotted before time began, and if that plot requires that some-
one play the part of the betrayer (someone whose presence fits into the geo-
metrically and numerically regulated design as harmoniously as does that of
any other man at the table), then one must give especial weight to the words
"Quod facis fac citius" ("Do quickly what must be done"). Steinberg speaks of
Leonardo's Christ as being simultaneously the Christ of the Passion, of the Res-
urrection, and of the Last Judgment. True enough, but from another point of
view we may say that he is simultaneously the author, director, and principal
actor in this drama of human salvation.

Manuscript paintings have come down to us from the Middle Ages in which
God is shown to be the architect of the universe, holding the dividers that are

the traditional symbol of the builder. The metaphor may still have been on the mind of Brunelleschi as he painted the *tavolette*—images in which there were apparently no human figures but only the static symbols of the institutions of Church and State, institutions whose enduring reality seemed more important to the artist than did the multifarious particularities of personal experience. Leonardo, on the other hand, is perhaps the first artist to ask us to consider that God is not an architect but a playwright—or a composer, for it is the rapid ascendancy of the art of music in Leonardo's lifetime, with the new direction it was being given by the inventions of his contemporary, Josquin des Prés, that marks the decisive shift from the static to the dynamic, the institutional to the personal, the architectonic to the dramatic. The new balance between those poles that is struck in *The Last Supper* constitutes one of its most distinctive characteristics.

This new awareness urged men simultaneously in the direction of personal freedom, as is conveyed by the extraordinary individualization of the roles Leonardo's disciples play and yet toward an acceptance of the idea of predestination, whence the suggestion that the disciples are like puppets, arranged into four groups of three each by a controlling hand, that of the director. Because the play has already been written, none of these men, not even Jesus himself, can alter its course or its outcome. Each must play the part that comes to him to the best of his ability, recognizing the necessity of there being villains as well as heroes. For if there were no evil in the world, there would be no good—or at least no goodness that might transcend the simple experiencing of pleasant sensations. Leonardo was prepared to "take his stand"—to avow his conviction that there is an ordering of things in the world that quite transcends the self-awareness of the single person. Though Christ does not look at or speak to any of his disciples, he knows what Judas and Peter are going to do that night, knows what they are all going to do, for in some mysterious sense the whole play is the content of his own soliloquy.

Leonardo employs focal perspective in order to underscore the essentially dramatic or theatrical nature of his invention, for the deep room behind the figures plays no self-evident role other than providing a stage—yet not a stage that the figures perform upon, since they occupy a foreground space as shallow as Castagno's. Nor does the room serve to establish a relationship with the refectory we find ourselves in, for, as Steinberg points out, there is no spot in that chamber from which we can perceive Leonardo's room to be an extension of the one we are in. We must bear it in mind, however, that in Leonardo's day no theatrical stage had yet been built in Europe that was as deep and wide as the one we see in *The Last Supper*. Leonardo appears to have used that rapid extension into depth to make us aware of the relation of the event to the *world*. On each of the side walls he has placed four brown tapestries or hangings, four being the number of the earth and earthly things, while across the far end of the

room we find three windows that open onto the sky and a bit of distant land-scape—and three, of course, is the number of divine and heavenly things. In other words, what is happening in the immediate foreground has a universal significance that wholly transcends the limitations of this room and of this moment in time. In retrospect, Leonardo's philosophical stance seems immensely provocative, full of possibilities that were open to being explored by generations of poets, dramatists, musicians, and painters. It had its concomitant hazards, of course, one of which is the tendency toward weakening those insti-tutional loyalties on which Brunelleschi and Leonardo Bruni would have said that our political liberty depends. The complexities of the human predicament being what they are, it is hard to say—but they may have been right.

# IV

No Renaissance artist dealt more variously with the theme of the Last Supper than did Tintoretto, who painted at least six distinctly different versions of the subject, ranging from the static, symmetrical, Düreresque image in San Mar-cuola (1547) to the almost incomprehensibly ecstatic and tumultuous one that was made toward the very end of the artist's life (1592–94) for Palladio's church of San Giorgio Maggiore. For our present purposes the most interesting of the six is the large painting, executed between 1576 and 1581, that is to be found at the far end of the left wall of the Salone Superiore of the Scuola di San Rocco, where it lies just to the left of the altar—though of course the building is not a church (see figure 43).

The context within which Tintoretto's image was meant to be understood is different from that of any of the three Last Suppers we have thus far consid-ered. The picture is one of thirty-five, of various shapes and sizes, that adorn the walls and ceiling of the large meeting hall and sometime chapel of a char-itable confraternity. The overall scheme constitutes an elaborate three-part allegory having to do with miracles of water, of healing, and of bread (that is to say, with the relief of thirst, sickness, and hunger)—miracles that bear upon Christian salvation and also upon the charitable activities of the Scuola itself. *The Last Supper* is one of a group of eight paintings lying above and beside the altar that pertain to feeding, the other two principal ones being *The Fall of Manna* and *The Multiplication of the Loaves and Fishes*.

Since the room is not a monastic refectory, Tintoretto's *Last Supper* was not intended to evoke a sense of the sacral significance of the shared meals of a religious community. Like Fouquet's miniature, it was addressed to a lay rather than to a clerical audience. Though it is affixed to the wall of a large building (it is painted on canvas), it does not have the same kind of institutional and liturgical meaning evidenced in the two refectories. Like Fouquet's painting, it is addressed directly to the matter of ethical conduct. In fact, the subject of the

painting (as is the case with the other five versions by Tintoretto) is what is usually called The Last Communion of the Apostles.

The artist has made explicit the nature of his concern by placing in the immediate foreground two poor people (Pallucchini calls them *mendicanti*), a man and a woman who are seated humbly on the ground outside the room in which the supper is taking place. Thanks partly to the dog that is between them, they bring to mind the story of Lazarus the beggar who lay starving at the rich man's gate. But they are not shut out and are not starving: beside the man is a large loaf of bread, beside the woman a large pitcher (of wine?) and a bowl.[6] One may reasonably suppose that Tintoretto chose to stress the relation of the Holy Communion to the primal Christian virtue of charity because the painting was made

FIGURE 43. Jacopo Tintoretto, *The Last Supper.* Scuola di San Rocco, Venice.
PHOTO COURTESY OF ALINARI/ART RESOURCE, NEW YORK.

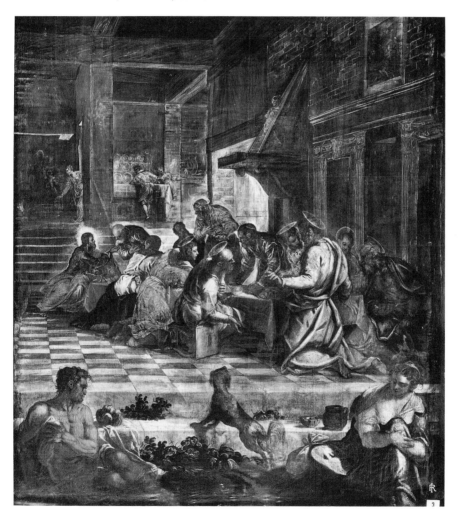

for a charitable confraternity, but in fact he had already introduced the same idea into an equally eccentric image of the Last Supper that he had made a few years earlier for the church of San Polo in Venice (see figure 44). There we see Christ offering bread simultaneously to Peter with his right hand and to Judas (?) with his left, while an unidentified disciple in the immediate foreground hands a loaf of bread to a sick or starving beggar who is lying on the floor, and someone else is offering an apple to a little boy. The biblical injunction Tintoretto appears to have had in mind was not "This do in remembrance of me" but "Feed my sheep." Not only such iconographic details but also the artist's nonsymmetrical and nonarchitectonic way of composing would seem to justify our assuming that Tintoretto's thinking was more than a little tinged with the kind of anticleri-calism and antidogmatism that had led Lorenzo Valla, a century earlier, to pose and answer the question *Scientia divinorum utilis est?* with *Utilior caritas.* ("Is a knowledge of divine things [theology] useful? More useful is charity.")

Because of the altar rail that runs across that end of the Sala Grande, one cannot easily take one's stand directly in front of *The Last Supper.* That may have been one consideration that caused Tintoretto to place his vanishing point just inside the left edge of the picture, though it must be said at once that he had no taste whatever for central vanishing points, that of the early *Last Supper* in San Marcuola being perhaps the only one in his extant *oeuvre.* Like most artists in the middle years of the sixteenth century, he had lost confidence in the Renaissance idea of center and in the notion that there exists a simple congruity between the patterned regularities of an established order of things and the symmetry of our own bodies. He seems to have been fully aware of the precarious contingency of existence that so limits our ability to compre-hend the central significance of the drama we are caught up in.

While there are several earlier works by Tintoretto in which we see dogs or cats in the foreground, the dog in this *Last Supper* appears to possess some spe-cial meaning, since its head lies exactly on the central axis of the picture and it is looking inward, thereby playing the role of the centered and central observer that is not available to us. Its own centrality compels us to reflect upon the fact that it is in the nature of the scene itself and of the composition of the figure group that there is no standpoint from which one might discover the event to possess anything remotely approaching the symmetrical orderliness that the *Cenacoli* of the quattrocento so commonly manifested. Number and geometry are irrelevant, as are the placement and scale of the figures: Jesus is the smallest and most marginal of the men at the table, while an unnamed kneeling disciple in the foreground appears to be larger than St. Christopher himself.[7] We cannot specify the moment in the narrative Tintoretto has chosen to illustrate, wherefore we cannot understand or feel ourselves to be in sympathy with the emotional excitement of the disciples. Christ is just touching St. Peter's lips with a tiny Eucharistic water, while Judas (without a halo) seems to shrink back from the

FIGURE 44. Jacopo Tintoretto, *The Last Supper*. Church of San Polo, Venice.

giving of the bread. Yet in drawing back he strikes a pose that causes the shape of his body, seen from behind, to be unmistakably similar to that of Jesus, as if the two were counterparts of one another.

That the dog should be gazing so intently from his central location at this apparently disorganized scene is subject to several different interpretations. Michael Levey makes the suggestion (which has been seconded by David Rosand)[8] that it is an allusion to lines from the sequence for the *Feast of Corpus Christi* composed by Thomas Aquinas, "Ecce, panis angelorum . . . non mittendus canibus." For my part, I find this unconvincing, since the Eucharistic bread plays so small a part in Tintoretto's painting; it is not being passed among the apostles and is not even remotely within the dog's field of vision. If the dog were interested in bread, he would see that there is a large loaf almost immediately beside him on the step. One could say, on the other hand, that the artist might have been mocking (as Bruegel might have done) the pretentions of all those artists who had reduced to a simple diagram not only the Last Supper but many another fateful event about which we in fact know so little and which we would probably have understood hardly at all even if we had been present as eyewitness observers. As with most biblical events, what mattered at the Last Supper was not an arrangement of figures but rather what was *said.* For my part, I prefer to see the dog as a symbol of the eye of faith (Fido = I trust, I believe), in which case Tintoretto may have meant to affirm that it is only the innocent eye, not the reasoning and analytical mind, that is capable of comprehending what was being made manifest that night in Jerusalem.

As we have seen, Castagno, Fouquet, and Leonardo chose different ways of enframing their architectural stage-spaces. Castagno shows us both the interior and the exterior of a building from which one wall has been removed, in a usage that takes us back to the early years of the trecento. Fouquet, painting at almost exactly the same time, took the radical step, in the direction of Tintoretto, of imposing upon his scene a proscenium frame that is unrelated to the shape and dimensions of the room itself. Leonardo retained something of Castagno's procedure in the lower part of his composition but used the upper part to create a room that extends as far into depth as does Tintoretto's. Since Tintoretto does not show us the left wall of his room in the Scuola, we are no more able to judge the total size and shape of that room than we are Fouquet's. The architecture is composed of an odd assortment of verticals, horizontals, and diagonals that do not define for us any recognizable kind of place. Though the room is apparently very large, its structure does not call to mind any domestic, civil, or religious institution. Tintoretto reminds us, one might say, that Jesus and his disciples were strangers in the city and in the house where they celebrated the Passover; they were not part of, but were opposed by, the institutional establishment.

Although the artist employed a "correct" system of one-point orthogonal

convergence, he chose to step outside the tradition of dialogical tension between Christ and Judas. If there is such a tension here, it is between the celebrants of the Last Supper and the beggars in the foreground—a reminder to the members of the Scuola, again, that what they should concentrate upon is not ceremony but charity.

One has only to look at Tintoretto's *Massacre of the Innocents,* which he painted a few years later in the Scuola di San Rocco (see figure 45), and to compare it with Giotto's fresco (figure 14), in order to see to what extent perspectival standpoint had ceased to be an issue. Tintoretto's figures act tumultuously and incoherently upon a receding architectural stage that consists of fragments of several buildings, the full shape and nature of which we cannot discern. The composition is more nearly reminiscent of Uccello's *Deluge* than of any earlier version of the Massacre.

Although they are separated by more than two hundred years, the step from Giotto's *Massacre* to Raphael's *School of Athens* is a relatively short one, since both pictures are equally governed by rational lucidity. However, the chasm that divides Raphael's fresco from Tintoretto's *Massacre* is oceanic—a chasm similar to the one that separates the *School of Athens* (see figure 46) from the same artist's *Coronation of Charlemagne* (see figure 47), which was painted in the adjoining Stanza dell' Incendio only about five years later. The subject lends itself perfectly to symmetrical formality, as Fouquet well understood when he showed the coronation (in *Les Grandes Chroniques de France*) to take place (see figure 48), as had actually been the case, in Old St. Peter's Church. Raphael, who had no doubt seen that church before its destruction was begun, chose deliberately to invent a highly fragmented architectural setting and to shuffle the arrangement of figure groups in keeping with that new way of thinking we now call Mannerism. What his reasoning may have been

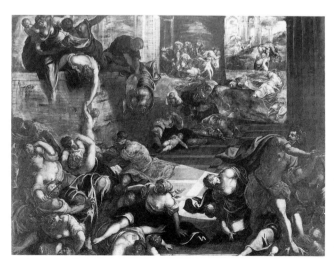

FIGURE 45.
Jacopo Tintoretto,
*Massacre of the
Innocents.* Scuola di
San Rocco, Venice.
PHOTO COURTESY OF
ALINARI/ART RESOURCE, NEW
YORK.

FIGURE 46. Raphael, *School of Athens*. Stanza della Segnatura, Vatican.

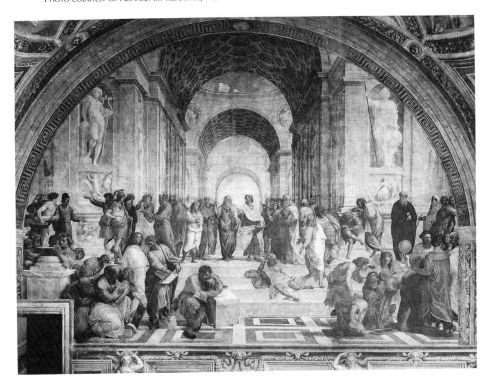

FIGURE 47. Raphael,
*Coronation of
Charlemagne.* Stanze,
Vatican.

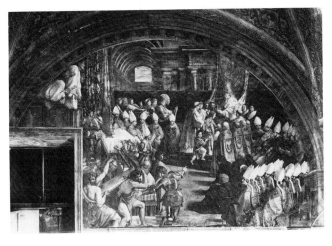

we cannot say. He was one of the first artists of the period to lose confidence in the idea of center and in the practice of imposing a regular and regulating schema upon a historical event.

On the other hand, if we compare Tintoretto's *Massacre* with Pieter Bruegel's version, which had been painted about twenty years earlier, we can see that for Bruegel perspectival standpoint was still a matter of the greatest importance (see figure 49), though it did not involve the use of the *costruzione*. In a wide and deep landscape setting he sought to establish a dialogical opposition between a Flemish village community and a troop of murderous foreign soldiers who are led by an officer clothed in black—surely a

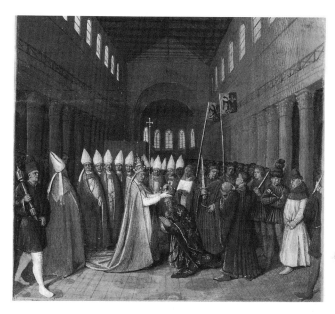

FIGURE 48.
Jean Fouquet,
The Coronation of
Charlemagne, from *Les
Grandes Chroniques de
France.*

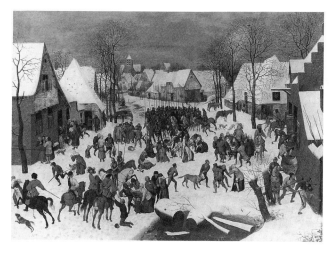

FIGURE 49.
Pieter Bruegel,
*Massacre of the
Innocents.*
Kunsthistorisches
Museum, Vienna.

reference to the Duke of Alva, who, because of the brutality of the repression he carried out in Flanders, came to be called "the black duke." Though he is a crucially important figure, he is shown to be small and distant—another instance of the kind of inversion that J. A. Emmens has dealt with. We see the same black-clothed man in the foreground of Bruegel's *Conversion of Paul,* where he sits astride a very white horse as he oversees an army of soldiers that is crossing the Alps on its way, we presume, to suppress heresy in the Low Countries. In the middle distance we see the little figure of Paul who has fallen to the ground, having been knocked from his horse by the force of divine reve-

FIGURE 50. Peter Paul Rubens, *The Last Supper.* Brera Gallery, Milan.
PHOTO COURTESY OF ALINARI/ART RESOURCE, NEW YORK.

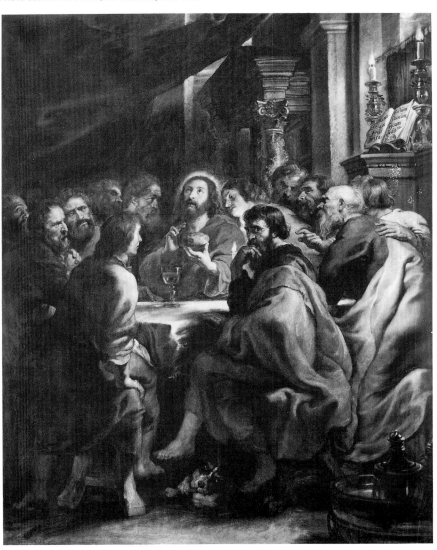

lation. Paul had been on his way to Damascus in order to persecute Jewish heretics who later came to be called Christians. Assuming that the artist's sympathies were with the Flemish heretics (or Protestants) whom the Duke of Alva was about to descend upon, it seems entirely possible that Bruegel was raising a theodicean question as to the nature of God's justice. Why had not God intervened *this* time so as to prevent the Spanish duke from carrying out his cruel purposes?

# V

By the time we come to *The Last Supper* of Rubens (see figure 50), the architectural setting has so shrunk that it consists of only a few fragments in the upper-right corner of the picture. The spatial volume is defined (or created) by the tightly compressed figures themselves, as they grimace and gesticulate, while the menacing dog looks not into the depicted scene but directly at us, as does Judas immediately above him. The occasion has become as dynamic and as internalized as a scene from Verdi's *Otello.* The notion of dialogue within an institutional frame of reference has quite disappeared and, along with it, every vestige of the *costruzione legittima.*

# An Eccentric Stance

One can easily see the art of the Renaissance as having been radically innovative and progressive, evolving from the medievalism of Cimabue to the optical subtlety of Masaccio and van Eyck within an astonishingly brief period of time. Yet we would do well, I believe, to avoid an hypostatization of "art" that could lead us to attribute to that imaginary entity a self-propelled life of its own. Throughout Europe in the fourteenth and fifteenth centuries there were taking place far-reaching reassessments of matters religious, philosophical, economic, ethical, and literary. Art did not passively reflect those changes of attitude; artists were themselves engaged—some much more than others—in shaping new ideas and new standpoints, and there was little unanimity among them. Since most paintings were commissioned by rich businessmen or by prominent business and religious organizations, the various standpoints that artists articulated and defended by means of pictorial perspective were not uniquely their own; the patron's standpoint had always to be given serious consideration. Many works are unsigned and attributed to an artist on tenuous grounds.

Yet for all that, it was an inevitable consequence of the new emphasis upon standpoint, within a framework of argumentative dialogue, that there should emerge the possibility of an artist's taking his stand outside the conventional mores of the community and of assessing those mores from an eccentric point of view—the possibility, that is, of satire. Anyone inclined toward a satirical viewpoint would certainly have jeopardized his prospects, for the rich patrons of the day took themselves and their positions very seriously indeed and were

not in the least given to self-mockery or to skepticism about the significance of their roles. Nevertheless, at least one such artist did come forth in Alberti's own generation, and that was Paolo Uccello.

No man's work has been interpreted more variously. He has been described as scientist and antiscientist, as classicist and as gothicist, as fantasist and fabulist and as experimentalist and researcher, as quasi-medievalist and as proto-Cubist, as pure formalist and as dramatist. Recently both Enio Sindona and Ennio Flaiano have come to see something of the ironical and sardonic sense of Uccello's stance, but they have not related it specifically to what has long been thought to be the most distinctive factor in his thinking—his fascination with perspective. That notion is surely attributable to Giorgio Vasari.

The author of the *Vite* evidently found Uccello a difficult figure to deal with. Although he recognized the painter's extraordinary ability, he had to cope with the fact that Uccello had remained a poor and relatively unpopular artist throughout his long career. Learning that Uccello had taken an interest in working out complex problems in perspectival representation, Vasari proceeded to explain the artist's lack of success in terms of his addiction to theoretical abstractions, arguing that anyone who devotes himself immoderately to such studies

> does nothing but waste his time, exhausts his powers, fills his mind with difficulties, and often transforms its fertility and readiness into sterility and constraint, and renders his manner, by attending more to these details than to figures, dry and angular, which all comes from a wish to examine things too minutely; not to mention that very often he becomes solitary, eccentric, melancholy, and poor, as did Paolo Uccello. This man, endowed by nature with a penetrating and subtle mind, knew no other delight than to investigate certain difficult, nay, impossible problems of perspective, which, although they were fanciful and beautiful, yet hindered him so greatly in the painting of figures, that the older he grew the worse he did them.

Now it seems highly unlikely that Vasari had ever known a sufficiently large number of monomaniacal theoreticians to warrant his concluding that such men "very often" become lonely and poor, and certainly he found little evidence of such an obsession with perspective in Uccello's paintings. While Vasari knew more works from Uccello's hand than are now extant, he observed nothing peculiar or labored about their perspective, nor did he think the works hard and dry. In short, he was trying to explain something about the artist's lack of popular success rather than to report what he has learned from the pictures. Except for the first two panels in the Urbino predella of *The Desecration of the Host,* painted at the very end of Uccello's life, there is hardly any work from his hand that even appears to exemplify the *costruzione legittima.* Much has been made of the celebrated drawings of the

chalice and of the *mazzocchio* rings, yet these are simply isometric constructions that have little to do with the optical experience of contemplating a scene from a definable standpoint. Within the Renaissance meaning of the term, they are hardly *perspectival* studies at all.

It has long been recognized that Uccello employed perspective in various eccentric ways, and a good deal of ingenuity has been brought to bear, especially by Decio Gioseffi and Alessandro Parronchi, upon the problem of finding a rational explanation for those aberrations. Characteristically, Parronchi has sought to establish a relationship between Uccello and Witelo. Gioseffi has found evidence of a radically scientific prefiguration of "3–D" stereometry. John Pope-Hennessey has belabored, on the one hand, the relationship between Uccello and the learned Alberti (stating even that the orthogonals in *The Deluge* converge to a single Albertian point, though plainly they do not) and, on the other, the qualities of flat-surface abstraction that have loomed large in so much modern English criticism. These writers have generally ignored the relation of Uccello's perspective to his interpretation of different kinds of subject matter.

The great majority of Renaissance artists appear to have taken their subjects seriously. Though Perugino may have had personal reservations about the argument he set forth in *Christ Giving the Keys* (at a later date he was at least accused of being an atheist), those reservations did not affect the consistency and integrity of his exposition. Only in the case of Uccello do we find reason to question the conventionality of an artist's interpretation of the theme assigned him. Though he was probably not the theoretician he has so often been made out to be, it is entirely right that his uniqueness as an artist should be associated in our minds with the matter of perspective—not perspective as linear construction but perspective as *standpoint.*

Uccello's most dramatic and exciting painting is his fresco *The Deluge* with its long ark-bounded corridor of desperation and disaster, its disconcerting distortions of scale, and its catalogue of the varieties of useless response to cataclysm (see figure 51). The rain and the rising waters are shown on the left side of the lunette, the landing of the ark and subsiding waters on the right. The artist's illustration seems conventional enough, in relation to the story in Genesis, except for the enigmatic figure on the right who dominates the entire composition. There is no agreement among scholars as to his identity. Salmi and Pope-Hennessey ignore the question altogether, while Boeck and Sindona simply call him "a praying man." M. L. Gengaro identifies him as Noah but does not attempt to explain why he should be standing there or why he should not at all resemble the bearded Noah who looks out from the ark. Hartt speaks

FIGURE 51. Paolo Uccello, *The Deluge.* Chiostro Verde, Santa Maria Novella, Florence.
PHOTO COURTESY OF ALINARI/ART RESOURCE, NEW YORK.

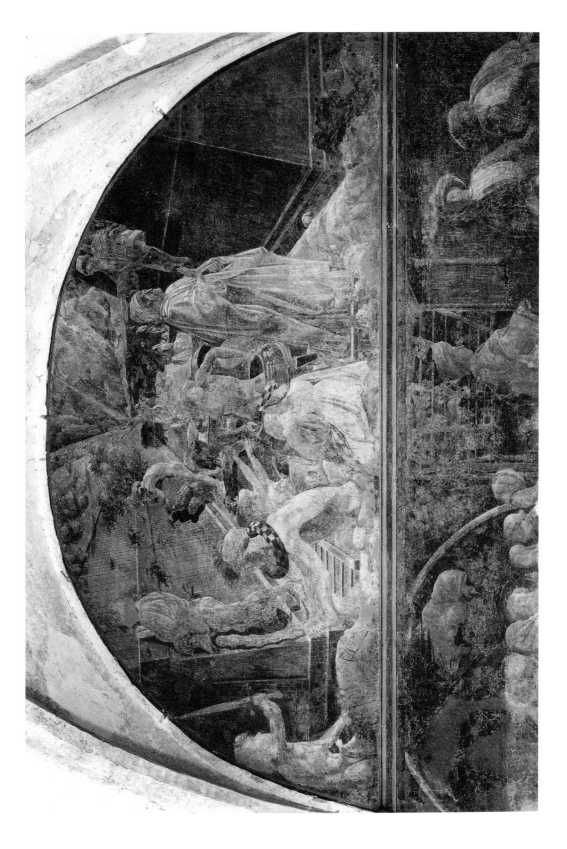

of the man as offering a prayer of thanksgiving, thereby associating him with the second or recessional episode in the story, but this is to overlook the fact that no one survived the Flood but Noah and his sons inside the ark, and that the man's ankles are being gripped by a drowning man, wherefore he unmistakably belongs among the struggling and dying figures above, below, and behind him. Moreover, neither his gesture nor his facial expression can reasonably be described as prayerful.

Instead, the man possesses a severe nobility of character that is approximated only in the works of Masaccio and Donatello—and later of Michelangelo. No other figure by Uccello remotely resembles him. Since his presence is the dominating factor in the painting, completely overshadowing poor Noah, his identity must surely be the key to the artist's meaning—to the ethical sense, that is, of his rhetorical address. Who is he, then?

In order to solve that riddle we need to take into account two commissions with which Uccello had been occupied some years earlier. It has lately been demonstrated rather convincingly by Robert L. Mode that around 1430 Paolo was engaged by Cardinal Giordano Orsini to paint some of the figures in a room in the Palazzo Orsini in Rome, a room that was decorated with frescoed images of some three hundred *uomini famosi,* chosen from each of the six ages of the history of mankind.[1] It fell to Uccello to depict our earliest progenitors, from Adam through Noah and Nimrod and perhaps thereafter. (The frescoes were long ago destroyed and are known to us only through small colored drawings.) The Latin humanists, following the precedent that Petrarch had set with his *De Viris illustribus,* enjoyed making lists of famous men, while citing the moral example of a famous man was a favorite rhetorical device of the learned. As Charles E. Trinkaus observes, "The rhetorical tradition . . . was centrally concerned with moral philosophy and the philosophy of man,"[2] and *The Deluge* is plainly a rhetorical work.

It was not the deeds of the three hundred *uomini famosi* that one was asked to contemplate in the *sala theatri* of the Orsini Palace but simply their having been the men whose names should never be forgotten. As Ficino later expressed it, every man aspires to endure forever, even as God endures; "he attempts to remain through all future time in the speech of men, and mourns that he is not able to have been celebrated also in past ages and that he cannot be honored in the future by all the nations of men and by all kinds of animals. . . . What all men desire, and especially the superior ones, is desired by them as a good by a natural law."[3] Fame, says André Chastel, "was the ruling passion of the Renaissance. Fame was the reward of men, victory over the slings and arrows of Fortuna and, in winning it, the prince, the hero, the genius came into his own."[4]

To begin with, then, Uccello is known to have participated in the execution of an early cycle of famous men. Moreover, it is recorded that in the entryway

of the Casa Vitaliani in Padua he painted a series of giants. We know nothing about their appearance, nor do we know the year in which the work was done. Uccello probably received the commission on the occasion of his trip to Padua at the invitation of Donatello, presumably in the mid-1440s.

Scholars seem generally to agree, though solid evidence is lacking, that Uccello painted *The Deluge* in the Chiostro Verde of Sta. Maria Novella around 1448. The identity of his commissioner is not known. We may reasonably suppose that in order to prepare himself for his task, Uccello turned to Genesis to read (or to have read to him) the familiar story. There he came upon the following sentences: "Gigantes autem erant super terram in diebus illis. Postquam enim ingressi filii Dei ad filias hominum, illaeque generunt, isti sunt potentes a saeculo viri famosi" (Gen. 6:4). It requires no great exercise of the imagination to understand how forcibly a sensitive Renaissance Florentine would have been struck by these phrases. "Giants [Nephilim] were on the earth in those days, and also afterward, when the sons of God came in to the daughters of men, and they bore children to them. These were the mighty men that were of old, famous men." In Noah's day there were men of giant attainment who deserved to be called *viri famosi,* and these were the very men whom God was determined to destroy. The author of the biblical story speaks of the "great wickedness" of men before the Flood, but he says nothing about the nature of that wickedness, except to sum it up under the word "violence." In fact, I find it easy to believe that he himself had rather lost sight of the point of the story that had been handed down to him, but from what he tells us we can only conclude that, like the builders of the Tower of Babel, those early famous men were guilty of the sin of arrogant pride, of hubris.

In other words, the creatures whom God had made in his own image and likeness had sought "to be as gods," as the serpent had expressed it to Eve. For their insolence they were wiped from the face of the earth, to be replaced by the descendants of Noah, a righteous and blameless man but merely an ordinary and unassuming farmer who after the Flood turned out to be not a giant at all but a drunken and rather spiteful old man some five hundred years old, and it is as such that Uccello represents him: he seems frail and shadowy by comparison with the titanic figure who dominates the right foreground of the painting. That man, of course, is a *vir famosus,* a giant among men.

Plainly Uccello was taking his stand (which may or may not have been that of his patron) with regard to an ethical problem that lay at the very heart of quattrocento humanism: the relation of the pursuit of personal fame and glory to Judeo-Christian ethics. Once more we are brought back to the polarity between the secular and the sacred, the Town Hall and the Baptistry, the temporal and the eternal, that Brunelleschi had understood to be the central issue. Is the truly Christian life that of the "religious"—the monk who seeks to efface

his own individuality within a Christian community and to embrace the virtues of poverty and humility that are extolled in the Beatitudes? Or is it a "natural law," as Ficino said, that, being made in God's image, we should aspire to be God-like? Gianozzo Manetti contended that God's purpose had been "that he might produce men as the most beautiful, the most opulent, and most potent of creatures," and he argued that the Incarnation was as much for the glorification of man as for his redemption.[5] On the other hand, as Trinkaus makes clear, there ran side by side with the optimism of Ficino and Manetti a strain of Christian pessimism that emphasized the sinful and miserable aspects of the human condition.

In all likelihood Uccello's patron, whoever he may have been, was aware of the artist's interpretation of the story of the Flood, for Uccello was taking his stand with regard to one of the central themes of humanist thought, addressing himself to the question of man's capacity for nobility and to the theodicean problem of God's justice. The gesture that the giant is making with his right hand is surely not one of prayer but of defiant rejection. He turns his back upon the closed and fortress-like ark on the left, symbol of the inscrutability of divine judgment (what of the little boy who lies dead and bloated at the man's feet—did *he* deserve to die?), and he turns his face away from Noah and Noah's kind of salvation on the other side. He has no recourse to sword or cudgel, nor does he strip himself naked and climb into a barrel in order to save his own skin, as does the poor frightened man behind him. Finding God's justice to be incomprehensible, he stands his ground with stoical calm and accepts his fate, though declaring to the end, in the manner of Job, that he has done nothing to deserve annihilation.

When Uccello was a little boy, Brunelleschi had confronted the Baptistry from his solitary standpoint inside the unfinished Duomo and had found himself face to face with an ancient and enduring symbol of a transcendent order of things at the center of which lay, in all its ultimacy, the reality of divine judgment. Among artists of the following generation only Uccello, perhaps, may be said to have fully understood his meaning. He, at least, grasped the fact that focal perspective has the basic function of putting us into a strictly defined relationship with structures that are prior to and independent of our acts of experiencing them. Unlike innumerable lesser artists, he perceived that the significance of those structures resides in institutionalized patterns of relatedness, in Platonic realities, in ethical frames of reference that cannot be brought within the confines of a single act of comprehension. In the composition of *The Deluge,* with its two vanishing points, plus a third "point of center" determined by the two stormy diagonals in the upper part of the painting, there is a disparity related to the incommensurability that Brunelleschi found to exist between the Baptistry and the Palazzo Vecchio. There is the impenetrable closure of the ark (like that of the Baptistry) on the one side. There is an engulfing

sea of worldly troubles all around. And there is an assertion of man's capacity for standing firm amidst disaster, proclaiming a nobility of character that is yet destined for destruction. We are invited to admire the dignity and fineness of this giant of a man and at the same time to recognize that his glory is of this world, hence perishable and transitory.

## II

Let us turn now to Uccello's *St. George and the Dragon* (see figure 52). It is conceived in a totally different spirit, from a wholly different point of view. Though there has been considerable disagreement among scholars as to the dating and attribution of the picture, I find no fault with the majority opinion that holds the work to be a relatively late invention, though probably no more than eight or ten years later than *The Deluge.* The obvious differences of style have nothing to do with the artist's "development"; the character of the image derives, instead, from the utter uniqueness of Uccello's perspectival standpoint.

As Millard Meiss was wont to say, *St. George* is virtually the only amusing painting that we have from the hand of a major Renaissance artist. On the right

FIGURE 52. Paolo Uccello, *St. George and the Dragon.* National Gallery, London.

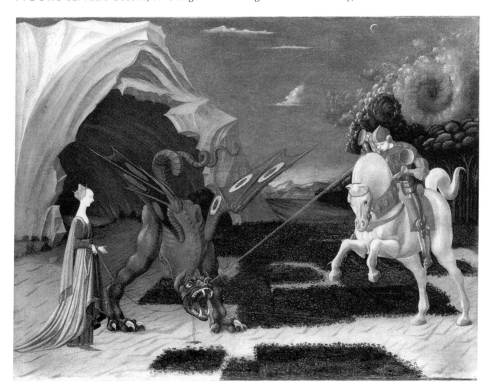

side we behold a smooth-faced and boyish figure of the saint, dressed in the heavy armor of the mid-fifteenth century and mounted upon an absurdly large horse, lunging forward to thrust the point of his spear into the dragon's eye. That two-legged, winged monster seems especially fearsome as Renaissance dragons go, but far from being on the verge of devouring the sacrificial princess it appears to have been led forth from the cave by the princess herself, who keeps the creature on a slender leash. The dragon has plainly become what can only be called knight-bait, the lure by means of which the wily woman entices gullible young men into her cavernous lair.

Surely the young lady was conceived as a deliberate caricature of Domenico Veneziano's St. Lucy, in whom the Florentine ideal of the courtly gentlewoman is so beautifully set forth. The fashionable coiffures, costumes, and red slippers of both figures are strikingly similar, except that in Uccello's version the length of the woman's neck, the height of her plucked hairline, the smallness of her hands, and the length of her pointed shoes are all ridiculous exaggerations. The appearance of delicate fragility is nothing more than an artificial contrivance to make her a decoy that knights-errant find irresistibly attractive.

About the saintly and heaven-sent nature of St. George's errantry, Uccello seems to have a tongue-in-cheek attitude. Above the errant and erring knight (in Italian as in English the word *errant* has both meanings), we see a curious conflict in progress between a spiraling light-colored cloud and a convoluted dark cloud that, like the dragon in relation to the knight, is lower and to the left. The inflated legend of St. George suggests a parallel between the slaying of the dragon and St. Michael's expulsion of Lucifer from heaven. But are those vapors above the wood to be interpreted as preternatural manifestations, as ordinary clouds, or merely as smoke from a brushfire in the grove of trees that stretches away toward the distant town? Has our heroic warrior arrived in the knick of time to save the maiden from mortal danger, or is this simply an episode in the war between the sexes in which our manly hero has been hopelessly outwitted?

As in other paintings by Uccello we find no Albertian grid, no evidence of the artist's having begun with that celebrated first step of laying out a gridiron pavement that would enable us to chart all of the relationships among figures and objects. Instead, it looks as if an incompetent gardener had been instructed to lay down squares of sod so as to provide an appropriate turf for this chivalrous performance—but had bungled the job badly. At the center of this patchy and confusing sodding lies a large and conspicuous "U," which is surely the monogram of the stage manager who produced this farce.

We may be reasonably certain that Uccello's invention expresses an attitude toward what historians refer to as the "chivalric revival," that odd outbreak in the early and middle years of the fifteenth century, in Florence and in other Italian cities, of a taste for jousting and tournaments—a taste that led rich

businessmen to don suits of plate armor and to ride at one another, in single combat and in groups, in what often turned out to be bloody and even fatal encounters. Because of the needless violence the practice was actively opposed by churchmen, while leading humanists disapproved of the ostentatious extravagance and pretentious braggadocio that surrounded the tournaments. Indeed, the Florentine enthusiasm for such displays was riddled with ambiguities, for active soldiering at that time had been turned over almost entirely to non-Florentine mercenaries. As Michael E. Mallett has observed, "These Florentine pageant-tournaments were pale imitations of war, the pseudo-chivalric cavortings of an essentially unmartial society: a society which admired the military virtues and looked with interest and awe on the accoutrements of war, but feared the practice and distrusted the practitioners of it."[7] One could not find an apter phrase with which to describe the activity of Uccello's St. George: he is engaged in "pseudo-chivalric cavorting."

## III

All of which leads us to consider the perspectival standpoint that Uccello adopted in devising his most celebrated paintings, the three large panels that were made to commemorate the victory of Florence over Siena at San Romano on June 1, 1432 (see figures 53, 54, 55). There is no firm evidence as to just when the pictures were painted, but it seems probable that they were made in the late 1450s, or at about the same time as the *St. George.* They were created for the adornment of a large room in the recently completed Medici Palace, though just why the Pater Patriae (Cosimo de Medici) should have wanted a pictorial celebration of that military engagement is not at all clear. The battle had taken place in the course of the ill-conceived and mismanaged war that the Florentine oligarchy had rashly launched against the city of Lucca in 1429. The Lucchese had promptly sought and received support from Siena and Milan, old adversaries of Florence, thus forming an alliance the Florentines could not possibly have defeated. Although a minor victory was won at San Romano, extensive Florentine territories were ravaged before the disastrous campaign was concluded by the signing of a treaty on May 10, 1433.

Cosimo de' Medici had been a member of the *Dieci,* the council that was responsible for prosecuting the war against Lucca, and though it is hard to believe that any credit redounded to his name because of that involvement, he did manage to emerge from the debacle with no loss of popularity among the Florentine people. No one has ever suggested that he had anything to do with the decision making that resulted in the victory at San Romano, and by no stretch of the imagination could the battle be regarded as one of the highlights in the history of Florence.

FIGURE 53. Paolo Uccello, *Rout of San Romano.* National Gallery, London.

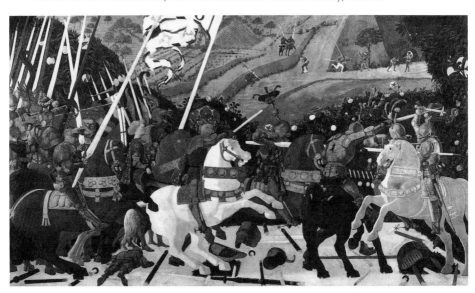

FIGURE 54. Paolo Uccello, *Rout of San Romano.* Louvre, Paris.
Courtesy of R. M. N.

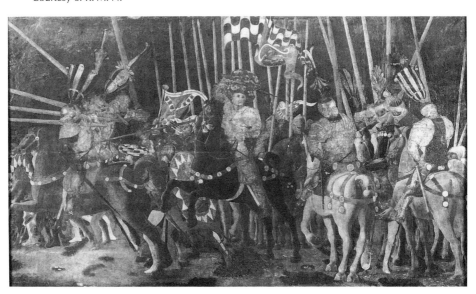

It seems altogether likely that Cosimo wanted the three paintings, not so much because of his interest in the history of the city as because of the contribution they could make to what we might today call the "Medici image," the reputation he was creating for his family, partly by means of architecture and works of art. Giovanni di Bicci, his father, had evidently been regarded as a nouveau-riche upstart, *un' arrivista,* but by seizing control of Florence and by building his imposing palazzo in the Via Larga Cosimo had, within a short period of time, come close to putting the Medici on equal footing with the oldest and most influential families in the city. It would have suited his purposes to have associated himself and his family with the aristocratic pretensions of the chivalric revival, since the connection between aristocracy and military prowess was indissolubly close. By the 1450s he was much too old to take up jousting (though his sons were doing so), but at least he could claim to have had something to do with one military victory, however slight his connection with the events may have been. Having some knowledge, as he probably did, of the battle tapestries that sometimes bedecked the walls of the palaces of the nobility (see, for instance, those depicted in the January scene of the *Très riches heures*), he may have welcomed Uccello's suggestion that the battle pieces be painted in an old-fashioned, tapestry-like style. Or it may even have been his own idea, for a similar motivation probably underlay his choice of the theme of the journey of the Magi for the walls of the family chapel, with all the references the subject permitted the artist to make to kingship, the panoply of aristocracy, the ownership of country

FIGURE 55. Paolo Uccello, *The Battle of San Romano,* Uffizi, Florence.
PHOTO COURTESY OF ALINARI/ART RESOURCE, NEW YORK.

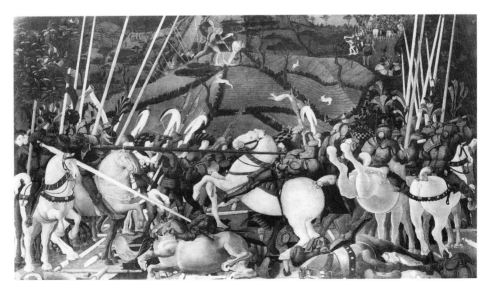

estates, the royal sport of stag hunting, and the kind of leisurely peregrination through the countryside that had traditionally been the prerogative of the nobility (and that is so beautifully celebrated in the May and August scenes from the *Très riches heures*). Within this context we can understand Cosimo's choice of the somewhat old-fashioned Benozzo, still practicing many of the conventions of the early years of the century, as recipient of that commission.

Though a revival of the decorative "International Style" may have posed no problems for the pedestrian Benozzo, it is hard to believe that the painter of *The Deluge* and *St. George* could have accepted the old usages or could have subordinated his own viewpoint to that of his patron as completely as Castagno had done in Sant' Apollonia. There are many indications in the battle panels that lead me to think that Uccello, by virtue of his *being* a great perspectivist, was capable of taking his stand quite outside the sociopolitical context within which the battle itself had occurred and also, though less obviously, outside the frame of reference within which Cosimo himself found the project to be meaningful. He was able to see, as perhaps no artist had ever done before, that not only the military but also the artistic practices of his contemporaries constituted a complex of rather arbitrary and not altogether admirable conventions.

To begin with, there was already in Uccello's day a well-established tradition of skepticism in regard to the condottiere system. "Petrarch launched unrestrained vituperation against mercenaries, and Coluccio Salutati . . . denounced them as 'outcasts who had entered into a perpetual conspiracy against peace and order.' This was the tradition which led the Florentine politician Almanno Salviati to write: 'In general all men of his (Niccolò da Tolentino's) occupation disgust me, because they are our natural enemies, and despoil all of us, and their only thought is to keep the upper hand and to drain us of our wealth.'"[7] The practice of settling political disputes by sending hired troops onto the field—troops who were known to have no genuine loyalty to one side or the other, who fought cautiously, who balked when their pay was in arrears, and who could sometimes be bought off by a higher bid for their services—was intrinsically suspect, and not only because of its own defects. There also lay behind it the plain fact that the patrician leaders of the Italian city-states were, on the one hand, unwilling to bear arms themselves in defense of their cities and of their own privileged status and, on the other hand, afraid to arm the *popolani* and to train them in military skills lest they turn upon their patrician oppressors. Though Machiavelli's expectations as to what could be accomplished by relying upon a citizens' militia were probably ill-founded, he was expressing an old and well-rooted opinion when he denounced the "bloodless battles" that were fought by mercenaries in wars that were "commenced without fear, continued without danger, and concluded without loss." As Mallett

has shown, Renaissance warfare was a good deal deadlier and more destruc-
tive than Machiavelli pretended; nevertheless, the conventional practice of the
art of war as it was conducted in Italy in the fifteenth century was manifestly
open to ridicule.

That much we can say about the social and political context within which the
rout of San Romano occurred. Equally important is the rather exceptional nature
of Uccello's training and experience as an artist. Not until he was forty years old
do we hear of his having made a painting. He began his career in the shop of the
sculptor Lorenzo Ghiberti, but so far as we know he never practiced the art of
sculpture (though his earliest painting is one that simulates an equestrian monu-
ment). In the mid-1420s we find him working as a mosaicist in Venice. Upon
returning to Florence around 1430, he found that the Brancacci frescoes had
been partially finished and Masaccio was dead. Coming fresh from the Byzan-
tine church of San Marco, he must have been especially well prepared for see-
ing what a giant step had been taken at the Santa Maria del Carmine in his
absence. However, he appears already by that time to have been finding it hard
to secure commissions. After completing the Hawkwood fresco in 1436, he
turned his hand to designing stained-glass windows for the Duomo. Not until
around 1448, so far as we know, did he receive another major commission in
Florence—for the Chiostro Verde paintings at Sta. Maria Novella.

Let me return for a moment to Erich Auerbach's comparison of a passage
from the *Odyssey* with the story of Abraham's sacrifice from the book of Gene-
sis. He observes that the latter is "oriented toward truth" in an altogether differ-
ent way from the former. The protracted adventures of Homer's hero constitute a
good story, but the events remain essentially external both to us and to Odysseus
himself, who is not *changed* by anything that befalls him. We are invited to wit-
ness events that take place in the immediate foreground. In the story of Abraham
and Isaac, on the other hand, Auerbach finds the events to be "fraught with
background," even though no object or person is described and only a minimal
number of words are exchanged. "The Scripture stories do not, like Homer's,
court our favor, they do not flatter us that they may please and enchant us—they
seek to subject us, and if we refuse to be subjected, we are rebels."[8]

We can discern a similar contrast when we compare the imagery of the
Limbourg brothers, Lorenzo Monaco, and Benozzo Gozzoli with that of
Masaccio, Donatello, and Van Eyck. The former endow their works with
pleasing and enchanting qualities we can easily associate with fable, the lat-
ter, with something that inspires in us a recognition of compelling truth.
Their artistry does not intervene between us and the grave, powerful persons
we see before us—men we know to have been racked and shaped by their
life histories. We know that it was Masaccio's purpose in painting *The Trib-
ute Money* that we should be changed, that we should be persuaded to
accept our obligations as citizens more fully and form a community with our

fellow Christians more wholeheartedly. Uccello understood this: his own fresco *The Deluge* is virtually the only Florentine painting from the middle years of the century that looks as if it could have held its own on the walls of the Brancacci Chapel.

It is inconceivable that any of those images could have been translated into either mosaic or stained glass, for those media, at least as they were practiced in the quattrocento, are so dominated by the technical artistry with which the colorful surface itself is contrived that the possibility of the picture's being "fraught with background," in Auerbach's sense of the word, is all but ruled out. Neither the mosaics of San Marco nor the *vitrate* of the Duomo demand of us that we "take our stand" with regard to vital issues of belief and action—nor do the panels of the *Rout of San Romano*. In *The Deluge* Uccello had demonstrated that he was capable of painting a battle picture that could have taken its place alongside the ones that Leonardo and Michelangelo were later to make for the Palazzo Vecchio. When he chose to make Niccolò da Tolentino and his mercenaries look like dolls astride toy horses, he must surely have meant precisely that: that these men were not *uomini famosi,* that their battling was only a carefully controlled game. In fact, I suspect that when Machiavelli spoke of the battle of Anghiari (which took place only eight years after the rout at San Romano) as having been a battle in which only "one man was killed and he fell off his horse and was trampled to death," he was thinking of Uccello's paintings rather than the historical event in which some nine hundred men are reported to have died.

Uccello's battle is quite literally bloodless. Of the seventy spears he has represented, sixty-four are carried vertically, as by knights on parade, six are shown to be lowered in combat position, and only two make contact with an adversary. The fallen cavalrymen in the Uffizi panel look like chess pieces that have been carelessly knocked over; the four crossbows that figure so prominently are pointed toward the sky, as if they were trumpets rather than weapons. Directly above the crossbows we see a rabbit pursued by a dog—which in turn is pursued by another rabbit! Two of the little figures who are ineffectually running about in the background of the London panel are wearing armor on one leg only, while four soldiers wear *mazzocchio* rings instead of helmets. Indeed, everyone seems to understand that this affray has more to do with fancy dress than with mortal danger. The paintings are cluttered with multicolored legs for which there are no bodies and with decorative spears for which there are no spearmen. The action, such as it is, takes place on an artificial, peach-colored stage-plane under an artificial brownish-black sky: there is no sunlight, and there are no cast shadows.

Much has been written about the broken spears that are said to have fallen into an Albertian grid on the ground, revealing once more Uccello's obsession with the wonders of the *costruzione.* In fact, the orthogonal spears do not

come at all close to defining a single-point construction. They are like the haphazardly placed squares of sod in *St. George and the Dragon* and similar squares in the Louvre *Rout of San Romano* panel, all of which mock the very idea that there is some intelligible principle of order that might make these scenes accessible to rational understanding. We see only a sham battle, devoid of all sense of dramatic destiny, a battle that is shown to be fought mainly by men who have no faces, no eyes, no capacity for intelligent thought.

Some writers in recent years have contended that Albertian perspective is merely one representational convention among many, having no greater claim to "correctness" than do the conventions of Egyptian tomb paintings, the Japanese print, or the Byzantine mosaic. In some sense that may be true. Certainly it would have been "incorrect" for an Egyptian painter to have tried to simulate the qualities of a photograph in an image of the dog-headed god Anubis conducting the souls of the deceased toward paradise. The truths that were affirmed in such pictures did not in the least depend for validation upon the experience of witnessing. Since mortal eyes had never beheld the god Anubis, it would have made no sense whatever for the artist to have shaped his visual prayer on the basis of his own experiences of looking. Recent discussion of this issue has turned upon the question of whether Renaissance focal perspective has a "scientific" basis that makes it objectively more "correct." But the issue cannot be resolved on those grounds at all, since there is no scientific way of addressing oneself to the subject matter of Renaissance art, any more than there is to that of Egyptian funerary painting. If a well-equipped modern photographer had been present at San Romano, he could not have made an image that would have conveyed Cosimo's or Uccello's understanding of the battle, for understanding involves insight and standpoint, some purpose that transcends momentary appearances.

In painting *The Deluge* Uccello was declaring, in effect, "Here is where I take my stand, bearing witness to a truth on the validity of which I am prepared to stake my integrity as a man." When it came to dealing with *The Sacrifice and Drunkenness of Noah* he could discover no ethical issue he might address himself to, wherefore the paintings seem hopelessly pedestrian in comparison with *The Deluge*, even though they are rendered in the same "style." The situation he faced in dealing with the *Rout of San Romano* was altogether different, for in that case he was convinced, it would seem, that neither the event itself nor his patron's attitude toward the event was "oriented toward truth." It was a matter of uncommonly good luck that he should have been able to paint the battle scenes in a manner that pleased his patron and at the same time allowed him to make clear that the battle was not to be taken seriously. It should not surprise us, and it probably did not surprise him, that such commissions were few and far between.

Uccello suffered the great misfortune that he was never given a subject like *The Tribute Money.* Not many artists were. Hence, there were not many occasions in the subsequent history of Florentine painting for anyone to follow in Masaccio's footsteps. If Masaccio himself had lived another fifty years, he might never again have had an opportunity comparable to the one he found in the service of Felice Brancacci at that particular moment in the political and religious life of Florence. There existed just then a situation that evoked from him an especially powerful response, a situation involving a highly charged relationship between self and world, between the artist's own role as a Christian citizen and a process of decision making that was going on in the city as it faced the prospect of another war with Milan. Masaccio rose to that occasion as no other artist in Florence could have done, yet the occasion itself had to be there.

Bearing all these things in mind, we can see how grievous a distortion Vasari perpetrated by picturing Uccello as having been fanatically obsessed with the mechanics of perspectival rendering. Perhaps during the long periods when he waited for a good commission to come along, he whiled away his time by making ingenious constructions such as the faceted chalice or the seventy-two-sided polyhedron (now lost). But those inventions had nothing whatever to do with his *standpoint.* For some reason, perhaps because of his temperament, the challenging commissions were not given him. Certainly he cannot have taken seriously the repellent little story that he had to illustrate in *The Desecration of the Host* toward the end of his life, probably in order to keep bread on the table. Little wonder that, as in the battle scenes, he should have resorted to using puppetlike figures on an artificially shallow foreground stage and beneath a black sky, in a world without sunlight. He, at least, knew how severe were the demands that the new perspective imposed upon an artist.

# Family and Church

In earlier chapters we considered a number of dialogical issues arising out of the dual allegiance owed to civil and religious institutions, with the disparate traditions and ethical demands that those allegiances entailed, but only in passing did we take note of the existence of the family, the third member of the institutional triad that was, for centuries on end, responsible for the maintenance of social cohesion and of ethical standards in the West. In order to round out our inquiry into the relation of perspective to content, let us look briefly at a few images in which that aboriginal social group is reckoned with—for it goes without saying that the family antedates both Church and State and has served in various ways as the archetypal model for each.

That is not to say, however, that the nature or role of the family has been a constant factor, for that institution has undergone changes in the course of our history no less than have Church and State. In the Dark Ages domesticity suffered a long eclipse. Throughout the Carolingian era, when painters mainly confined themselves to producing endless numbers of little evangelist portraits, there was rarely an image of a woman or a child, not even of the Virgin Mary and the Christ Child, to say nothing of a representation of any aspect of "family life." It is true, of course, that the artists were cloistered scribes, and they dealt with the evangelists as if they, too, had been cloistered scribes. But all the evidence available to us seems to indicate that in the long period of breakdown that followed the fall of Rome and the headlong decline of urban life the primary family relationship was to the clan rather than the intimate domestic circle of parents and children that the word *family* brings to mind today. Many people developed deeply negative attitudes toward procreation and genera-

tional continuity: as Alois Riegl pointed out at the turn of the century, in the Dark Ages children often were baptized with the names of sins or evils.

One of the most striking evidences of the renascence that began shortly before the year 1000 is to be found in the treatment of the Annunciation, a subject that had been as completely ignored during the Dark Ages as had been the Last Judgment. In works such as the Benedictional of St. Aethelwold and the Codex Egberti, scenes of the Nativity are celebrated with exuberant excitement, scenes that are in their very nature forward-looking and optimistic as nothing at all in the art of the immediately preceding centuries can be said to be. Another indication of the fundamental change of outlook that occurred reveals itself in the rapid growth of what is sometimes referred to as "the cult of the Virgin," a religious development that entailed an unprecedented and hardly explainable idealization of womanliness, motherhood, and childhood (in art and liturgy, if not in everyday family practice.) As early as the eleventh century there began to appear, in the East, mosaic and manuscript illustrations of the apocryphal life of the Virgin, in which special prominence was accorded her birth. Between the eleventh and the fourteenth century the rendering of the subject was enriched and elaborated upon, as we can see when we put side by side the twelfth-century mosaic at Daphni (see figure 56) and the frescoed version c. 1315 in the King's Chapel at Studenica in Yugoslavia (see figure 57). The latter involves a much larger number of figures and "props," by means of which the painter conveys his sense of the expansive significance of a birth's occurring within a diversified context. It would be a mistake, however, to interpret these changes as indicating any advance toward a perspectival art in the Brunelleschian sense, for though the fourteenth-century image is richer in anecdotal detail, it does not in the least suggest to us that we should "take our stand" with regard to a definable set of issues. The Nativity scene is part of a continuous frieze that includes other scenes to the right and to the left, all shown against the same background of discontinuous architectural fragments. The work lacks *integrity* even more obviously than does the Bigallo View of Florence and the Limbourg *Temptation*. Although Giotto's rendering of the subject is not one of his most compelling inventions, it possesses the formal, spatial, temporal, and psychological unity of a full-fledged Renaissance painting, even though it is earlier in date than the Studenica fresco.

In the very fact that artists from the eleventh century onward increasingly painted Nativity images, it is plain to see that attitudes toward matrimony and parenthood were becoming steadily more affirmative. Yet all the while the Church continued to assert that chastity was the highest virtue, the celebate monk, nun, or priest the truest of Christians. The first artist who fully understood the ethical conflict in all this was Pietro Lorenzetti. In *The Birth of the Virgin* (see figure 58), his fixed triptych of 1342, he confronted the fact that it was necessary that the ecclesiastical frame of reference and the domestic or familial

frame of reference be reconciled with one another and with the lives and ethical commitments of the Sienese Christians who were his fellow citizens.

In order to show that what he affirmed was in keeping with the long-established traditions of eccesiastical thought, he composed his Nativity scene in a way that differs only slightly from what we see in the twelfth-century mosaic at Daphni and the very early fourteenth-century fresco at Studenica. First, he introduced an element of tension between the masculine and feminine roles. The greater part of the composition is dominated by large figures of women, but Joachim, waiting in the anteroom and attended by another male figure (both drawn to a smaller scale), leans forward expectantly to receive the page's message. "It's a girl!" Men's passivity on such an occasion is underscored by Joachim's being seated, as is his friend, in contrast to the two female attendants in the right wing, who are doing something useful. On the other hand, the simple containment of the bedroom (clearly a modern

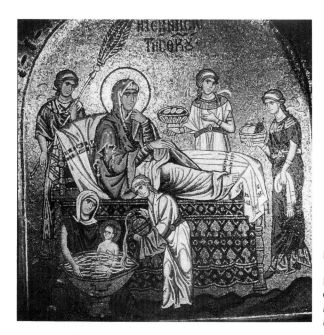

FIGURE 56.
*The Birth of the Virgin Mary.*
Byzantine mosaic, Daphni.
Courtesy of Mrs. Nike
Michalou-Alevizou, Greek
Ministry of Culture.

FIGURE 57. *The Birth of the Virgin.* Fresco in King's Chapel, Studenica, Yugoslavia.

Sienese bedroom) is contrasted with the corridor-like passageway the men occupy—a hallway that is illuminated by a prominent Gothic window, that is articulated by means of transverse beams and two kinds of vaulting, and that leads out into an open courtyard that unmistabably resembles the cortile of the Palazzo Comunale in Siena. All of this suggests that in spite of their temporary inactivity these are "men of the world" who normally play their parts on a deeper and more complex stage than do the women of the household—though the latter are no less important for that reason. There is an overall unity of space and time: it is appropriate that the washing of the baby and the relaying of the news to the father should occur simultaneously.

Second, Lorenzetti has employed his triple frame in order to establish a new kind of connection between the picture and its situation. The triptych was

FIGURE 58. Pietro Lorenzetti, *The Birth of the Virgin,* Museo dell'Opera dell'Duomo, Siena. PHOTO COURTESY OF ALINARI/ART RESOURCE, NEW YORK.

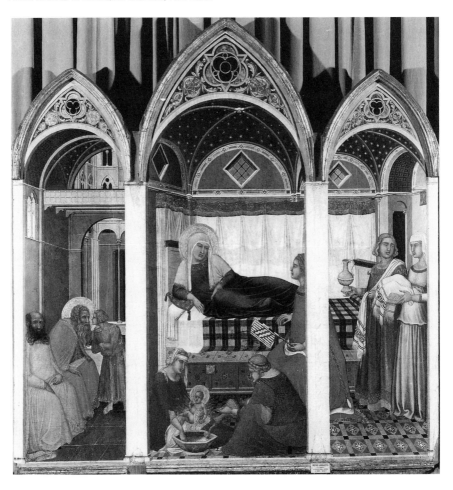

made for one of the side-chapel altars of the Cathedral of Siena, taking its form from the three-aisled structure of the church itself. The three-dimensional colonnettes of the frame are directly related to the many slender shafts of which the church is composed. Or the frame may be regarded as a miniature version of the pinnacled, three-doored entryway of the building itself, thereby associating entry into the church with entry into the life of the family, or, vice versa, the occasion of birth with that of entering the Christian community. In either case we find ourselves engaged in a provocative dialogue concerning the relation of the institution of the Church to the institution of the family.

Third, and most obvious, Lorenzetti's painting differs from the Studenica fresco in its use of perspective. Although there is some sense of central convergence, only the lines in the floor come close to meeting in a single point, as is not at all the case with the haphazard, nonenclosing architecture of the fresco. Nevertheless, it is by means of perspective—by organizing his whole scene so as to create the appearance (though hardly the "illusion") of there being a direct continuity between Anna's bedroom and the space we occupy in the cathedral—that Pietro in effect compels us to recognize that something of urgent importance is happening here. We cannot simply "enjoy" the painting as an attractive formal composition on a flat surface, for if we comprehend anything at all of the picture's message, we know that we are being urged to think seriously about the life of the family as it is led within the context of home, church, and city.

By attributing so much importance to the figure of Anna, Lorenzetti gives us a premonitory indication of the interest that would lead, more than a century later, to the widespread celebration of her abundant maternity in the many paintings of the Holy Kinship that were made, especially in the North, on the eve of the Reformation. In the Middle Ages it had been customary to identify the Virgin Mary with the Church and to declare her to be the Queen of Heaven, but from the early fourteenth century onward artists were increasingly drawn to the legend of Anna, according to which that venerable woman was the grandmother not only of Jesus but of five of his disciples—John the Evangelist, James the Elder, James the younger, Simon Zelotes, and Thaddeus. Probably the best-known version of the Holy Kinship is that of Geertgen tot Sint Jans (see figure 59) in which that extended family is shown to be gathered in the nave of a moderately large Gothic church, the size of which seems quite subordinate to that of the two men, five women, and assorted children in the foreground. The holiness of familial kinship affirmed by Lorenzetti in his altarpiece has been reaffirmed by Geertgen.

In Lorenzetti's painting, too, it seems legitimate to speak of his perspective as being "in the accepted sense of the word," as Roberto Longhi said of the perspective of Giotto's *coretti.* If one were to repaint his *Birth of the Virgin* in accordance with the *costuzione legittima,* the sense of the image would in no

way be altered or enhanced. One would still find oneself earnestly solicited to "take one's stand" with regard to the same issues and concerns. Alberti's refinements would make no real difference, for the vanishing point is simply not a factor that matters. Lorenzetti's image, for all its "inaccuracies," is a far more stimulating and thought-provoking invention than Ghirlandaio's large fresco of the same subject in Sta. Maria Novella, which I find to be a handsome but rather boring work of art (see figure 60).

<div align="center">

## II

</div>

The dialogue concerning the relation of Church to family was not exclusively a preoccupation of the laity. Since members of the clergy had in most cases grown to maturity within a domestic household, and since the family looms large in biblical story and thought (to say nothing of the fact that family ties were of the greatest importance in all that pertained to advancement in the ecclesiastical hierarchy), it should not surprise us to find that clerics, too, had to wrestle with the ethical and emotional concerns that arise out of familial

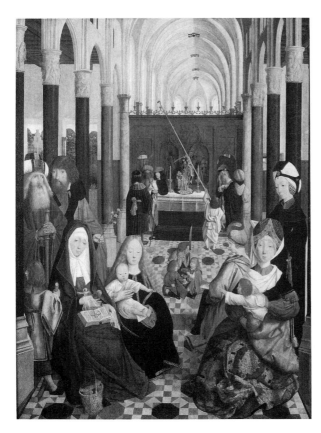

FIGURE 59.
Geertgen tot Sint Jans,
*The Holy Kinship.*
Courtesy of
Rijksmuseum,
Amsterdam.

relatedness. Surely the subtlest and most penetrating address to these matters was made by that subtlest of artists, Jan van Eyck, in his *Madonna in the Church* (see figure 62). As James Snyder has so persuasively argued, the little picture (12 inches high) is probably one of the artist's last works.

One begins with the assumption that the panel is, as it was first thought to be when it was rediscovered in the middle of the nineteenth century, the left half of a diptych. As has been demonstrated by Erich Herzog, the missing right half of van Eyck's work almost certainly corresponds as closely to the donor panel of the *Diptych of Christiaan de Hondt* (see figure 61) as the left half of the latter painting corresponds to the *Madonna in the Church*.[1] The four other pictures that have. also been attributed to the Master of 1499 are not in the least like van Eyck, wherefore we have reason to believe that the donor panel of the de Hondt diptych, with its many conspicuously van Eyckian details, cannot possibly have been an original invention of that now nameless "master." Inventiveness was not his forte, nor was he even a competent copyist. The mysterious subtleties of van Eyck's Gothic interior were more than he could cope with: he did not even attempt to capture the magical luminosity that pervades van Eyck's church, and he managed to transform the majestic yet girlish Queen of Heaven into a rather commonplace woman. Misunderstanding

FIGURE 60. Domenico Ghirlandaio, *The Birth of the Virgin*. Santa Maria Novella, Florence. PHOTO COURTESY OF ALINARI/ART RESOURCE, NEW YORK.

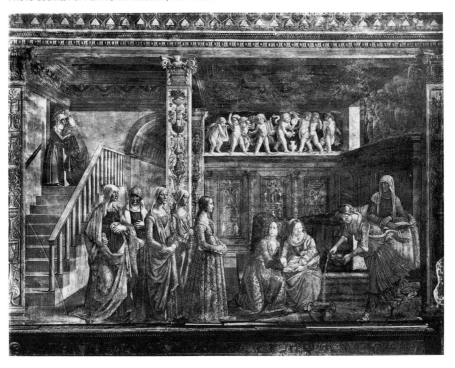

entirely the relation of the Virgin's splendid crown to the donor's mitre (which has been laid on a cushion on the floor like the crown of an adoring magus), he has gratuitously introduced a large metal vase filled with flowers as a purely formalistic balancing device (like the draped urn and other vessels one so commonly sees introduced into cheap chromolithographic reproductions of Leonardo's *Last Supper*). Whether the size of the vase should be judged in relation to the Virgin or to the church building we cannot tell, an irritating ambiguity that van Eyck would never have tolerated.

In the de Hondt diptych the size of the abbot seems overly large, but when the right panel alone is paired with van Eyck's picture (see figures 62 and 63), the two figures appear to have been drawn to approximately the same scale. When we see van Eyck's *Madonna in the Church* by itself, we are led to conclude that the artist has presented Mary as being about fifty feet tall within a hundred-foot-high Gothic nave, employing a symbolism of size that seems reminiscent of Phidias's huge statue of Athena in the Parthenon. But when we see her drawn to the same scale as the donor, we ask ourselves if she may not be of normal size within a miniature church whose vaults are only about twelve feet above the floor, as is the ceiling in the abbot's bedroom. And how large are we ourselves? Since our own eye-level is the same as that of the Virgin (we are not looking up at her from the standpoint of a normal observer on the floor),

FIGURE 61. Master of 1499, *Diptych of Christiaan de Hondt*. Royal Museum, Antwerp.

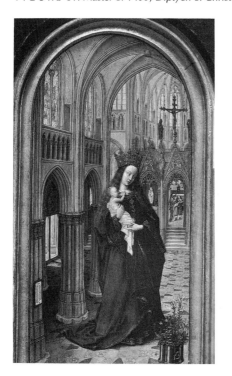
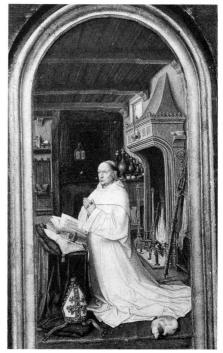

should we think of ourselves as being fifty feet tall? But then what are we to make of the fact that the figure we are looking at is little more than six and a half inches high, the great nave only twelve inches? That is to say, is the reign of Christ and his Mother rightly symbolized by a gigantic Gothic church, or is it as intimately personal as the "still small voice" in which God revealed himself to Elijah on Mount Horeb? The image itself is as small as the little Crucifixion diptych we see hanging inside the canopied bed behind the abbot.

Clearly it was van Eyck's purpose to engage us in the subtlest meditation upon *scale* that is to be found in all Western art. The figure on our left is at once a virgin mother—a very young mother with an unusually small baby— and a regal queen wearing an enormous crown and appearing, because of the small size of her head in relation to her body, to be extraordinarily tall. As a stately queen, her stature dwarfs that of an average person in the same way that a thirteenth-century Gothic cathedral dwarfs all the other buildings around it and also the worshiper on its floor. Yet this tenderest of young mothers occupies the church as a housewife might occupy her living room or as the abbot occupies his bedroom. That largest of public gathering places has become the locus of an intimately personal encounter. In the richest and most provocative of all metaphors, the Virgin is shown to be queen, priestess, mother, and maiden all in one.

For his part, the clerical donor (and surely the original donor was a member of the higher clergy) is shown to play the contrapuntal role of "virgin father"—*un père spirituel,* a father-confessor who is himself engaged in an act of confession, perhaps, in the privacy of a domestic interior. Yet his jeweled miter and gilded crozier remind us of the role he normally played within, and only within, a stately church. Herzog suggests that the bedchamber is not merely that, but should also be seen as a thalamus, the mystical bridal chamber that symbolizes the relation of the sacrament of ordination to the sacrament of marriage. The bedroom contains many objects that can be interpreted as Marian symbols.

While the point is not without validity, I believe Herzog errs, as does Roosen-Runge in his analysis of the *Rolin Madonna,*[2] in trying to find a unitary meaning that may be thought to correspond to the aesthetic unity of the composition. Both men try to relate all the symbols to one signification only—the Virgin Mary—but in so doing they ignore or minimize the dialogical tension that gives the painting its striking power. I think it likely that van Eyck meant to aver that the fatherhood of a priest is as charged with familial implications as is the motherhood of Mary with ecclesiastical meaning. Like the Arnolfini bedchamber, this one, too, invites us to ponder the sacral significance of conjugal matrimony as well as the abbot's mystical marriage to the Church—to consider the relation of all motherhood to that of Mary the Mother of God, to reflect upon the relation of all fatherhood, parental and priestly alike, to that of

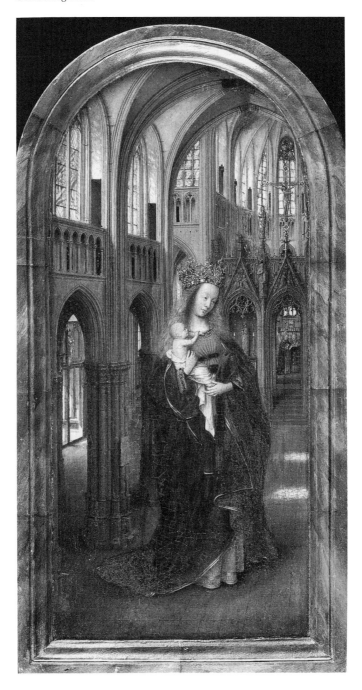

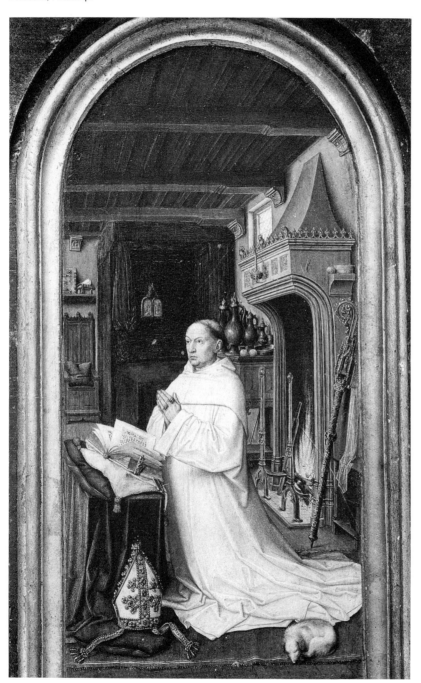

God the Father, who is visibly present to us here in the form of the smallest fig-
ure of all, the tiny baby. For "He that hath seen me hath seen the Father. . . . I
and my Father are one" (John 14:9).

In the copy of the *Madonna in the Church* that Gossaert made for Antonio
Siciliano, in which the right half of the diptych is given over to a deep land-
scape wherein Siciliano is being introduced to the Virgin by his patron saint,
the artist has altered the church, as Herzog observes, so as to show us the
south wall of the nave, which is not visible in van Eyck's version or in that of
the Master of 1499. Gossaert, who was presumably acquainted with the origi-
nal diptych, recognized that his open landscape could not be continuous with
the architectural interior—or, to put it the other way around, he perceived that
the two architectural interiors in the Eyckian diptych are continuous with one
another. The one opens directly into the other, so that the two figures, Virgin
and donor, look toward one another, but their eyes do not actually meet, since
the kind of vision van Eyck had in mind is not that of the eyes. In the donor
panel of Christiaan de Hondt two sources of light are shown, a flickering fire in
the fireplace directly behind the abbot and a small window admitting daylight
just above the mantelpiece. Yet Christiaan's face is not illuminated by light
from either of these sources but rather by light coming from the direction of
the clearstory of the church—by a mystical light coming from the north, as
Panofsky pointed out many years ago, a light that is not of this world. Well
may we bitterly lament the loss of the original right wing, for van Eyck must
surely have handled the interplay among the firelight, the daylight, and the
mystical luminosity as only he could have done in his last years. The Master of
1499 probably captured no more of van Eyck's magic in the right panel than
he did in the left. In all likelihood the continuity of the illumination from the
left panel to the right, along with the spatial continuity that makes the two
rooms so mysteriously analogous to one another, was one of the chief glories
of what may well have been van Eyck's final masterpiece.

## III

A little less than a hundred years later another great artist, Albrecht Altdorfer,
addressed himself, in his painting *The Birth of the Virgin* (see figure 64), to the
relation between Church and family, but from an altogether different point of
view. As in van Eyck's diptych, we find cathedral church and domestic bed-
chamber brought together, though now in so intimate a fusion that Anna's
canopied bed seems to be located in the north aisle of an immense church,
where it rests upon a wooden floor that is elevated a few feet above the floor
of the church itself. Upon this foreground stage (in a fully theatrical sense of
the word), separated from the nave of the church by a balustered railing, there
are six figures—Anna, Joachim, two midwives, a servant, and the newborn

infant. On the opposite side of the church we see a young woman (engaged in washing the floor?) and an older couple who are simply bystanders. In the air above, at the level of the aisle vaults, there is a whirling ring of some three dozen childlike angels who appear to be singing. Both their busily varied poses and the variegated colors of their dress are strongly suggestive of musicality. At the center of the painting, and of the ring, a larger angel is swinging a censer that gives off clouds of smoke.

Scholars who have written about the painting—Baldass, Tietze, Benesch, Winzinger, et al.—have belabored an obsessive concern of German art historians, *der Raum* ("space"). They have emphasized the artist's quite extraordinary evocation of vast spaciousness by means of his diagonal perspective and his sharply foreshortened ring of angels. Mention has commonly been made of a

FIGURE 64. Albrecht Altdorfer, *The Birth of the Virgin.* Alte Pinakothek, Munich. Courtesy of Bayer. Staatsgemäeldesammlungen.

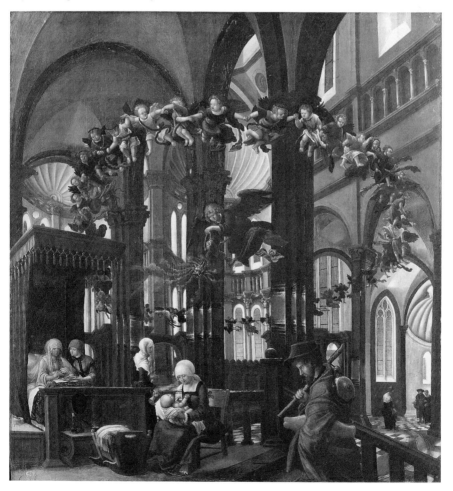

signed drawing by Altdorfer, now in Berlin, that looks as if it might have
served as a preparatory study for the Munich panel (see figure 65). The identity
of the building has not been established. The drawing may be based upon
Hans Hieber's design (c. 1520) for the new Schönen Maria church in Regens-
burg. It may have been inspired by the architectural setting we see in Wolf
Huber's drawing *The Presentation in the Temple*, which may also derive from
the Schönen Maria church. Or it may be an original architectural invention,
drawn when Altdorfer was city architect of Regensburg. While the orthogonal
lines in the drawing do not meet in a single point, the nature of the building
itself is made perfectly clear in this perspective image.

A grid pattern has been superimposed on the drawing, as if to facilitate its
enlargement and transfer. But if a similar grid is laid over the painting, there is
to be found no correspondence at all between the disposition of elements in the
drawing and in the large picture. In the painting there are simply not enough
orthogonals to enable us to locate a vanishing point, nor can we make even a
wild surmise as to the floor-plan and elevation of this imaginary church. Com-
posed of Romanesque, Gothic, and classical elements, they cannot possibly be
fitted together into an intelligible whole, for they lie in ill-assorted planes and
appear to be seen from a variety of unrelated vantage points. Baldass observes,
without comment, that the building could not possibly have been built.
Benesch remarks, in comparing the drawing with the painting, that in making
the latter the artist "threw to the winds" his architectonic schema in favor of a
"magical chiaroscuro." Winzinger speaks of its being "pure poetry."

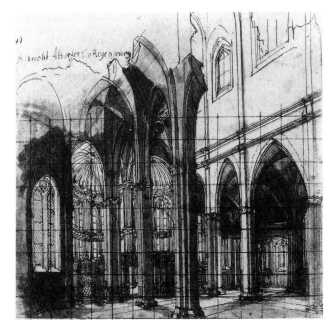

FIGURE 65.
Albrecht Altdorfer,
cut-away drawing of a
church.
Courtesy of Staatliche
Museen zu Berlin,
Stiftung Preussischer
Kulturbesitz,
Gemaeldegalerie.

And yet the building was laid out on the picture surface by a practicing architect who is known to have designed several buildings in Regensburg and who was, moreover, a member of the town council, a burgomaster, and a trusted emissary of the city. On the face of the matter one might suppose that Altdorfer should have been especially concerned with the symbols of established institutional authority. Was he merely seeking a novel aesthetic effect? I think not, though I must admit that it is difficult for us to assess his intentions without knowing when and for whom *The Birth of the Virgin* was painted. It has generally been assigned a date of around 1520, presumably because of its relation to Hieber's church and to Huber's drawing. I would suggest a date of 1530 or a little later, for I am convinced that the painting is demonstrably related to Altdorfer's sympathy for the Protestant cause, though we do not know how early the painter may have turned in that direction.

His attitude toward the Reformation appears to have been ambivalent. He is known to have participated in inviting a Protestant preacher to Regensburg in 1533, and there is said to be evidence of his Lutheran conviction in the twenty-page will that he drew up a month or so before his death in the spring of 1538. On the other hand, in 1534 he was appointed to be a guardian of the Augustinian monastery in Regensburg, and at some still later date he accepted a commission from the bishop of the city to decorate the episcopal bathroom with a frescoed image of nude men and women bathing. (Fragments of the painting survive, as does the preparatory drawing, now in the Uffizi.) It seems likely that Altdorfer was sympathetic to Luther's message but would have liked to see the unity of the Church preserved. What we find in the Munich panel is a fundamental reassessment of the nature of the Church as institution and of its relation to the family as the embodiment of a different principle of relatedness.

In order to discover the sense of the painting we cannot do better than to turn to the writings of Luther himself. One of the issues on which Luther was persistently outspoken was the relation of Church to family. Although he thought chastity admirable, he was bitterly opposed to the enforcement of clerical celibacy. "For we cannot vow anything contrary to God's commands. God has made it a matter of liberty to marry or not to marry, and you, you fool, undertake to turn this liberty into a vow contrary to the ordinance of God. Therefore you must let it remain a liberty and not make a compulsion out of it." Acting upon the strength of that conviction, Luther renounced his monastic vows, married his "dear Katy," and fathered three sons and two daughters. "I find there is nothing but godliness in marriage," he declared. Or again: "Married life is not a subject for jest, but an excellent estate. . . . If bishops and emperors desire to lead their lives in piety, they must become married, just as they also come out of this estate." By contrast, Luther found the celibate lives of the clergy to abound in abominations. "The pope and his cardinals, monks, nuns, and priests have tried to improve things and ordain a holy estate in

which they might live in holiness and chastity. But how holy, pure, and chaste the lives of popes, cardinals, monks, priests, and nuns have been is so apparent that the sun, moon, and stars have cried out against it. Pigsties are nasty, dirty places, but they are clean and pure compared with the cloisters. . . . Why did this happen? Because they tore down and despised God's holy ordinance of the estate of matrimony."

Though neither Baldass nor Tietze nor Benesch nor Ruhmer nor Winzinger mentions the fact, the most prominent figure in Altdorfer's painting is not Anna or Mary but Joachim, husband and father, who is pictured in the act of mounting the steps that lead from the floor of the church to the higher floor of the natal chamber. He carries under his arm a loaf of bread and over his right shoulder a staff from which there is suspended a large flask of wine. What he carries, needless to say, are the elements of the Mass. But in this church there is no high altar, no vested clergy, no reference to the celebration of the sacrament that has always been the very centerpiece and cornerstone of Catholic worship. "No tongue can express and no heart can grasp," said Luther, "the abomination of the Mass. It's a wonder God hasn't destroyed the world long ago on account of it."[3] Though he rejected the doctrine of the Transubstantiation and the belief that the Eucharist constitutes a propitiatory sacrifice, he did accept the notion of Consubstantiation—the belief that there is a Real Presence in the elements of the Lord's Supper.

The Swiss reformer Zwingli, who reached similar conclusions at about the same time as Luther, though for the most part independently, went even further. One of the theses he defended at Berne in 1523 affirmed that the Mass, in which Christ is offered to God the Father for the sins of the living and of the dead, is contrary to scripture and a gross affront to the sacrifice and death of the Savior. Zwingli rejected Consubstantiation as well and held that the Lord's Supper is a commemorative celebration only. Like Luther he held that "marriage is lawful to all, to the clergy as well as the laity," and in 1524 he, too, took a wife, one Anna Reinhard. From the beginning of his ministry, Zwingli vigorously repudiated those Catholic conventions that regulated what men ate. It is altogether possible that Altdorfer had some knowledge of the teachings of Zwingli, who was killed in 1531 in the course of a civil and religious war among the Swiss cantons. At any rate, it is easy to see that the importance Altdorfer assigns to the figure of Joachim, bringing his family the same food that Christ and his disciples ate at the Last Supper, is consonant with the characteristically Protestant belief in "the priesthood of all believers."

Sensitive artist that he was, and practicing architect, Altdorfer was no doubt fully aware of the relation between the regularities of architectural design and the regulatory functions of the institutions that had traditionally erected great stone edifices in cities—aware, too, of the regulated and regulatory architectonics of Albertian perspective. We can best understand his intention if we

place his painting *The Birth of the Virgin* alongside Roger van der Weyden's *Seven Sacraments Altarpiece* (see figure 66), which also includes a bedroom scene in the side-aisle chapel of a large church. Van der Weyden's painting constitutes a splendid defense of just what it was that Luther and the reformers were later to sweep aside: a pattern of ritual and sacramental observances, of beliefs, traditions, and practices, that shaped and affected the daily lives of the vast majority of fifteenth-century Christians. That pattern provided what has been called the "sacred canopy" of medieval life, providing it with meaning and security. Van der Weyden's altarpiece was made for the Bishop of Tournai, Jean Chevrot, and explicitly affirms the all-encompassing role of the Church in measuring out, by means of sacramental observances at crucial points, the course of the Christian's life from birth to death. The regularities of this Gothic church perfectly symbolize the regulatory authority of the Church as it dispenses the "means of grace" for the salvation of men's souls.

Van der Weyden's perspective is so nearly perfect that one has to look carefully, or even to draw out his orthogonal lines on a photograph, in order to ascertain that he has used three points of convergence rather than one— though the painting would not have been the least bit better if he had followed Alberti's "rules." Yet even van der Weyden may have had some misgivings about the Church and its sacramental shaping of men's lives, for he has given central importance to the enormous image of Christ Crucified and of the grieving women, all drawn to so large a scale as to make the many figures engaged in administering and receiving the sacraments seem marginal (as they are in the composition). Even the church building itself seems hardly adequate to contain this higher and more personal order of meaning.

Altdorfer, for his part, thought it appropriate to hold fast to the symbolism of the great cathedral church, even as he was engaged in "disintegrating" its structural integrity. Though his sympathies may have lain with Luther's cause, he seems to have drawn back from a full acceptance of a central consequence of the reformer's doctrine—the assertion of the autonomy of the self. If all believers are to be considered priests, and if there is no institutional hierarchy, no pope, no bishops, and if the "sacred canopy" has been torn down, who can know where he stands? Focal perspective, as we noted at the outset, is meaningful only if the painter assumes that there is a steadfast order of things "out there" in the world with reference to which he can say, "Here I stand!" Luther's preaching had placed that objective certainty in jeopardy.

It is in the very nature of Protestant thought that none of the various denominations should have been able to bring forth a "doctrine of the Church," a theoretical statement of the nature of the Church's being. For the Platonic realists of the Middle Ages the issue posed no problem at all: for them, the idea of the Church was timeless and unchanging, a real entity, created and established by God himself, a house built upon the rock. The relation of that idea to a large

and well-ordered stone building was so generally self-evident as to afford the medieval architect a splendid opportunity for the invention of formal metaphors that had the widest popular appeal. For the Protestants, however, with their strongly nominalistic cast of mind, their inclination toward identifying the Church with congregations of living members, and their rejection of both a personified "Ecclesia" and an association of the Church with the supernal personhood of the Virgin Mary, the realist bases of architectural symbolism were all but obliterated, as Altdorfer seems to have perceived. Absent the centrality of the Church, yet given the centrality of the autonomous self, con-

FIGURE 66. Roger van der Weyden, *Seven Sacraments Altarpiece.* Royal Museum, Antwerp.

fronting the world in solitude, what emerged inevitably was the art of landscape painting—of which Albrecht Altdorfer was perhaps the very first practitioner, as well as being the chief inspiration of the school of South-German landscape painters that followed in his wake.

Though the Protestant church has not created a great architecture (with the exception of the Church of England), it has from the beginning placed an emphasis upon participatory music that has distinguished its forms of worship from those of the medieval church. One could argue that the Reformation itself was closely related to changes that were taking place in the art of music during Luther's lifetime. The basic symbolism of polyphony (that is, of two or more voices pursuing their separate melodic lines within an agreed-upon rhythmic and modal framework, resolving their transient dissonances in tentative harmonies but pressing on always toward an ultimately harmonious and all-resolving conclusion) increasingly appealed to cultivated Europeans from the fourteenth century onward. But it entered an altogether new stage in its development with the inventions of Josquin des Près and his followers—inventions that pertained to the driving dynamics of personal consciousness and to the articulation of nuances of personal feeling as earlier music had rarely done. Whereas only a devoted musicologist can take real pleasure in the music of Dufay and Binchois, that of des Prés, or of the court of Henry VIII, is plainly on our side of a watershed that lies in the vicinity of the year 1500. It was to just that new sense of dynamic musicality that Altdorfer alludes by introducing his great circle of fluttering angels who set the church to ringing and reverberating with their song, and by transforming the architecture of his church into a flickering, nontectonic array of varied shapes and chiaroscuro patterns.[4] It was said in his own day that Luther had conquered Germany with singing.

<div align="center">IV</div>

During the century and a half that followed Altdorfer's death, a new genre in the art of painting developed in the Low Countries—the interior architectural vista. The earlier examples, by artists such as the Steenwycks, are generally imaginary; the later examples, by Saenredam, de Witte, and Houckgeest, are mostly depictions of identifiable buildings. The genre has been studied at length by art historians (from Hans Jantzen and Dagobert Frey through Friedrich Heckmanns and Rob Ruurs) who, not surprisingly, have been mainly preoccupied with problems of *Raumdarstellung* and of surface composition. Their *modus cogitandi* has been much the same as John White's: they have not asked why anyone should have wanted such pictures or what they may have meant to the artists who painted them and to the people who bought them. Though the history of the genre is interesting, it must suffice for our present purposes to consider only two of the more than two hundred architectural

paintings by Emanuel de Witte—or in fact only one of them, and that one as it appears in another picture, his unique *Family Portrait* of 1678, in which the dual allegiances to Church and family are set forth with remarkable subtlety (see figure 67).

Let us begin with a few general observations about seventeenth-century Dutch paintings of church interiors. It is easy to regard these works as being hardly more than large picture postcards, souvenirs made for people no longer seriously concerned with religious matters. Witness the dogs, children, beggars, and miscellaneous bystanders one so commonly sees in such images. But if we understand church buildings to be primary symbols of the enduring reality of the Church, and if we concede to the artists a seriousness of concern that is commensurate with the intensity of their acts of looking, composing, and rendering, then we may see those paintings as religious affirmations.

The most engaging and provocative of the works of both Saenredam and de Witte are those in which the artist has chosen a perspectival vantage point from which he can win for himself a harmonious but asymmetrical composition created out of the regularly disposed elements of a great basilica, a composition that had little or nothing in common with the tectonic schema that the architect himself had invented as an appropriate symbol of the Church. (Altdorfer had achieved this sort of composition by a deliberately irrational shuffling of architectural elements that were probably drawn from many sources or were simply invented for his purpose. The Dutchmen managed it by choice of standpoint alone.) What is small and marginal in the building itself may loom large in the painting, in a hierarchy of sizes that depends entirely upon the location of the crucially important "I" (or eye), rather than upon a pattern that obviously inheres in the church itself. By such means the artists did not seek to deny or diminish the significance of the Church but only to establish a relationship of reciprocity between the mobile, self-conscious, self-centered individual and a collective ordering of things that could be represented by an enduring immensity (the painters had no interest in little parish churches), even though the nature of that encompassing immensity could not be grasped in its entirety. What mainly matters is the relation of the Church to *praxis*—to moral action, to the on-going demands of "life as drama"—wherefore there are some fifty pictures by de Witte in which a preacher is shown to be addressing his congregation, expounding the relevance of a particular biblical passage to daily decision making and to the modes of self-understanding with which his flock had to wrestle. Although the Lord's Supper was presumably celebrated in the great churches of Amsterdam and Delft, that sacramental service is never represented. If we compare any or all the church paintings with Brunelleschi's *tavolette*, we see at once that the qualities of formality and of transcendency that Filippo associated with the Baptistry are virtually absent, while the openness, irregularity, and mobility he linked with the Piazza della Signoria have

become central to the artists' religious concern—that is, to their sense of what is essential to the "binding-up" of the community and of the world.

While Saenredam usually meditated in solitude upon the experience of being inside an old church, de Witte commonly populated his interiors with numerous visitors and with congregations of worshipers. The members of such assemblies—male and female, old and young, rich and poor—are gathered loosely around the pulpit, some standing, some seated in choir stalls, some on low stools, some listening attentively, some gazing in other directions, all participating in a social occasion that is not at all governed by the architectonics of the building itself but rather takes on something of the undulating flexibility we see in Rembrandt's *Hundred Guilder Print* and in his small etching *Christ Preaching* and that we hear in the contrapuntal structure and rhythms of the church music of the period. Yet the age and grandeur of the Gothic interior are made to seem wholly consonant with Calvinist worship. Plainly the Dutch felt no desire to tear down the medieval buildings and to replace them with modern ones; the need for the kind of steadfastness and continuity within the

FIGURE 67. Emanuel de Witte, *Family Portrait* (1678). Alte Pinakothek, Munich. Courtesy of Bayer. Staatsgemäldesammlungen.

Christian community that architecture so well symbolizes was probably greater in the seventeenth century than in the fourteenth when the social order had possessed a clearly established hierarchical structure.

In those fifty paintings by de Witte that show a preaching service in progress, the pulpit is situated against one of the nave piers and is seen from a vantage point in the aisle behind, in the opposite aisle, or in the transept, so that the axiality that is the most conspicuous feature of every basilican church is explicitly denied, while the freedom of the worshiper to participate in a variable process of ordering is just as explicitly affirmed. De Witte employs architectural elements (arches, moldings, windows, mullions, piers), together with memorial plaques, banners, chandeliers, organs, and miscellaneous furnishings, to create a composition that has much in common with still-life painting and that is analogous to the casual ordering of the people gathered on the floor of the church.

In all this de Witte's church paintings are close to Altdorfer's *Birth of the Virgin*. Although his preoccupation with the family as social paradigm was not so aggressively asserted as was Altdorfer's (for the matter of clerical celibacy had long since been settled in the Netherlands), de Witte's mode of composing suggests a kind of relatedness that we can easily associate with the informalities of domestic life, in contrast to the stately and hierarchical characteristics of the medieval buildings he chose to represent. His orthogonals converge to a single point, but, as in Altdorfer's picture, there are so few of them that one often finds it difficult to locate the point of convergence.

And so we come back to that unique and especially revealing example of the artist's work, his *Family Portrait* (see figure 67), in which we see on the far wall a miniature version of one of the artist's many representations of the Oude Kerk in Amsterdam. The painting within the painting is strikingly similar to (though not identical with) the view of the Oude Kerk in The Collection Tresfou, Johannesburg, a view in which (according to Ilse Manke) portraits of the same family are to be seen in the right foreground (see figure 68). Both paintings are dated 1678 and are very nearly the same size—66 x 84 cm and 80.5 x 69.5 cm, respectively. They were evidently painted as a pair, perhaps the only pair ever made in which one of the two appears also in the other, with minor alterations.

The differences are not without interest. In the Johannesburg painting the father of the family faces the preacher while the mother and daughter are looking out toward us. In the miniature version, which is only about seven inches high, all three are turned inward toward the pulpit, gravely attending, we may suppose, to their spiritual well-being, for any attempt at portrait likenesses at this scale would have introduced a miniaturist's technique that would have been incompatible with the overall character of the picture. De Witte has also altered the lower-left corner of the Johannesburg composition, substituting a standing couple and a dog for the miscellaneous elements in the large picture,

which are plainly subordinate to the portraits on the right. In the small version the latter figures are in shadow, and it is the couple with the dog that stand out—and with reason, for the descending pattern, from man to woman to dog, is re-echoed in the relation of father to daughter to dog in the portrait group.

With that connection in mind, we cannot fail to see the relationship (again from upper right to lower left) between the prominent column in the church painting and the column we see through the doorway behind the daughter, the two being of exactly the same width on the surface of the portrait. A similar connection exists between the arches of the Oude Kerk and those we see

FIGURE 68. Emanuel de Witte, *Interior of Oude Kerk, Amsterdam.* Collection Tresfou, Johannesburg.

through the rectangular doorway—arches that enframe the girl's head in a way that echoes the enframement of the female bust over the door and of the mother's head by the mantelpiece columns on the opposite side of the picture. The father is seated in a high chair, somewhat as the preacher is elevated in his pulpit directly above, while the mother is seated at a lower level, as she is in the church scene. Each of the figures occupies a position that is closely related to architectural patterns. It is entirely appropriate that the father's position should be the one that is least restricted by the domestic architecture and that is most clearly related to the larger order of things symbolized by the gathering of the community in the great church.

Through the doorway at the left we see, between the column and the doorjamb, a marble statue of a nude female figure that faces in the same direction as the daughter and that is drawn to just the same scale as are the men and women in the foreground of the church scene on the wall. The statue alludes, in all probability, to the popular notion of a "love garden," introducing still another ethical and emotional factor into the dialogical argument of the painting. Although in most of de Witte's church pictures both men and women are present, men generally predominate in the congregation and a man always occupies the pulpit. But in the *Family Portrait* there is no mistaking the fact that the women are in their own domain, their dominance being reinforced by the statue in the garden and the bust over the door. The interplay between the masculine and the feminine, the dialogue between the public and the private, the institutional and the personal, is as striking as in van Eyck's *Madonna of the Chancellor Rolin*, but the balance or thrust of the argument is altogether different.

The church painting on the wall appears to be approximately as tall as the doorway—that is to say, about seven feet high, or much larger than any painting de Witte is known to have painted. In other words, the artist has greatly enlarged the picture in relation to the room in which it presumably hung, while at the same time he has sharply reduced its size (from a height of thirty-two inches to about seven inches) as it appears on the surface of the canvas. As in van Eyck's *Madonna in the Church*, we find here an ingenious and thought-provoking essay on the significance of scale, on the relation of persons to the institutions of Church and family, and of living persons to images of the human figure in painting and sculpture.

As we can see, by means of perspective de Witte has integrated the structure of the church with that of both the living room and the figure group so as to create what amounts to an allegory of the relation of Christian church to Christian family, or about an all-encompassing religio-ethical order of things by virtue of which men may know how to establish right relationships with one another. That is exactly the sense of the man's lifting a bunch of grapes from the tray of fruit that his daughter holds out to him. The gesture is based upon the twenty-seventh emblem in Jacob Cats's *Proteus of sinne-en*

*minnebeelden* (1618), the principal Dutch contribution to the plethora of emblem books that appeared in Europe during the last years of the sixteenth century and the first half of the seventeenth (see figure 69). The emblem is accompanied by a twenty-four-line poem that gives good advice that Henkel, in *Emblemata*, epitomizes as "rechter Umgang"—right relationships, or the right way of going about things. The verse is surmounted by the phrase *Omnibus Ansa Rebus Inest* ("The handle to all things is in the things themselves"). One is counseled to learn how to manage matters not by intellect but with sensitivity, not grasping too tightly or pinching too sharply but recognizing that in all things there are certain rules and laws that must be obeyed by anyone who would be "een handigh man," a deft or clever man. Cats concludes his verse with the advice that one should seize the pot by the handles (or "ears"), beautiful fruit by the stem, dirty scoundrels by the neck; one should catch fools by words, naughty boys by the sleeve, and simple maidens by fidelity. Both Church and home, one might say, are "handles" by means of which a good and well-ordered life may be grasped.

In his church interiors no less than in his one family portrait and in his one domestic genre scene, de Witte declares that, on the one hand, buildings should remind us that "daer is in alle saecken / Seker regel, seker wet" ("There is in every matter certain rules and certain laws"), but, on the other hand, those rules and laws should not be regarded as constituting a rigid code but rather a flexible and infinitely variable framework within which each of us must exercises wise judgment, good taste, and the *handigheid* that becomes

FIGURE 69. Jacob Cats, Emblem 27 in his *Emblemata Moralia et Aeconomica* (1627).

the canny man. No less than Brunelleschi and Alberti, he presents us with a "legitimate construction," but his sense of what constitutes legitimacy is different from theirs. For all the differences of style and technique that separate them, de Witte's *Family Portrait* is spiritually akin to the family pictures of Rembrandt, including his pictures of the Holy Family. It was just that sense of the sacredness of the family, we may suppose, that led de Witte's patron to commission, as a companion piece to the portrait of his family, a view of the Oude Kerk that included him and his wife and their daughter.

Such a relationship could hardly have existed in Brunelleschi's mind between Sto. Spirito and the Pitti Palace. The institutional order to which those buildings refer, and which they sustain, is symbolized, insofar as domesticity is concerned, by Piero (?) Pollaiuolo's *Annunciation.* (see figure 70.) The painting involves a dialogical relationship between male and female, active and passive, openness and containment, that is reminiscent of Pietro Lorenzetti's *Birth of the Virgin.* Behind the mobile and gesticulatory figure of the angel a busily articulated corridor pulls us urgently toward the open sky and a far hori-

F I G U R E 70. Antonio or Piero Pollaiuolo, *Annunciation.* Courtesy of Staatliche Museen zu Berlin, Preussischer Kulturbesitz, Gemaeldegalerie.

zon, while the windowless bedchamber behind the Virgin seems spaciously tranquil by comparison. The elaborate perspective does not define an interior the figures occupy, for they constitute a frieze in the immediate foreground in a truly trecento manner. As in so many other perspectival paintings, the grids serve to establish a lawful frame of reference, an almost legalistic context, a *costruzione legittima*, within which we are invited to understand the meaning of Gabriel's message. Through the window over his head we can see an adjoining balcony from which the owner of the palazzo (surely not the carpenter Joseph!) could have had a commanding view of the Tuscan countryside and of the walled city of Florence—its shape and skyline clearly dominated by the Duomo and the Palazzo Vecchio.

# The End of the Matter

Since the end of the eighteenth century, people's sense of the binding and legitimatizing function of established institutions—civil, domestic, and religious—has steadily declined. The course of that descent has been traced, from another point of view and with other purposes in mind, in Richard Sennett's *The Fall of Public Man.* From what has been said in the foregoing chapters, it has become apparent, I trust, that focal perspective is a device that for about five centuries was bound up with the idea and condition of "public man"— that is to say, with the attitudes and commitments of men who affirmed an order of things out there in the world that can be comprehended and that demands that we assume a responsible and responding stance before it, and also makes it possible for us to do so.

Since the changes that have taken place are related to the decline of monarchical institutions, both civil and ecclesiastical, and to the rise of democratic ones, we should expect to find evidence of fundamental changes of standpoint, or of perspectival usage, in the art of the Dutch Republic of the seventeenth century. Rembrandt made no use of linear perspective in any of his hundreds of images, for he was not at all concerned with the institutions that had erected the kinds of building that had challenged the imaginations of all the great perspectivists of the Renaissance. He was primarily a portraitist; he was interested in the intimately personal nature of persons, singly and in their relation to one another. Though he did not address himself to the old issues, his ablest pupil, Carel Fabritius, did in one of the subtlest inventions in Dutch art, the little painting (only six inches high) that is entitled by the National Gallery, rather unimaginatively, *A View of Delft, with a Music Instrument Seller's Stall* (see figure 71).

FIGURE 71. Carel Fabritius, *A View of Delft*. National Gallery, London.

There is, in fact, nothing in the painting to indicate that the two instruments are for sale or that the solitary man is the keeper of a music shop. He has his hand to his chin in a classic philosopher's pose, and though a fairly strong light is shown to be falling on the lute that leans against the wall, he is in shadow. What sort of space he occupies we cannot tell. He appears to be wedged tightly between a tabletop and a trellis consisting of ten vertical palings—palings that can be associated in one's mind with the strings of the instruments, with the striations on the bottom of the lute, with the lines of a musical staff, and with prison bars. The lute and the viol, the scroll of which has been carved into a little face, are arranged so as to form a tabletop still life. They rest upon a loosely folded blue cloth before a plastered wall that is a miniature masterpiece of "abstract expressionist" brushwork, composed of the same colors that are used in rendering the street, the buildings, and the trees in the right half of the picture. In all likelihood, Fabritius had in mind an analogy between painting and music.

What we see on the right, in contrast to the flattened and compressed arrangement on the left, is an exaggeratedly wide-angle view of the Nieuwe Kerk, the Stadhuis (small in the distance), and a row of gabled houses. (A photograph taken of the Nieuwe Kerk with a 35-mm lens is shown in figure 72; Arthur Wheelock has argued that Fabritius looked through a double-concave lens to obtain his wide-angle perspective.[1] Like the painting, the photograph magnifies the breadth of the paved *plein* that is formed by the intersection of two relatively narrow streets.) Fabritius has done something that is surprisingly similar to what Brunelleschi did in painting his *tavolette*: he has taken his stand at an identifiable spot—at the corner of the Vrouwenrecht and the Nieuwelangendijk—from which vantage point he (or his imaginary philosopher) contemplates the architectural symbols of the institutions of which he is a member. As in the second *tavoletta*, the foreground consists of a broad cobblestoned piazza, beyond which we see the narrow canal that formerly ran around the trapezoidal area that contains the Nieuwe Kerk and the Stadhuis, which are separated by the Groote Markt, about a hundred yards wide.

Fabritius's perspective is the opposite of Castagno's. Where the earlier artist employed a "telescopic" scheme in order to make a deep room seem shallow, the Dutch painter has looked at his scene through the "wrong end" of a telescope, thereby producing a panoramic perspective that makes proximate things seem very far away. Castagno minimized the stage-space on which his tableau of the Last Supper, in all its stasis, was displayed for the sake of a gathering of "immobilized" nuns. Fabritius, on the other hand, made his urban scene seem strangely remote from his artist-musician. One might say that between 1452 and 1652 the world had indeed become a much wider place in which to live, and the role of the artist more problematical and more private.

Though his theme is related to that of the *tavolette*, it is even closer to the *View of an Ideal City* shown in figure 25, for it includes domestic as well as civic and religious architecture, and it raises the possibility of there being a single standpoint from which the wholeness of the city can be grasped. We have reason to suppose that Brunelleschi's dual standpoints involved questions of loyalty and allegiance—that he was a fully engaged member of both Church and State. Nothing of the sort is suggested by Fabritius's lonely meditation. And while the *Ideal City* was painted from the point of view of a ruler and his architect, both of them "public men," Fabritius's standpoint attaches significance to the art of music, opposite in every way to architecture in that music is totally an art of process, having no existence apart from the dynamic of performing or experiencing it, while architecture is totally an art of stasis. Surely it is not without significance that the head of Fabritius's lute rises to just the same height as does the spire of the Nieuwe Kerk, suggesting that a new tension, the personal against the public, has supplanted the old rivalry between Church and State that caused fourteenth-century builders to raise the tower of the

FIGURE 72.
Photograph of Nieuwe Kerk,
Delft.

town hall to precisely the level of the tower of the cathedral. (In Siena, for example, the Torre del Mangia down in the Piazza del Campo had to be raised to an absurd height in order to reach the level of the hilltop Duomo.) Surely the flattened curves of the instruments are echoed in the curving edges of the canal, the shape of the bridge of the viol is repeated in the shapes of the two bridges over the canal, and the rendering overall is in delicately modulated tones in contrast to the drafting-table precision of the *Ideal City* where the buildings define a geometrically regular and symmetrical stage upon which, we are led to believe, the lives of citizens-as-public-men may lawfully be led. Fabritius's sloping pavement suggests, instead, an undulating and divergent movement. The five or six people we can barely see in the painting are isolated from one another, all as solitary (despite their being at the city's center) as the foreground philosopher. The role of the church as institutional center was already in jeopardy.

Though Fabritius's perspective may be optically "correct" (the artist may well have used a camera obscura in making his image), its correctness is of an altogether different kind from that of the *costruzione legittima*. Nothing could make plainer the expressive nature and purpose (and the expressive limitations) of the Albertian construction than does this comparison of the little *View of Delft* with the large *View of an Ideal City*—or, better, with Perugino's *Christ Giving the Keys* (figure 18), which expresses the Albertian belief that there exists an order of things in a lawful universe that possesses the reality and intelligibility of durable stone buildings. Clearly Fabritius began with a different set of assumptions. He could not possibly have shown his thoughtful man in a face-to-face encounter with the Queen of Heaven and the Sol Justitiae, as van Eyck had done, for that lay quite outside the realm of Protestant thought. One can easily imagine that he was meditating upon an idea that was to be expressed fifty years later in the early writings of Bishop Berkeley: objects only *appear* to be invested with the concrete reality we associate with stone buildings; in truth, their reality is like that of music, inconceivable apart from its being experienced, however partially and inadequately, by a comprehending mind. Fabritius does not claim to see the objective factuality of the buildings. He shows us the result of his having, so to speak, "listened with his eyes." The cityscape is so obviously a work of art that we can readily believe that we are looking at an image of the artist in his studio, caught in the act of contemplating a large painting that is leaning against a nearby wall. The horizontal plane he appears to be resting upon is only that of the tabletop. We are not shown, nor do we sense, that his feet are in contact with the pavement of the Vrouwenrecht.

The lute and the viol do not produce music of their own accord. They are fragile and responsive instruments by means of which a sensitive and accomplished performer can bring forth music that is capable of giving the keenest

pleasure to the single person in his solitude—a pleasure that may be shared with others, though whether that sharing constitutes a form of communication is debatable. In many ways we find anticipated in Fabritius's little picture the conviction that Walter Pater expressed two hundred years later: all the arts aspire "towards the principle of music, music being the typical or ideally consummate art." Moreover, all our experiencing of the world consists of the impressions "of the individual in his isolation, each mind keeping as a solitary prisoner its own dream of the world." It seems likely that a similar thought led Fabritius to place his philosopher against a pattern of confining bars.

## II

Our second item is from the middle years of the eighteenth century, namely, the *Prisons* of Piranesi, to which I would accord a significance comparable to that of the *tavolette*. Like those lost panels, the series of etchings was created by a young would-be architect in his twenties. The *Carceri* proclaim, far more clearly than had any of the works from which Piranesi is said to have drawn inspiration, the assumption of a new standpoint toward the art of architecture and, by implication, toward the organizations for which great buildings had traditionally been erected. Brunelleschi, as we have seen, was perhaps the first artist to reflect self-consciously upon the relation of buildings to the institutional and ethical frames of reference within which human beings had long attempted to live together as mutually responsible fellow members. For him, both the institutions and the buildings still possessed in full measure that "attribute of the eternal" that Sir Christopher Wren later avowed to be essential to works of architectural art, whence it followed for him that architecture should be "the only thing uncapable of new Fashions." Palladio and Jefferson would surely have agreed. Brunelleschi was not preoccupied with the *history* of either State or Church (and certainly not with the history of architecture!) but only with the relation of the steadfastness of those institutions to men's temporal and spiritual lives.

Although Piranesi claimed for himself the title "Venetian architect," he actually designed only one small building. Yet he deserved the name, for the role he played in the history of architecture was of the greatest theoretical importance. He is chiefly known, of course, for his hundreds of etchings of city vistas and of ancient ruins. In his polemical writings he extolled the magnificence of ancient Rome. Yet he did not imaginatively reconstruct vistas of the ancient city. Rather, he devoted himself to elegiac meditations over the processes of ruination that had overtaken that grandeur. His concern was similar to that of his younger contemporary Edward Gibbon, who was inspired by the ruins of the Forum to write a history not of the rise to splendor but of the decline and fall of the Roman Empire.

Yet Piranesi's most famous and most sought-after works are the *Prisons* (see figure 73), which antedate all but a small handful of the *vedute*. Needless to say, they have been interpreted in many different ways, ranging from Emil Kaufmann's assertion that they embody chaos and utter confusion to Maurizio Calvesi's belief that they glorify Rome, Roman law, and Roman order. Both these interpretations seem to me wide of the mark, although Calvesi, alone among recent writers on Piranesi, has had the good sense to detect a connection between the artist and Giambattista Vico, whom he thinks Piranesi may actually have met on a trip to Naples in 1743, the year before Vico's death. However, the relationship Calvesi discerns between the two men has only to do with their common concern for the greatness of Rome and the non-Hellenic origins of Roman civilization. Calvesi belabors beyond all reason the relation of the *Carceri* to the Mamartine Prison, a minor Roman relic that consists of two cramped cells, one above the other; he can actually find no basis for linking the architecture of the *Prisons* with that of ancient Rome. The connection with Vico surely lies elsewhere.

The fundamental principle of the *Nuova Scienza* (published in 1726, revised in 1730 and 1744) is Vico's identification of truth (*verum*) with what is made (*factum*). Unlike the natural scientists of the time, he held that the natural universe was made by God and therefore can be understood only by

FIGURE 73. Piranesi, *Carceri* XIV.

God. What men can understand is the world of human history, since that is entirely man-made. (One of the most obvious characteristics of the *Carceri* is their total artifactuality, their complete separation from nature.) The object of Vico's study was the *mondo civile*—that hypothetical hypostatization that we have since come to call "the culture" of a people or a nation or an age. The development of that civil world was shaped by the decision making of free and intelligent men but was at the same time governed by divine Providence—by an immense necessity that presides over the destinies of nations, leading them from primitive barbarism through the age of the gods, the age of heroes, and the age of rational men, until eventually corruption and self-indulgence bring about a collapse into barbarism again. Out of the rigors of the barbarous condition, with its mythic gods, there will come forth heroes again and the beginning of a *ricorso.* As has been the case with cyclical historians ever since, Vico's archetypal model was to be found in the rise and fall of ancient Rome.

The first edition of the *Carceri* was probably published in 1745, or at about the time of the young Piranesi's trip to Naples and of Vico's death. Since the *Scienza* had by that time gone through three editions, it is entirely possible, even probable, that Piranesi was acquainted with the book, even that he had gone to Naples in order to visit the founder of historicism, for throughout the remaining thirty-three years of his life Piranesi devoted himself single-mindedly to reflective meditation upon the visible evidences of the ancient and ongoing history of the *mondo civile.* Like Vico, he found it to be in the nature of the human condition that men find themselves free to direct their individual lives (not a single figure in the fourteen plates of the first edition is shackled or enchained), and yet they are located within an all-encompassing cultural context that is man-made but not of their own making. The few small figures that occupy these titanic interiors are like bemused tourists: they climb and descend palatial stairways without knowing for whom they were made or whither they may lead; they traverse wooden bridges that lead nowhere, abutting against solid masonry walls; they are surrounded on all sides by arched openings and passageways that do not join, making communication between and among the little clusters of people who are scattered throughout the edifice impossible. Ropes and scaffoldings abound, but no one is shaping or placing a block of stone. An inconceivable amount of toil must have gone into the creation of the structures, yet they are totally without political implications: one cannot imagine what kind of state or what sort of ruler may have marshaled those efforts or to what kind of society the little human beings may belong. The context is wholly noninstitutional: it demands no allegiance or allegiances of its occupants. The etchings exhibit strong chiaroscuro, yet there are few visible sources of light; the structures, for all their apparent substantiality, are curiously dreamlike.

Vico claimed to have established a "philosophy of mind." "For the first indubitable principle above posited is that this world of nations has certainly been made by men, and its guise must therefore be found within the modifications of our own mind." It was the vast man-made and mind-modifying cultural totality, complete with languages, laws, customs, and institutions, that Vico conceived to be accessible to scientific study. Therewith he laid the foundations for the subsequent development of *Kulturgeschichte* ("cultural history"), *Geschichtewissenschaft* ("historical science"), *Kulturwissenschaft* ("culture science"), and, unfortunately, of *Kunstwissenschaft* ("art science"). But at this point Piranesi reveals himself to have been wiser than his mentor Vico: in order to achieve "scientific objectivity" the scientist must be able to stand apart from what it is that he is examining, but the all-embracing panculturalism of the *Carceri* affords no such standpoint, all imaginable standpoints being themselves the products of the very thing the scientific observer (including Vico himself) aims at studying.

Although Vico professed to remain a loyal member of the Catholic Church, he had in fact invented a new religion, according to which there is an all-governing Providence (later to be called the Zeitgeist) that brings it about that historical process itself can be relied upon to provide the total "binding up" of a civilization, no matter how disparate its various facets may seem to be. There was no place in his New Science for a biblical or Christian view of history—no teleology, no eschatology. Though he made a distinction between the false religions of antiquity and the true religion of the Church, he found no need for transcendency or for divine intervention in men's affairs, no need for according historical significance to the Incarnation, no need for concepts of sin and redemption, no reason for expecting a Last Judgment.

It was the grandeur of this fresh idea, I believe, that inspired Piranesi in his mid-twenties to produce the first edition of the *Carceri*. Fifteen years later he took the plates in hand again, subjected them to varying amounts of revision by intensifying chiaroscuro, adding more ropes, bridges, ladders, beams, and trusses, and by inserting two new compositions into the series, numbering them II and VII (see figure 74). Only in these new inventions, and in the radically altered final plate, now numbered sixteen, do we find specific references to Roman history and Roman art, to the rack, and to construction and ruination.

Only in II and VII do we catch a glimpse of the open sky and of a modern Italian city. These glimpses may rewardingly be compared with the ones we see through the Bramantian architecture of Raphael's *School of Athens* (see figures 75 and 76), where we see a gathering of Greek philosophers inside an unmistakably Roman building that closely resembles the as-yet-hardly-begun Basilica of St. Peter. However, Raphael was not in the least concerned with either Greek or Roman history, Greek or Roman culture, but rather with the power of Christian thought to encompass all that was admirable in Greek

74. Piranesi, *Carceri* VII.

philosophy and in Roman statecraft. Both, for all their being man-made rather than divinely revealed, were at least partially in harmony with the universal order of God's creation, here symbolized by glimpses of the open heavens. The full revelation comes on the opposite wall where, in the Dispute of the Sacrament, heaven and earth are brought together in an outdoor scene, the unity of which stands in contrast to the essential dividedness of the School, in which there is no resolution of the conflict between Plato and Aristotle.

Piranesi's bit of sky, on the other hand, only intensifies our sense of being confined within some vast subterranean world that forms, so to speak, the "cultural underpinning" of the sociohistorical order symbolized by the imposing and respectable palazzi barely visible up there in the sunlight. In what amounts to a proto-Freudian vision of cultural inheritance, that dark substructure contains fragmentary suggestions of violence, barbarism, imperial grandeur, ruination, torture, and conquest. Whereas Raphael invites us to take our stand within a frame of reference that the Church (or perhaps Christian humanism) provides and to contemplate the wisdom and nobility of that stand, Piranesi asserts the ultimate reality of historical process itself and the impossibility of our gaining a vantage point outside its confines.

FIGURE 76. Raphael, *School of Athens*, detail. Stanza della Segnatura, Vatican.
Photo courtesy of Alinari/Art Resource, New York.

FIGURE 75. Piranesi, *Carceri VII,* detail.

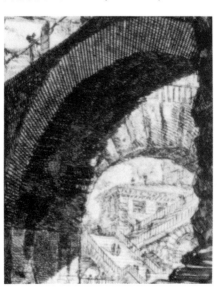

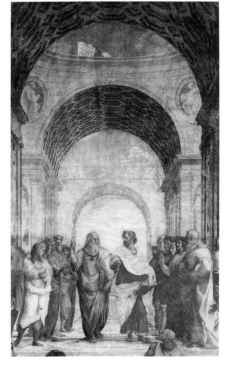

It has been the burden of my argument from the beginning that the quintessential sense of Renaissance perspective is bound up with architecture and with men's attitudes toward the institutions that commission works of architectural art. At this point I think it worthwhile to digress briefly to consider the question: what if an architect were to adopt Piranesi's (or Vico's or Hegel's) standpoint in regard to the relation of edifices to history, what kind of building could he design as an appropriate expression of this new conviction or *doxa?*[2] The principal metaphorical or mythopoeic resources that architecture had traditionally provided the architect-as-artist had been scale, structure, and permanency: in their size, their memberedness, and their steadfastness buildings had symbolized the prime attributes that were at least sought after by the organizing institutions by whose agency men had been enabled to live together as law-abiding fellow members, fellow citizens. To these must be added the capacity of a building to contain within itself the assembled community, forgathered for explicitly collective purposes, and to stand as a completed object within the city, declaring the real existence of a given institution as a landmark or reference point in the community's ongoing life. All these architectural significations were struck down by the *Carceri,* just as they were by the cultural historicism, or cultural relativism, that evolved from Vico's *Nuova Scienza.*

There are two ways that architecture can be based upon process, both of which were clearly set forth during Piranesi's lifetime. One possibility is deliberately to build into the architectural fabric of the city a visible embodiment of a collective or ancestral memory, a record and reminder of the history of the community's existence. This is to deny Wren's assertion that architecture should be the only thing "uncapable of New Fashions" and to assert that changing fashions are intrinsic to the very nature of civilization itself, which is cumulative and progressive in character. This is the option that dominated the architecture of the late nineteenth and early twentieth centuries, though the beginnings of what has misleadingly and disparagingly been called "revivalism" or "eclecticism" can be traced back to the middle years of the eighteenth century. All such architecture differs from that of Brunelleschi and Wren in that it was intended primarily to produce a "modification of the minds" of relatively private persons, within a philosophical frame of reference that accorded a higher order of reality to the experiencing mind than to the institutions that had traditionally been thought to make up the State. The churches for which Gothic Revival buildings were erected did not perform the functions of those that had been presided over by thirteenth-century bishops—men who (or churches which) enforced canon law, suppressed heresy by military force, challenged the authority of kings and princes if need be, and regulated men's lives in countless ways. Nineteenth-century churches depended upon suasion. They sought to save men's souls and to promote virtue, but the sinner could take his choice among many denominations, none of which could send him to the stake, or even to the pillory.

Given the limited number of options available to the architect since the middle of the eighteenth century, there is much that can be said in defense of this cultural historicism, for at least it did undertake to preserve within the makeup of the city something that all cities had always had—namely, a visible reminder of historical continuity, of the fact that civilization itself is something we have inherited from generations of forebears, all of whom contributed to making us what we are today. That that debt should be acknowledged in the way we build our cities seems hardly so unworthy, so contemptible, so dishonest a thing as it has loudly been proclaimed to be by the devotees of the other choice.

The second possibility was formulated during Piranesi's lifetime by his fellow Venetian Carlo Lodoli (1690–1761), who left no writings from his own hand, but whose ideas were published by Count Francesco Algarotti at about the time of Lodoli's death. Rejecting cultural history as the basis of architecture, Lodoli proposed that architecture should be grounded in processes of construction and of use. Whereas Vico and Piranesi had internalized the significance of art and artifacts by relating them ultimately to the processes by which minds are modified, Lodoli externalized or objectified the principles of architecture in a way that quite divorced architecture from perspectival "stand-taking" of the sort that had been espoused by Brunelleschi and his heirs. Despite his being a monk, Lodoli rejected entirely the traditional conception of buildings as institutional symbols.

It is one of the ironies of modern history that Lodoli's doctrine, which had little or no effect upon the architecture of his own day, should have gained a complete triumph over cultural historicism—but only by way of a later development in historicism itself. Vico did not foresee the possibility of dividing a people's history into a succession of more and more narrowly defined style-periods, each with its own distinctive art and architecture. It was only with that development that people began to ask, "What is the nature of our own style-period, and what kind of architecture would be appropriate to our Age?" Following the Positivists of the mid-nineteenth century, they concluded that they were entering the Age of Science, to which the functionalist theories of Lodoli seemed wholly apposite—though in fact their theorizing owed more to the Gothic Revivalists than to Lodoli himself.

What Lodoli looked forward to was the emergence of an architecture that would be perpetually young, *eterna giovanezza*. Count Algarotti, perhaps by virtue of his *being* a count, had grievous misgivings. "Algarotti felt that the realization of such new principles would wreak catastrophe in architecture. He foresaw for his beloved art 'the most terrific consequences'" from so novel a doctrine.[3] We are living today, I believe, with just those consequences. They have resulted from the belief, cherished by a small but immensely influential elite within the architectural profession in the early years of the twentieth cen-

tury, that human beings can step outside history and build cities that will remain perpetually young, impervious to the processes of corruption and decay, even to the processes of stylistic change that the passage of historical time brings about. But though the new buildings, with their vitreous surfaces, may seem timeless, history continues. Circumstances change; architects feel the need to be creative, inventive, up-to-date; fads succeed one another more and more rapidly. But as architects have pursued their Lodolian goals, they have aided and abetted the anti-institutionalist and experientialist aspects of modern liberal thought, for once one enters the indefinable and incomprehensible world of the *Carceri,* perfect symbol of "cultural relativism" and the absence of ethical and political frames of reference, the possibility of "taking one's stand" with regard to matters of institutional loyalty and civic allegiance simply melts away, as do the traditional meanings of architecture itself.

# III

Our study ends as it began, with our considering an artist's prolonged and intense contemplation of architectural symbols of Church and State. Having come full circle, we conclude with Monet's paintings of Rouen Cathedral and of the Houses of Parliament, which were made almost exactly five hundred years after Brunelleschi's *tavolette* of the Baptistry and Town Hall of Florence.

We need to look first at the route by which Monet became the perfect exemplar of the private man (in contrast to his older contemporary, Gustave Courbet, who had long been deeply concerned with the idea of community as in his *Burial at Ornans,* and with political ideals, as evidenced by his involvement with the Commune, which cost him his career, his freedom, and his fortune). For his part, Monet came close to being the complete nonmember. So far as we know, his one political act was that of signing a petition that had been drawn up by Zola and Clemenceau in support of the cause of Captain Dreyfus. But when he was invited to join a committee to work for the reversal of Zola's conviction for libel following the publication of *J'Accuse,* he declined: "Quant à faire partie d'un comité quelconque, ce n'est pas du tout mon affaire."

During the 1860s Monet had been actively involved with the group of young painters—Pissarro, Sisley, Renoir, Bazille, Cézanne, Manet—who were accustomed to meet, toward the end of the decade, in the Café Guerbois in Paris. During these years Monet shared the ideas of the group and worked closely with Renoir in particular. Like Renoir, he painted pictures of figure groups, sometimes on very large canvases. Like other members of the Guerbois group, both Monet and Renoir painted landscapes, sometimes setting up their easels side by side. Throughout most of the period, Monet had to endure

extreme poverty, finding himself unable at times to provide for the minimal needs of his wife, Camille, and their son, Jean.

On July 18, 1870, the Franco-Prussian War was launched by Louis Napoleon; it lasted forty-six days. Renoir and Bazille enlisted in the army. Renoir was wounded and mustered out; Bazille was killed. Cézanne remained in Provence, where his father paid for a substitute. Monet evaded military service. After the defeat at Sedan and the Prussian march on Paris, at a time when the government in Bordeaux was trying to raise an army to relieve the siege of Paris, Monet abandoned his wife and child and moved to London, where he was soon joined by Pissarro and later by Camille and Jean. While in London Monet and Pissarro were helped by Daubigny, whose paintings sold very well in England, and by Durand-Ruel, who had moved his business to the British capital. After remaining for several months in London, Monet moved to Holland, where he painted canal scenes and windmills until near the end of 1871—that is, until the siege of Paris, with its dreadful privations, had been lifted and the Commune had been instituted and then violently overthrown, at which point, with some degree of peaceful normality restored, and after one more trip to Holland, Monet came back to devise a new kind of urban imagery.

The new type, which is best represented by his *Boulevard des Capucines* (1873), minimized or obliterated the grand perspectival vistas that had recently been built into the city by Baron Haussmann and stressed, instead, the casual observer's enjoyment of random sensations as he looked down upon the traffic of the boulevards from an upstairs window or balcony. *The Boulevard des Capucines* (see figure 77) is the most celebrated example because of the prominent place accorded it in Louis Leroy's mockingly hostile review of the first Impressionist exhibition of 1874. The composition is a novel one in that the dullest and least interesting area lies at the "dead" center of the canvas, while the shapes and colors that attract the eye are dispersed toward the margins. It is as if the painter had covered the fovea of his retina (that small area that is alone capable of focused vision), leaving exposed only the peripheral field that is sensitive to color and movement. Just as the structure of the picture denies the traditional significance of centrality, so, too, does it present us with a city that seems to be without Center, in the sense of that word that we encounter in the writings of Mircea Eliade and of Hans Sedlmayr. It is a city without landmarks, historical and institutional symbols, collective goals, a city of apartment houses and of strolling *boulevardiers,* whose attitude toward common purpose seems no different from Monet's own.

Although Leroy's "argument" against Impressionism, presented in the form of an imaginary dialogue, is badly muddled, one can see plainly that what offended him was Monet's reduction of the "reality of things," including the reality of the city of Paris, to a scattering of loosely defined "impressions"—a

FIGURE 77. Claude Monet, *Boulevard des Capucines* (1873–74). The Nelson-Atkins Museum of Art, Kansas City, Missouri. Purchase: The Kenneth A. and Helen F. Spencer Foundation Acquisition Fund; F72–35.

word he uses in the same sense in which Pater had employed it six years earlier, though what had seemed good to Pater was intolerable to Leroy. The consensus among critics and historians of modern art has been that Leroy was blind to the self-evident excellence of Monet's cityscape. But if it be admitted that city buildings provide us, collectively, with our most—indeed, our only—cogent visual symbol of the State's real being, then one may easily understand why Leroy's artist-companion at the exhibition, one "M. Joseph Vincent, . . . recipient of medals and decorations under several governments," should have been outraged. Even though he expressed himself badly, he (or Leroy) presumably perceived that the Impressionists' *imago civitatis* was as destructive to traditional political values, the values that sustain urban civility and the life of the *polis,* as Walter Pater's conception of the good life had seemed, to Londoners who first encountered it in 1873, destructive to traditional ethical and religious values. Solipsism and politics cannot possibly be reconciled, any more than can solipsism and Christianity.

In the 1870s Monet continued to paint kinds of scenes and occasions that have characteristically appealed to the modern tourist and vacationist—people who were, if only temporarily, as disengaged from the mundane world of workaday responsibility as was Monet in his upstairs room: scenes that involved sailboats and canoes, beaches and boulevards, poppy fields and parks, quiet ponds and broad rivers, all of which he savored in their pure presentness, without a thought, so far as we can tell, for past or future, memory or expectation. Many of the landscapes of the 1860s and 1870s contain figures—people who, it is implied, take pleasure in the colorful world around them in the same way the artist experiences it and invites us to experience it, as we vicariously stroll along country roads and through poppy-strewn fields or float peacefully in boats on the sunlit Seine.

During those years Monet, like his companions at the Café Guerbois, found much in rural nature that was worth celebrating for its own intrinsic goodness. In the 1880s, however, we find a conspicuous increase in the number of works that do not contain figures and that do not bring to mind the pleasures of the vacationist. Such are his many paintings of the cliffs along the Channel coast, of the barren hills and rocky outcroppings of the Creuse valley, and of the jagged rock formations that so fascinated the painter during the ten weeks he spent on the Belle Ile, off the west coast of France, in the autumn of 1886. These pictures seem remote from any kind of human activity. As Robert Herbert has lately observed, the element of sociability gradually disappears. What we are invited to enjoy has less and less to do with a comprehensible attitude toward "the world," stretching away toward a horizon (with all its connotations as to extension in time as well as in space), and more and more to do with the artist's processes of experiencing and of translating those processes into an analogous process of painting. In the early 1890s Monet became

wholly absorbed in contemplating proximate haystacks (or stacks of shocked wheat) and in devising ways of painting that would do justice to the rich diversity of optical sensations on which his sense of the *reality* of those simple shapes seemed to depend.

After devoting a few months in 1891 to producing a series of increasingly "abstract" or flattened compositions based upon the rows of poplars on the banks of the Epte near his home at Giverny (see figure 78), Monet turned to the facade of Rouen Cathedral (see figure 79). It was an astonishing choice of subject, sharply different from the characteristic concerns of both Monet and the other members of the Impressionist group. Before 1892, architecture had played a minimal role in Monet's art: nondescript houses along country roads, a distant church as part of the skyline of a village, anonymous apartment buildings along the boulevards of Paris, one lateral view of St. Germain l'Auxerrois (as background for the little park beside it), hardly anything more. Beginning in the spring of 1892, he chose to give over four years of his life to twenty-eight canvases that were completely filled with the facade of a medieval cathedral. In almost all his previous work nature had predominated; suddenly nature was as totally absent as it is in the *Carceri.*

FIGURE 78. Claude Monet, *Bend in the River Epte* (1888). Philadelphia Museum of Art: The William L. Elkins Collection.

FIGURE 79. Claude Monet, *Facade of Rouen Cathedral*. Sterling and Francine Clark Institute, Williamstown, Massachusetts.

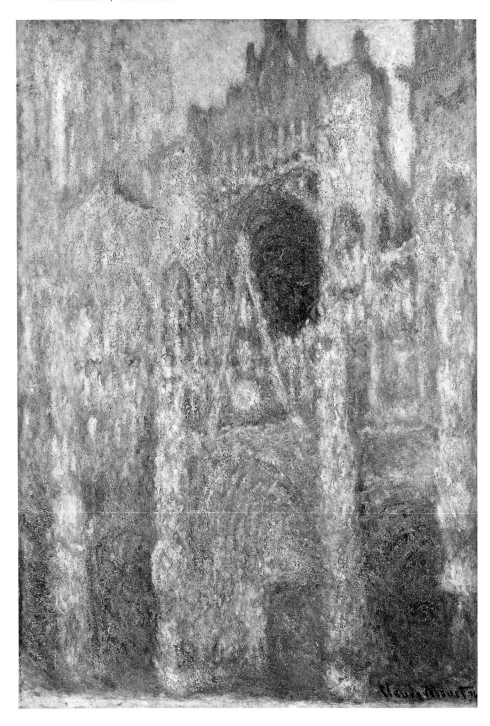

The various critical responses to the exhibition of 1895 (before which time no one had been allowed to see the paintings) have lately been surveyed and summarized by Joachim Pissarro in his excellent book, *Monet's Cathedral: Rouen, 1892–1894* (Knopf, 1990), which contains large color reproductions of all twenty-eight of the facades, plus two initial paintings of the base of the Tour St. Romain at one side. Monet's Impressionist friends were enthusiastic, especially Pissarro, who urged his absent son to return to Paris in time to see the exhibition as a whole. The most favorable and excited response was that of Monet's close friend Georges Clemenceau:

> And these gray cathedrals, which are shot through with purple of blue touched with gold, and these white cathedrals, with portals of fire, streaming with red, blue, and green flames, and these rainbow-colored cathedrals, which look as if they were seen through a turning prism, and these blue yet roseate cathedrals, would suddenly give you a lasting vision, not of twenty but of a hundred, a thousand, a billion states of the cathedral, always in an endless cycle of suns. This would be life itself, of which sensation would be able to give us the liveliest sense of reality. Ultimate perfection of art, never attained heretofore.[4]

Having looked at the same canvases, Roger Fry's response was wholly different. He declared that Monet's "achievement was too rigorous and 'scientific,' to the point of ruining his artistic achievement. . . . Monet cared only to reproduce on his canvas the actual visual sensation as far as that was possible. Perhaps if one had objected to him that this was equivalent to abandoning art, . . . he would have been unmoved because he aimed almost exclusively at a scientific documentation of appearances."[5] Perhaps one sees what one wants to see—though how anyone could have found the paintings to be a "scientific documentation of appearances" is hardly conceivable.

Much was made by Monet and has been made by generations of apologist-critics since his time, of his preternatural sensitivity to the subtlest nuances of light and color in the atmospheric *enveloppe* that seemed to him to hover around the things he chose to paint. Hardly anyone has been willing to admit, it would seem, that the colors he used in painting Rouen Cathedral do not at all correspond to what human eyes see. Modern color films are extremely sensitive to variations in color. While it is demonstrable that the light on the facade on a sunny morning is bluish and that of the late afternoon, reddish, every tourist can see perfectly well that the building is made of dull, gray, somewhat smoke-stained limestone and that its color remains essentially unchanged throughout the day. I have stared at it and can vouch for the fact that under no conditions does the church appear iridescent, nor does the building seem, on a cloudy day, to have been made of brown mud, though that is how Monet represented it in one of the versions now in the Musée d'Orsay in Paris.

While he did work on different canvases at different times of day and under different atmospheric conditions, it must be kept in mind that he spent only two relatively brief periods in Rouen, in the spring of 1892 and again in the spring of 1893, whereafter he worked on the paintings in his studio at Giverny, both between those two campaigns and for two full years thereafter. Not until 1895 did he exhibit any of the paintings. When he displayed twenty of the cathedrals at Durand-Ruel's in that year he arranged them (to the best of our knowledge) not according to a succession of times of day, from early morning till sunset, but rather so as to achieve a succession of color effects or harmonies on which he had been working for many months. By no means do the images record the "fleeting, momentary experiences" that have so often been said to be what it was that he tried to capture. The cathedrals are deeply meditated upon works of art.

A different response altogether in 1895 was that of André Michel and Camille Mauclair, both of whom were offended by what they took to be the moral implications of the works. As Joachim Pissarro sums up Mauclair's position, that critic found the paintings to be "insulting, disorderly, sensual, orgiastic, and even blasphemous."[6] What concerned both these men, it would seem, was the vast disparity between what Monet was affirming and what the cathedral itself had been built to mean, and had continued to mean, to the Christians of Rouen for some six hundred years. Though both George Heard Hamilton and Joachim Pissarro touch upon the matter, neither of them seems willing to concede that for various reasons—social, historical, ethical, philosophical, theological—the Gothic cathedral posed the greatest possible challenge to the solipsistic hedonism that Monet had long ago committed himself to and was resolved to defend.

As long as he had confined himself to such relatively neutral subjects as haystacks, ponds, poplars, and poppy fields, he had had no difficulty is asserting the primacy of his own acts of experiencing over any order of signification that might be thought to have its grounding out there in the world. Some have argued that the Impressionists' retreat from involvement in the affairs of the world was due to the successive defeats that republicanism had had ever since the seizure of power by Napoleon at the turn of the century. In fact, however, the position that Monet was defending had been beautifully articulated by Walter Pater in 1868, in an essay that he had privately printed in that year and that was later appended as a "conclusion" (which it was not) to his book on Renaissance painters published in 1873. His essay met with much the same opprobrium as did the first Impressionist exhibition a year later in Paris.

> At first sight experience seems to bury us under a flood of external objects, pressing upon us with a sharp and importunate reality, calling us out of ourselves in a thousand forms of action. But when reflexion begins to play upon those objects they are dissipated under its influence; the cohesive force seems suspended like

some trick of magic; each object is loosed into a group of impressions—colour, odour, texture—in the mind of the observer. And if we continue to dwell in thought on this world, not of objects in the solidity with which language invests them, but of impressions, unstable, flickering, inconsistent, which burn and are extinguished with our consciousness of them, it contracts still further: the whole scope of observation is dwarfed into the narrow chamber of the individual mind. . . . Every one of those impressions is the impression of the individual in his isolation, each mind keeping as its solitary prisoner its own dream of the world. Analysis goes a step farther still, and assures us that those impressions of the individual mind to which, for each one of us, experience dwindles down, are in perpetual flight; that each of them is limited by time, and that as time is infinitely divisible, each of them is infinitely divisible also; all that is actual in it being a single moment, gone while we try to apprehend it, of which it may ever more truly be said that it has ceased to be than that it is. . . . Not the fruit of experience, but experience itself is the end. . . . The theory or idea or system which required of us the sacrifice of any part of this experience, in consideration of some interest into which we cannot enter, or some abstract theory we have not identified with ourselves, or what is only conventional, has no real claim upon us.[7]

We have no way of knowing whether Monet had any knowledge of Pater's essay; it is unlikely that he did, though such ideas, which Pater associated with "the temper of the times," may possibly have been discussed in Monet's presence during the months he spent in London. Pater explicitly associates the ideas with the new scientific outlook upon the world. Not only Roger Fry but many other writers have at one time or another tried to establish connections between Monet and science, most often with discoveries that were being made at the time by physicists concerning our perception of colors. It is improbable that Monet was acquainted with those developments or that they would have affected his painting if he had known about them. If there is a connection to be found between the sciences and Monet, it has to do with sensationalist psychology, not with physics. The notion that all our knowledge of the world is grounded in moments of sensation, out of which the mind composes its conceptions of solid and enduring realities, was popular at the time. When Georges Clemenceau (a confirmed anticlericalist) acknowledged that only a hedonist could enjoy Monet's paintings of the cathedral and exuberantly proclaimed that there could be a hundred, a thousand, a a billion states of the cathedral—as many as there were moments of sensation in an artist's or an observer's experience—he was no doubt speaking as a sensationalist himself.

A billion *states* of the cathedral? A "state" is static. There is a building in Rouen that has remained essentially static for several hundred years, its stasis proclaiming the perduring reality of *Domus Dei,* of *Aula Reginae Coeli,* as Mauclair well understood. Monet was "taking his stand" in defense of an idea, but not with reference to something that existed "out there" in the public world that he shared with his fellow citizens. Instead, he sought to dissolve

away the ancient stonework of the building into a luminously colorful fabric of paint, affirming once and for all the absolute primacy of sensate experience, in all its ephemerality, over the durability of the building and of what it was the cathedral stood for.

Yet it was not simply because of its relationship to Christianity that Rouen Cathedral posed so grave a challenge to Monet's commitment. We have taken note of the fact that in the 1860s and 1870s Monet had been attracted to the kinds of subject that appealed to tourists and vacationists. But the greatest of all tourist attractions in the late nineteenth century were, in all likelihood, the Gothic cathedrals, both in France and in England. Yet it was neither as hedonist nor as Christian pilgrim that the tourist made the cathedral tour; it was rather as a somewhat romantic historicist. He had been persuaded by writers such as Ruskin and Hugo that those buildings were consummate works of *Gesamtkunst* in which the whole life and spirit of the medieval world were made visible—a world in which there had prevailed an "organic" Christian culture or civilization that had shaped and colored every aspect of human existence. Monet's contemporary Henry Adams was a devotee of that historicist faith, as was the American Gothic-revival architect Ralph Adams Cram. In the latter's introduction to the 1913 edition of *Mont-Saint-Michel and Chartres* the Middle Age is celebrated as a time when "Dante, the cathedral builders, the painters, sculptors, and music masters—all were closely knit into the warp and woof of philosophy, statecraft, economics, and religious devotion;— indeed, it may be said that the Middle Ages, more than any other recorded epoch in history, must be considered *en bloc,* as a period of consistent unity as highly emphasized as was its dynamic force." Like other twentieth-century architects, Cram lamented the absence of such cultural unity in the modern world of science and industry, though he believed that by erecting neo-Gothic churches in American cities he could do something, at least, toward regenerating the old attitudes—toward "modifying men's minds," as Vico would have expressed it, no matter how isolated his churches might be within the overall fabric of modern cities and modern life. If pressed, Monet might have said that he, too, intended to achieve such a modification of people's thought, for surely he hoped that many people would see his paintings and understand what it was that he was celebrating.

But if the Middle Ages were so admired for their "consistent unity," their art idealized for having been devoted so completely to the expression of that unity, what might one conceive to be the right relationship of modern art to our present "age"? Baudelaire had wrestled with the problem and had decided that the painter of modern life was Constantin Guys, with whom he specifically associated the stance of the dandy, whose doctrine of "elegance and originality" he regarded as a "kind of religion," as demanding in its discipline as medieval monasticism. Baudelaire believed that the type would survive

longer in England than in France; he would have been quick to recognize the kinship between the dandy and Pater's elegant esthete, burning with his "hard, gemlike flame." However, it is easy to see that what the cultivated Englishman or Frenchman admired in the Gothic cathedral—namely, its symbolization of the dynamic cohesiveness of medieval society—was the diametrical opposite of that "suspension of cohesive force," that dissipation of experience into an infinite number of momentary sensations, which Pater conceived to be the highest goal of the human spirit and the whole "tendency of modern thought."

What a bold tour de force it may have seemed to Monet, then, to confront the Gothic cathedral itself, that cornerstone of the edifice of romantic, collectivist, proto-socialist historicism, and to dissolve it into a shimmering fabric of sensation. What better way could he have found for showing his rejection of the claims that systems, ideas, theories, institutions, and conventions may have made upon him?

So long as he confined himself to poppy fields and ponds, Monet was able to produce pictorial affirmations that still seem today to be enormously persuasive, thanks to the vibrant immediacy of their esthetic impact. But even as he retreated to such lonely places as the valley of the Creuse, he must have known himself to be surrounded by, and wholly dependent for his security upon, the established and lawful institutions of the French state. Always there existed around him a religio-political order of things that implicitly charged him with self-indulgence and superficiality. Most obviously, of course, it was the Christian Church, so well represented by Rouen Cathedral, that had been devoted for some nineteen hundred years to upholding those ideas, traditions, and ethical standards, those teleological conceptions of ultimate purpose and worth, which constituted the body of conventional understanding that made it possible for people to *convene* as fellow members, fellow citizens. Monet, like Pater, rejected that traditional faith. Yet it was not possible for him to live his life in the world on the assumption that everyone else was a solipsist of the kind he himself aspired to be. Although his art at no point bears upon anything that might be thought to pertain to any of the virtues, he could not in actual life dismiss from his mind the whole realm of ethical concern. The cathedral was casting its shadow upon him, no matter how studiedly he might try to ignore its meaning. Twenty-eight times he tried to disintegrate its stubbornly unchanging facade into a finely textured and intensely colorful fabric of his own creation, to suspend its cohesive force by "some trick of magic"—all the while taking some deep-seated satisfaction in the fact that the church did continue to *be there,* despite all those ever-changing atmospheric effects to which he sought to attribute some comparable measure of significance. One might say that he was engaged in carrying on a dialogue, not between Church and State, in the manner of Brunelleschi, but between the building and his own self-conscious being.

That such ideas were on Monet's mind seems reasonably certain for at least three reasons. First, he deliberately chose the very old facade of Rouen Cathedral, intimately associated with the idea of zeitgeist, as the subject of his aggressively modern paintings, thereby setting up an opposition that is not to be found in his earlier work. Second, his mode of working depended, not upon his ability to capture an instantaneous impression, as so many have asserted, but upon his being able to count upon the fact that the conditions that prevail this afternoon at 2:30 will be observable tomorrow at 2:30, if the sun is shining. That is to say, he relied upon there being a pattern of predictable recurrences that alone made it possible for him to work on the same canvas over and over again. And third, he chose to frame the facade in such a way that there lay at the center, or near the center, of each of his twenty-eight canvases—a *clock!*

In the 1890s there was still affixed to the gable over the central portal a large wooden-faced clock, old and weathered, that is plainly visible in photographs taken at the time. In most of the paintings one sees within that gable a luminous disc that stands out as a distinctive feature, as if it were a little sun, a spiral nebula, a small whirlpool of activity in the midst of the plasterlike crust of the overall paint surface. At the center of what Monet had chosen to confront, week after week, there lay a ticking clock, its beat so similar to the rhythms of our heart and lungs, its function so closely bound up with the slow passage of the sun that measures out our days and years. Monet was in his middle fifties when he painted the cathedrals. The youthful ebullience of the paintings he had made at La Grenouillière and at Ste. Adresse had long since disappeared from his work. The passage of time may no longer have seemed to be the bearer of ever-fresh and delightful sensations; it brought with it, instead, worsening rheumatism, failing eyesight, and other evidences of advancing age. It so happens that there is no image of the Last Judgment over the central portal of the Cathedral of Rouen, but if there had been one, it would probably had meant less to Monet than did the inexorable turning of the hands of that clock, ticking away, minute by minute, what remained of his mortal life.

It is especially in connection with Monet's attitude toward time that it is interesting to compare his cathedral facades with the image that Jean Colombe made as he was completing the *Très riches heures* in the latter part of the fifteenth century. For his illustration of the *Presentation of the Virgin in the Temple* (see figure 80) he has created a stage, the backdrop of which is a finely detailed representation of the three central sections of the facade of the Cathedral of Bourges. Before these he has placed Joachim and Anna, aligned with the two lateral portals and, in the center, the Virgin Mary as a very young girl. Surely he did not mean for us to see these three people as actors performing a religious play on the *parvis* of the local cathedral; there is no

FIGURE 80. Jean Colombe, *The Presentation of the Virgin in the Temple.* Musée Condé, Chantilly. Courtesy of Giraudon, Paris.

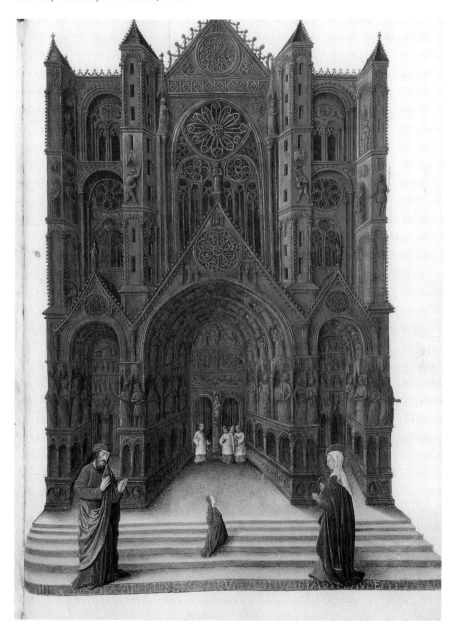

element of make-believe here. The point he is making is that *story-telling* lies at the very heart of biblical and Christian thought. The facades at both Bourges and Rouen are decorated with dozens of statues of saints who had lived during the many hundreds of years that had elapsed between the time of Jesus and that of the building of these two churches. Although it would not have been easy for someone on the ground to have identified each of the saints by name, anyone would have known that each of them could have been associated with a *story*, by virtue of which he or she had been endowed with miracle-working power, with the ability to intervene and intercede on behalf of living Christians so as to give shape and direction to the life-stories of individual citizens of Bourges and Rouen as they made their separate ways from birth to death and toward the Last Judgment that is depicted over the central portal at Bourges.

There are some sixty or seventy statues affixed to the facade at Rouen (spread out over the structure in the English manner rather than being concentrated in the portals in the French fashion), but Monet has obliterated all of them. He had no interest whatever in affirming the existence of an eternal community of saints, no interest in their lives nor in any life but his own—and even in that case, not in his "life story" but only in an infinite succession of *experiences* of light and color. And so there was sounded the death-knell for the art of narration that had been of central concern for Western artists for a thousand years. People continue to care about story-telling, of course, in novels, murder mysteries, soap operas, movies, but none of these is endowed with the kind of transcendent significance that is possessed by the stained-glass and sculptural imagery of the medieval cathedrals or by the great fresco cycles of the Renaissance. Our very lives have been "demythologized"—and nowhere more obviously than in twentieth-century painting.

After devoting four years of his life to painting the facade of a church of which he was not a member, in a city of which he was not and never had been a resident, Monet turned, in his next encounter with architecture, to the government buildings of a country of which he was not a citizen. Though he averred that he had always loved London because of its foggy atmosphere, it seems highly probable that his motivations in painting the Houses of Parliament (see figure 81) were not merely aesthetic but were bound up, again, with complex emotional attitudes. It was to England that he had fled in the fall of 1870 when he decided to renounce his citizenly obligations to his own nation, and it was in London that he had lived during the Prussian siege and occupation of Paris and during the weeks that saw the setting up and overthrowing of the Commune. Nearly thirty years later he returned to London, where his status was that of a foreign visitor, and there he contemplated at length the buildings that lay at the governmental center of the British empire. To that activity he brought a detachment that depended not only upon his being an outsider

(with little sympathy, probably, for British imperialism) but also upon the buildings' being separated from him by a wide body of water and by their being made only dimly visible through the fog. (No doubt there were bright sunny days during his sojourn in London, but he had no interest in the kind of "seeing" they provided.)

Taking inspiration, perhaps, from Clemenceau's assertion that there could be a billion states of the cathedral, Monet undertook in London an even more ambitious project than the one he had carried out in Rouen. He installed in his hotel room some ninety stretched canvases—three times the number he had used for the cathedral—and began making notations thereon of the ever-changing phenomena of light that he observed and that he thought to be the very substance of his existence at its best—for why else should he have attached any importance to those slight changes in the way the light stimulated his retina? Why should he, or anyone else, have thought them to *matter*?

FIGURE 81. Claude Monet, *The Houses of Parliament, Sunset,* 1903, Chester Dale Collection, National Gallery of Art, Washington, D.C.

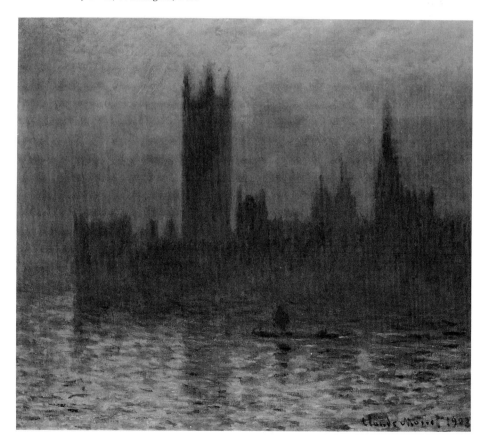

However, the procedure of shuffling through that great stack of canvases in search of the one that corresponded most nearly (though never exactly) to a particular set of conditions proved impossibly cumbersome, so he had the lot of them bundled up and shipped home to his studio in Giverny, where he completed the paintings (though not all ninety of them), working from picture postcards!

Having dealt with church architecture and with civic architecture, Monet turned finally to domestic architecture. In the early 1900s he went to Venice and there made a few paintings of palaces along the Grand Canal. We need not linger over them, for the subject did not inspire the painter as earlier themes had done. Painted in cold blues, these are surely the most dispiriting of all Monet's works. The facades of the palaces lie parallel to the picture plane above a surface of water, so that no element at all of the perspectival *costruzione,* of which nothing was more important than the ground plane, survives. Obviously the buildings did not challenge him as Rouen Cathedral and the Houses of Parliament had done. Possibly the apparent gloominess was the result of dismal weather, possibly of his steadily failing eyesight. At any rate, the paintings reveal no discernible attitude on his part toward Venice or Italy or the family, or even toward Impressionism and the art of painting, for the Venetian buildings brought forth no new ideas or new approaches, no new insights into the meaning of architecture or locale. He spent the remaining years of his life in producing a long series of works devoted to water lilies, watery surfaces, and flower beds, in relation to which the idea of "taking one's stand" is wholly irrelevant—as it has been in all modern art since that time.

# Epilogue

So what happened to perspective, that it should have disappeared from twentieth-century art? In the foregoing chapters I have tried to elucidate its meaning—to find out what made it compelling as a pictorial device—for artists of the Renaissance. It is not hard to see why those same factors are no longer operative within the modern artist's frame of reference.

The most important factor of all, I believe, has to do with the radical change in the status of membership institutions, which are no longer accorded the kind of Platonic *reality* they once possessed, a kind and degree of reality that was closely related to that of the buildings that were erected for those same institutions—the buildings that housed the great majority of the perspectival images that were produced during the Renaissance, most of which incorporated within themselves pictures of buildings. Both the public edifices and the pictures that adorned them continuously challenged the member to "take his stand" with reference to a body of narrational and iconic subject matter that served to authenticate the real and enduring being of the institutions and their power to give order and meaning to the life of the community. That orderliness and meaningfulness were undergirded and sustained by the rhetorical and elevated modes of speaking that once obtained among educated Europeans (and later among Americans such as Washington and Jefferson, though hardly any longer). We have seen that painters, too, employed rhetorical devices in similar ways.

Nothing has done more to undercut the claims of any institution to ultimate reality than has the burgeoning of a radical nominalism that owes much to the triumph of science and the "scientific outlook." That triumph has quite changed the balance in our thinking between a physical and a spiritual duality

within the very nature of the world. That balance, in turn, is crucial to the relation of self-consciousness to world-consciousness that sustained the concurrent development of portraiture and landscape painting between the fifteenth century and the end of the nineteenth—a linkage that remained intact for Courbet but that was dissolved away by Cézanne, who was increasingly given in his later years to masking the faces of his sitters and to painting landscapes that are devoid of mood, atmosphere, weather, sunlight, and chiaroscuro. The old balance between self and world depended in good part upon the conviction that all things, human and nonhuman alike, are God's creations, a conviction we see most beautifully expressed in Giovanni Bellini's painting *The Stigmatization* (or *Ecstasy*) *of St. Francis* now housed in the Frick, in which the artist avows that St. Francis, Moses, and the rocky bluffs of Mt. Laverna have all been created by the same hand and in the same *style.*

I stressed in chapter 2 the importance of the idea of *character* that I found to be closely bound up with a conception of the Christian citizen as a responsible, role-playing participant in the life of the community, the arena of "public man." The representation of such members/characters persisted throughout the careers of Courbet and of Eakins, both of whom were given also to grouping persons in ways that were charged with meaning (as in Courbet's *Burial at Ornans* and Eakins's clinic pictures). Such a relationship between character and community was always found to be problematical by Cézanne who, in his later years, liked to group anaphrodisiacal female nudes, often faceless (compare Philadelphia's *Great Bathers*), in positions that owe no more to personal volition on their part than do the positions of stone statues on medieval church facades. The end of *that* matter was reached with Picasso's *Demoiselles d'Avignon,* in which any effort at defining a common emotional bond or even a shared physique that might link the painted figures with the gallery-going observer within a perspectival context is abandoned; since then themes of character, personhood, and community have all but disappeared from modern art, along with the use of perspective.

Let me conclude by taking note of two very different uses of perspective in twentieth-century art. The first is to be found in Eugene Berman's 1941 painting entitled *View in Perspective of a Perfect Sunset* (see figure 82), which reveals an understanding on the artist's part of something that was elaborated upon at length in Philip Rieff's *Triumph of the Therapeutic*—to wit, that human personalities are shaped by traditional beliefs, by faith, by enduring institutions, and that when those things fail, when people have only the abandoned and meaningless monuments of dead civilizations but no cities, no citizens, no public beings, no shared purposes or goals, then the creation of a perspectival stage only intensifies our awareness of how much has been lost—for on this stage, as on that of Beckett's *Waiting for Godot,* nothing has happened or is going to happen.

The second image I have in mind is one of Le Corbusier's drawings from the early 1920s, *A Contemporary City* (see figure 83). The work, in perfect

FIGURE 82. Eugene Berman, *View in Perspective of Perfect Sunset,* 1941. Philadelphia Museum of Art: Gift of Mr. and Mrs. Henry Clifford.

FIGURE 83. Le Corbusier, *A Contemporary City,* c. 1922, from *Le Corbusier et Pierre Jeanneret: Oeuvre Complete, 1910–1929* (Zurich: Les Editions Ginsberger, 1937).

Albertian perspective, seems to me as deeply disheartening as Berman's, even though it had great influence upon the thinking of the young architects who gravitated in the 1920s and 1930s toward CIAM, the Congrès Internationale de l'Architecture Moderne, and who were later caught up in an international enthusiasm for *Siedlungen* ("settlements") and "housing projects" that lasted until the destruction of St. Louis's ill-fated Pruitt-Igoe project in the 1970s. Such projects, sometimes vast in scale, were not grounded in history, in any existing patterns of community or of political or economic structure. Behind these rows and rows of identical buildings there lies no conceivable *imago hominis*—and, consequently, no *imago civitatis*. Both those *imagines* were of critical importance to Brunelleschi as he devised his *tavolette* and to subsequent generations of perspectivists. Le Corbusier's, on the other hand, does not result from his having taken his stand with regard to anything that exists "out there" in the world; it is a projection from the mind of a lonely, friendless young Swiss expatriate who had abandoned all hope for the historical traditions of Western civilization and who imagined that architects alone could lay the foundations of a New World Order, one that would entail no loyalties to subsidiary institutions of any kind—and that would therefore constitute the kind of monism that, as Eugen Rosenstock-Huessy observed, can lead only to tyranny.

Architects cannot be pessimists, cannot give way to despair. They can devise ways of making us more comfortable, of moving traffic more expeditiously, but they cannot, any more than can deracinated painters, install the institutions that must, in the long run, be more important and more enduring than any work of art can possibly be.

# Notes

## Introduction: The State of the Question

1. Erwin Panofsky, "Die Perspektive als 'symbolische Form,'" *Vorträge der Bibliotek Warburg* (1924–25): 258 ff.

2. Giulio Carlo Argan, *Brunelleschi* (Paris: Macula, 1983) p. 146 (originally published in 1952).

3. John White, *The Birth and Rebirth of Pictorial Space* (London: Faber and Faber, 1957); introduction, pp. 19–21.

4. Walter J. Ong, *Rhetoric, Romance, and Technology* (Ithaca: Cornell University Press, 1971), p. 180.

5. Before proceeding, let me acknowledge the fact that some writers employ the term *scientific perspective* to refer to any representation of a vista that extends continuously into depth and toward the horizon. This is the sense in which Fritz Novotny uses it in his book *Cézanne und das Ende der wissenschaftlichen Perspektive*. However, this seems to me to be a misuse of the word *scientific*. When Ruisdael looked out over the Dutch plain stretching away toward Haarlem, he was not looking scientifically or as a scientist, nor did his rendering of that scene involve any element of scientific calculation. He simply depicted what he saw, rendering the vista in a way that was emotionally satisfying to him, as it still is to us.

## 1: The Lost Tavolette

1. Antonio Manetti, *The Life of Brunelleschi,* ed. by Howard Saalman, trans. by Catherine Englass (University Park: Pennsylvania State University Press, 1970).

2. Richard Krautheimer, *Ghiberti* (Princeton: Princeton University Press, 1956), p. 240.

3. Samuel Edgerton, *The Renaissance Rediscovery of Linear Perspective* (New York: Basic Books, 1975), pp. 56–59.

4. Richard Krautheimer, *Studies in Early Christian, Medieval, and Renaissance Art* (New York: New York University Press and University of London Press, 1969), p. 130. Krautheimer might have done better to argue that what was changing was not people's attitudes toward *buildings* but toward the reality of the *institutions* that had traditionally erected great stone edifices.

5. Thomas Molnar, *Twin Powers: Politics and the Sacred* (Grand Rapids, Mich.: Wm. B. Eerdmans, 1988), p. 107.

6. Richard Sennett, *The Fall of Public Man* (New York: Knopf, 1977), p. 150. Much that Sennett has to say is relevant to my argument.

7. M. H. Pirenne, *Optics, Painting, and Photography* (Cambridge: Cambridge University Press, 1970), p. 12.

8. Sir Isaiah Berlin, "The Question of Machiavelli," *New York Review of Books,* 17, no. 7 (Nov. 1971): 25.

9. Eugen Rosenstock-Huessy, *Out of Revolution* (Norwich, Vt.: Argo Books, 1969), p. 543. "The modern democracies are leading to slavery because they have no guarantee against the monocratic tendencies of popular government."

## 2: On the Relation of Perspective to Character

1. Anthony Molho, "The Brancacci Chapel: Studies in Its Iconography and History," *Journal of the Warburg and Courtauld Institutes,* 40 (1977): 50–98.

2. Cf. Warman Welliver, "Symbolic Architecture of Domenico Veneziano and Piero della Francesca," *Art Quarterly,* 36, nos. 1–2 (1973): 1–30.

3. Erich Auerbach, *Mimesis: The Representation of Reality in Western Literature* (Princeton: Princeton University Press, 1946), chap. 1.

4. As quoted in Morris Bishop, *Petrarch and His World* (Bloomington: Indiana University Press, 1963), pp. 109–10.

## 3: The Two Allegiances

1. Alessandro Parronchi, *Studi su la dolce prospettiva* (Milan: Aldo Martelli, 1964), pp. 245–81.

2. Heinz Roosen-Runge, *Die Rolin-Madonna des Jan van Eyck: Form und Inhalt* (Wiesbaden: L. Reichert, 1972).

3. Richard Vaughn, *Charles the Bold* (London: Longman, 1973), p. 40.

## 4: Perspectives on the Last Supper

1. Lawrence R. Brown, *The Might of the West* (New York: Obolensky, 1963), p. 119.

2. Frederick Hartt, *History of Italian Renaissance Art* (New York: Harry N. Abrams, 1970), pp. 222–23.

3. Leonardo Olschki, *The Genius of Italy* (New York: Oxford University Press, 1949), pp. 40–41.

4. The prominence given to Nicodemus may well derive from the close association that is established in the Golden Legend between him and Etienne Chevalier's patron saint, St. Stephen. It is recounted that Nicodemus and Gamaliel took the body of Stephen and buried it, whereat the Jews were so outraged that they beat Nicodemus and left him half dead. When he died a few days later, he was buried at St. Stephen's

feet. Moreover, Fouquet, may have had his own reasons for including Nicodemus, for it is further recorded that the man was an artist. He made a miraculous image of Christ Crucified that later fell into the hands of a community of Syrian Jews. On giving forth water and blood from the wound in Christ's side, it brought about their conversion. Surely Fouquet would have liked the idea of associating both exhortation and wonder-working power with an artist's role and works.

5. Leo Steinberg, "Leonardo's *Last Supper*," *Art Quarterly,* 36 (1973): 297–409.

6. I am beguiled by the fanciful notion that Tintoretto may have visited Ravenna, which it not far from Venice, and may there have seen the Justinian and Theodora mosaics in San Vitale. Being a most perceptive artist, he may then have grasped the fact that the Emperor, on our left, is carrying the bread of the Eucharist toward the seated figure of Christ in the apsidal mosaic above, while the Empress, on our right, is carrying the wine. The meaning of the Eucharistic elements that is affirmed in that pair of mosaics is diametrically opposite the one that Tintoretto sets forth. One might almost regard his *Last Supper* as an explicit refutation of the mosaicist—a rejection of the hierarchical and caesaropapist order of things in favor of a symmetrical disposition of two beggars and a dog.

7. Tintoretto's use of large genre figures in the foreground contrasted with small but important figures in the background brings to mind a Flemish usage of the middle years of the sixteenth century that was explored several years ago by J. A. Emmens in his essay "Eins aber ist nötig: Bedeutung von Markt- und Kuchenstücke des 16. Jahrhunderts" (in *Album Amicorum J. G. van Gelder,* The Hague, 1973, pp. 93–101). In paintings by Joachim Beukelaar and Pieter Aertsen we repeatedly see scenes in which the foreground is filled with large kitchen maids or shopkeepers while Christ is shown to be very small in the background, either in scenes of "Christ in the House of Mary and Martha" or in "Ecce Homo" images on the far side of a crowded market place. What those painters meant to call to our attention is the extent to which worldly preoccupations distract us from attending to "the one thing that is necessary"—namely, Christ's message. The purpose of Tintoretto's rendering in *The Last Supper* raises similar questions in our minds, except that for him the beggars on the steps, with their bread and wine, seem almost to take precedence over the Eucharistic feasting that is taking place at the far end of the table. As in the image of Paul in Bruegel's painting of his conversion, the use of perspectival distance may be intended to suggest a greater remoteness in time—for the beggars are modern Venetians, like the members of the Scuola confraternity.

8. David Rosand, *Painting in Cinquecento Venice: Titian, Veronese, Tintoretto* (New Haven and London: Yale University Press, 1982), p. 209 and note 74.

## 5: An Eccentric Stance

1. Robert L. Mode, "Masolino, Uccello, and the Orsini Uomini Famosi," *Burlington Magazine,* 114 (June 1972): 368–75.

2. Charles E. Trinkaus, *In Our Image and Likeness: Humanity and Divinity in Italian Humanist Thought* (Chicago: University of Chicago Press, 1970), vol. 2, p. 492. (Professor Trinkaus informs me that he knows of no Renaissance writer who refers to the passage in Genesis about "famous men." But surely Uccello knew about it.)

3. Ibid., vol. 1, p. 300.

4. André Chastel, *The Myth of the Renaissance, 1420–1520* (Geneva: Albert Skira, 1969), p. 200.

5. Trinkaus, vol. 1, p. 245.

6. Michael E. Mallett, *Mercenaries and Their Masters: Warfare in Renaissance Italy* (London: Bodley Head, 1974), p. 214.

7. Ibid., pp. 208–09.

8. Erich Auerbach, *Mimesis: The Representation of Reality in Western Literature* (Princeton: Princeton University Press, 1946), chaps. 3–23, pp. 12, 15.

## 6: Family and Church

1. Erich Herzog, "Zur Kirchenmadonna van Eycks," *Berliner Museen: Berichte aus den ehm Preussischen Preussischen Kunstsamlungen,* Neue Folge 6 (Aug. 1956): 2–16.

2. Heinz Roosen-Runge, *Die Rolin-Madonna des Jan Van Eyck: Form und Inhalt* (Wiesbaden: L. Reichert, 1972).

3. *Luther's Works,* vol. 51, (Philadelphia: Fortress Press, 1971), p. 81; vol. 54, p. 161; vol. 51, pp. 360–61; vol. 54, p. 161.

4. I would attach great weight, as well, to Altdorfer's deliberate introduction into his architectural invention of elements from different historical periods. Panofsky has pointed to a consciousness of changes in architectural style on the part of earlier Northern Renaissance artists, who used Romanesque and Gothic buildings to allude to the Old and New Law respectively. In Altdorfer's case, however, I believe he meant, instead, to take into account, from a new point of view, the role of history as a factor in the very nature of the Church's being. Architect that he was, he could see in the church buildings of South Germany that men's ways of thinking about the institution had undergone changes, wherefore the medieval conception of a timeless Ecclesia was not in accord with the visible evidence. If sweeping changes had taken place between the time of the apostles and that of Constantine, and just as plainly between his time and that of Innocent III, then clearly Luther's call for radical change was not without precedent. Altdorfer is perhaps the earliest painter to assert that the Church itself exists in historical time and undergoes changes as other entities do. Such an awareness on his part is again in keeping with the characteristic concerns of the Reformers, whose followers turned almost at once to writing *histories* of the Reformation. Altdorfer's own distinctive concern with historical perspective is manifested in a truly spectacular fashion in his *Battle of Issus* of 1529, where spatial and temporal perspective take on a virtually "cosmic" dimension.

## 7: The End of the Matter

1. Arthur K. Wheelock, "Carel Fabritius: Perspective and Optics in Delft," *Nederlands Kunsthistorisch Jaarboek,* 24 (1973): 63 ff.

2. The relation of architecture to the philosophy of historicism has lately been explored with insight and intelligence by Robert Jan van Pelt and Carroll William Westfall in their book (of alternating assays), *Architectural Principles in the Age of Historicism* (New Haven and London: Yale University Press, 1991).

3. Emil Kaufmann, *Architecture in the Age of Reason* (Cambridge: Harvard University Press, 1955), p. 97.

4. Georges Clemenceau, "Revolution des cathédrales," in Clemenceau's paper, *Grand Pan,* Paris, 1896. "Et ces cathédrales grises, qui sont de pourpre ou d'azur violentées d'or, et ces cathédrales blanches, aux portiques de feu, ruisselantes de flammes vertes, rouges ou bleues, et ces cathédrales d'iris, qui semblent vues au travers d'un

prisme tournant, et ces cathédrales bleues, qui sont roses, vous donneraient tout à coup la durable vision, non plus de vingt, mais de cent, de mille, d'un milliard d'états de la cathédrale de toujours dams le cycle sans fin des soleils. Ce serait la vie même telle que la semsation nous en peut être donnée dans sa réalité la plus vivante. Ultime perfection d'art, jusqu'ici non atteinte."

5. C. Mauclair, "Choses d'Art," *Mercure de France* (June 1893): 357.

6. Joachim Pissarro, *Monet's Cathedral: Rouen 1892–94* (New York: Alfred Knopf, 1990), p. 29.

7. Walter Pater, from an essay he wrote and had privately printed in 1868. It was published in 1873 as "The Conclusion" of his book *Studies in the History of the Renaissance.* In the second edition (1878) the title was changed to *The Renaissance: Studies in Art and Poetry*—and the "Conclusion" was omitted, because, Pater said, he thought it might mislead the young. The essay could not be reprinted in London until 1905.

# Index